FANDEMONIUM
RED HOT CHILI PEPPERS

INTRODUCTION BY
ANTHONY KIEDIS

PHOTOGRAPHS AND INTERVIEWS BY
DAVID MUSHEGAIN

RUNNING PRESS
PHILADELPHIA · LONDON

Books published by Running Press are available at special discounts for bulk purchases in the United States by corporations, institutions, and other organizations. For more information, please contact the Special Markets Department at the Perseus Books Group, 2300 Chestnut Street, Suite 200, Philadelphia, PA 19103, or call (800) 810-4145, ext. 5000, or e-mail special.markets@perseusbooks.com.

ISBN 978-0-7624-5148-7
Library of Congress Control Number: 2014943002

E-book ISBN 978-0-7624-5536-2

9 8 7 6 5 4 3 2 1
Digit on the right indicates the number of this printing

Designed by Jack and Louis Shannon
Edited by Cindy De La Hoz
Special thank you to Anna Glen @ Wet Noodles Inc.
Typography: Orator Std, Futura, Orca

Running Press Book Publishers
2300 Chestnut Street
Philadelphia, PA 19103-4371

Visit us on the web!
www.runningpress.com

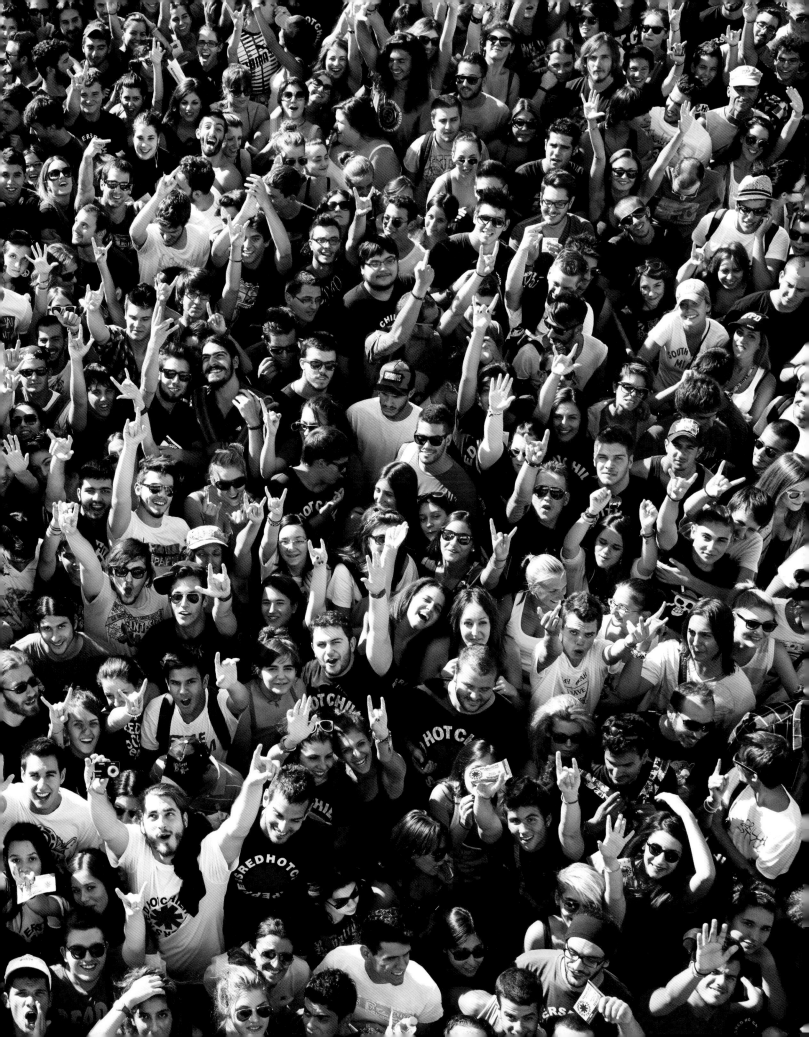

Growing up I was never really a "fan" of anyone, as we normally think of being a fan. From the age of eight onward, my father, Blackie, turned me on to all kinds of great music: Blondie, Benny Goodman, Roxy Music, the Sex Pistols, and the Clash. I loved all that music but I didn't consider myself a fan of those people. I was always one step removed from that "I'm a fan, I have to go to this show" mentality. It wasn't because I was rebelling against my dad; I loved the art he was showing me, but my personality at that time was to be more of an observer than a rabid participant.

I felt the music, I loved it, and I would dance and sing along with it and get excited. The only way to create a vibe for going out to a club is to listen to music that you like. When you're getting dressed, when you're doing your hair, you just need to have the jam going. But I wasn't a fan per se. Perhaps it was because I always had a grandiose idea that my destiny was to be an artist myself so I couldn't go around idolizing another artist too much. My father had planted the seed when I moved from Michigan. "Here's the plan, you are going to move to L.A. and you'll be a movie star." And I'm like, "Okay." That's what I told my friends before I moved back to California when I was eleven.

They were like, "Why are you moving to California?"

"Well, because I have to go and be a movie star."

"Oh, okay. We'll keep an eye out for you."

So I started getting into acting and I got this audition for a huge part in a big Hollywood movie, American Hot Wax. Ironically enough, I was going up for the part of an obsessed fan—the president of the Buddy Holly fan club—so I had to study what it was like to be the fan of one of the first rockers ever. My dad helped me a lot. "Here's a Buddy Holly cassette tape, learn the music. And here's the story of Buddy Holly, learn everything about this guy. Just think about him a lot and remember that you really love this guy and you want to turn other people on to him and his music. You're the guy who's going to spearhead the Buddy Holly movement," he told me.

I got so into Buddy Holly that out of the one thousand people that auditioned for that part, it came down to two people—me and this famous child actor named Moosie Drier. Moosie had been doing movies since he was three years old, so they went with the veteran, which broke my heart. I went on a bender of drugs and alcohol but, in retrospect, the Universe was looking out for me. If I had gotten that part, my whole life might have been different and I might never have become a musician. But that was the first time that I really got the sensation of what it was like to be fanatical about a musician—to study what they wear, emulate their haircut and their glasses and their dance moves.

The dictionary definition of fan is "an enthusiastic devotee, follower, or admirer of a sport, pastime, celebrity, etc. a baseball fan; a great fan of Charlie Chaplin." It's an Americanism, originating around 1885, and it's short for "fanatic." By that definition I certainly am a fan, of musicians and songwriters and singers, famous or not famous.

I'm a fan of nature. I admire nature every day. Every time I look at a tree, I'm in awe; I'm a fan of that tree. What a perfect thing. It's bigger downstairs than it is upstairs; we don't even see half the tree. It's cleaning the air. It makes everything look better even if it's in the middle of a badly architected city with horrible buildings, you see a row of ten trees and you have to say, "Whoa, look at the shape of those leaves. Look how they blow in the wind." I'm such a massive, enthusiastic fan of nature that every day I look at the mountains in our neighborhood and point them out to my son. "Look at that mountain. Look how that cloud is sitting on top of it." Then at night, we just stare at the stars in the sky shining over the ocean. So I'm a big fan of creation. I absolutely love life and the will to live, the life force finding ways to exist and create.

Look what this framed beauty had to say, somewhere in Australia.

I'm a big fan of underdogs, of people and animals that have a hard time and have managed to persevere. And I'm a huge fan of kindness. Of all the weird shit that we all experience, when I actually see true kindness being exhibited, it makes me well up with emotion; it's just the craziest thing. Pure kindness, with no ulterior motive, that just knocks me out.

And I freak out when I hear artists like Eric Dolphy or Miles Davis or John Coltrane, guys who are on an alien level of intelligence, dedication, and magic. They blow me away. I would love to meet these people, but I'm not the guy who follows them around on tour.

When I was growing up, it was natural to become a fan of the people you saw on TV. I came out of Grand Rapids, Michigan, back in the era of three television channels. It was a very middle-American ritual to go to school, come home, have a snack, and go out and play—bike riding or tree climbing or skipping rocks, whatever—until you couldn't play anymore. Then you came home and had dinner and sat down in front of the television. You watched a Disney show, or the

current hits, whether they were *The Wild Wild West* or *Get Smart* or *Bewitched*. I fell in love with all the cute girls on the screen and wanted to be like the dudes, especially David Carradine in *Kung Fu*. And when my dad dropped me off at a karate movie downtown, I came home and took it to another level and started practicing some slick Bruce Lee moves.

I guess my first fan experience came when I was about five years old. We were living in California and my mother was the secretary of an entertainment lawyer. At that time, *Gilligan's Island* was massive and the lawyer represented the show. So my mom said, "Do you want to go to the set of *Gilligan's Island* and meet the cast and characters?" And I was like, "Well, why yes, I do. I would like to go and meet Gilligan and Ginger and the Skipper." So I went to the set where they filmed the show and there was the island; there were the palm trees and the sand and some little pools of water. I met the whole cast and they all gave me signed, glossy eight-by-tens of themselves. We moved to Michigan and those things went up on my playroom wall.

The only other time I can remember actually going out to seek someone's autograph was when I was about twelve years old. I was at a restaurant with my dad and he pointed to another table. "That's O. J. Simpson." "Oh, I know who that is. He's with the Buffalo Bills," I said. "You want to get his autograph?" my father asked. "Sure." So I walked over to his table and asked him to sign this little card and he accommodated me and I saved it for a long time. I wasn't all that into O. J., but he was a famous guy. I'm no longer a fan, though.

Other than the *Gilligan's Island* photos, I never really adorned the walls of my room with posters of my heroes. I did have that famous Milton Glaser multicolored Bob Dylan poster on my wall but I didn't really know much about Dylan, I just liked the way his rainbow-colored, animated hair looked.

I guess I was just not cut out to be an average fan. Part of that was because as soon as I moved back to L.A. in 1973, when I was eleven, the very first person that I ended up being friends with was Sonny Bono. Sonny and Cher had their hugely popular TV show then and I befriended both of them, even though she was getting divorced from Sonny at the time. So that whole mystique of the world of the super-famous performer was instantly penetrated, and I was no longer on the outside of that bubble; I was right inside it. That really changed my perspective of looking at people that might seem bigger than life, or impossible to attain communication with. And I also took the standpoint that I was probably better off not meeting my superheroes because I might be disappointed when I did. Except for the Beatles.

One night when I was in my teens, I went out with my father and his drinking buddies to a big party in Beverly Hills. Every famous couple in Hollywood was there. My dad

and his pals were all high as fuck and we got to the doorman and they wouldn't let us in. Suddenly, I saw Cher leaving the party and I'm like, "Hi, Cher!"

"Oh, hi, Tony. What's going on?" Cher said.

"Well, I'm here with my dad and his friends and they're not letting us in."

"Oh, that's fine," she said. "Just go right in."

It turned out that it was her party. So we went in and my dad and his friends were all luded out and high on champagne and I looked in one corner of the room and there was Paul McCartney standing and talking with John Lennon. The two guys who were supposed to be archenemies at that point in time were chatting it up at this Beverly Hills party.

"Wow, the guys from Yellow Submarine," I said to my dad.

My dad was totally lubricated and he walked up to John Lennon and said, "Hey, John Lennon, come here. I want you to meet my son, Tony. Tony, get over here."

My dad sort of knew Lennon from hanging out at the Roxy but they certainly weren't besties. I was a little embarrassed that my dad was so high but at the same time, I was certainly going to go over and say hello to the two greatest guys on earth.

They were very tolerant of the whole situation. I suppose they would be when there's a kid involved; no one wants to make a father look bad in front of his child. I think even super-mega-massive celebrities always make an exception for a child. So they were nice and I loved seeing them. They were so flippin' stylish. Just to be around those two icons that were part of everybody's upbringing was amazing. They were omnipresent in my life since I was five. Everybody was Ob-La-Di-ing, no matter where they were on the earth. Everyone was watching that little Apple spin around on their turntables in the basement, dancing to those iconic songs.

I didn't really understand everything that the Beatles had been through at that point. I didn't know that Paul and

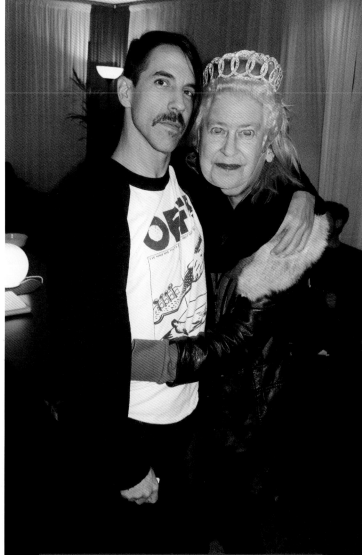

Anthony and "the Queen" in London

John had really gone their separate ways and had written sort of malicious songs about each other. I didn't realize how special it was at that moment that they were together having a moment of either reconciliation or just humanity, whatever was happening. But they were beautiful.

My love for The Beatles got way stronger years later. I still get the biggest thrill whenever I see Ringo anywhere. And it is love; I see these people and what I feel is love. Just like, "Oh I love that guy; he's such an awesome human being." These are guys that have been through the wars and they came out alive and they've got great energy.

Cut to decades later [last week at the time I'm writing this], I went with my girlfriend to an Oscar party at Guy Oseary's house and every actor, every actress, whatever, they were all there; they were having a great time. It was a beautiful thing; people were dancing and smiling. And there was Paul McCartney and I have the same feeling about him today as I did when I was a kid. I just love that guy; I love him so much. He has given the world more than the world could ever give him back. He's endlessly bestowed love and beauty on Planet Earth like nobody's business. We're so lucky to have him; this guy is magical. "Blackbird singing in the dead of night..." There he was, what a beautiful thing.

"It felt so good to both be a fan of this person's art and his beauty and his history but also for him to be so welcoming... It's Paul."

Normally I wouldn't really know how to say, "Hey, let's talk." But Paul said, "Get over here; we played that festival together in Outside Lands." I was drenched in sweat because I had been dancing and he came over to give me a big hug and I was like, "Whoa, whoa, whoa" and he said to me, "Oh, come on, some of my best friends are sweaty." Back to the party. I was there with my girl, Helena; he was there with his beautiful, new, super-sweet wife, and he wouldn't let us go. He just wanted to tell us story after story after story, about his kids, about his wife's business. She finally goes, "Come on, Paul, you're boring these people to tears." And I say, "No, this is good, this is fine, we'll listen." So he was telling me how his wife was in charge of a New York-based trucking firm and she was responsible for three thousand trucks. I was thinking, "That's so cool." It felt so good to both be a fan of this person's art and his beauty and his history but also for him to be so welcoming and just kind of dismantling of the separation that fame imparts on you. Because if anybody knows what it is to live a life of separation, it's Paul.

✳

I was aware of Iggy Pop from a very young age because I saw him perform at the Whiskey when I was maybe thirteen. When I watched his show, I thought, "This guy is completely original; he's one of the greatest performers I've ever seen." He was

beautiful and he was stylish and brimming with raw energy. I went home and was like, "I saw the coolest show the other night. You've got to check this guy out." It wasn't like now he was my guy, or I was going to identify with him, but I liked what he did. I went and saw Blondie at the Whiskey on their first trip out west and I went back to the hotel and proposed marriage to Deborah Harry as a child. But I wasn't a fan of hers. I emotionally felt the experience of seeing these artists live, I would lose myself in reckless abandon on the dance floor, but my observation was a little bit studious or clinical. I guess I just wanted to quietly take it all in on some level.

Even when the punk scene started in L.A. I'd go to see The Germs and The Dickies and all of these very, very important, early L.A. punk rock bands, but I'd just stand on the side and see what was going on. All of the people in the audience had Mohawks and I sat there and watched a girl put a gigantic safety pin through her cheek because she really wanted to express her dedication to this new, beautiful, and indescribable punk rock scene that was happening. But again, I didn't feel like, "Oh, I am a fan now." My feeling was, "I've got to go tell my friends about this, we've got to get to some more shows."

I was acting in my high school theater group then and Flea was just starting to play bass in the band Anthem. At very best, I was introducing Anthem at their shows. That was my first live performance, which was really lots of fun. I didn't have in mind that I wanted to be in a band, per se, then. I didn't set the course for that outcome.

Along with my friend Dondi, who played bass, we had a weird jam band in 1980 and we'd play in a little Hollywood nonequity theater. We called ourselves "Spigot Blister and the Chest Pumps" and I was Spigot Blister and I'd just scream into the mic and Dondi just made this aggressive noise on the guitar. It was fun to jump around and just generally freak out.

I guess it was a little bit of a foreshadowing of my future, but playing as the Red Hot Chili Peppers wasn't even my idea. It wasn't until our friend Gary Allen suggested that we get together in 1983, that our band was born. I wasn't looking at my friends and going, "Oh, I gotta sing with these guys." It really didn't dawn on me.

Flea was like me at that time. He was definitely a fan of the punk rock scene, but again, he was such a young stud himself, as a musician and as a character, that he mingled very easily in the scene. He just became more a part of it than being on the outside as a fan. He joined Fear, the top-dog punk band in L.A., and he became their bass player. So he was a lover of the scene and a lover of music but I never saw Flea draw "Van Halen Rules" on his high school notebook.

In some respects, to be a fan is to give up some of your own identity. And I think, even unconsciously, when you have a strong sense of self and you get a bit of a momentum for creating your own art—even if it's just the art of living—you're less likely to attach yourself to another artist and follow them and emulate them. Believe me, we loved a lot of bands. We would have Black Flag parties at our house where we would drink a lot of beer and dance. But it was more for inspiration to do our own thing.

I'd say Jimi Hendrix is the closest I ever came to idolizing another musician, but it was not so much to be a fan of the guy as it was to try to figure out what made him tick so we could go tick that hard. When I was in my late teens, Flea, Hillel, and I got heavy into Jimi. *Electric Ladyland, Axis: Bold as Love*, we would just listen to those albums over and over again to try to understand the fire and the energy and the genius and the dedication that guy had, and then we wanted to go play his music.

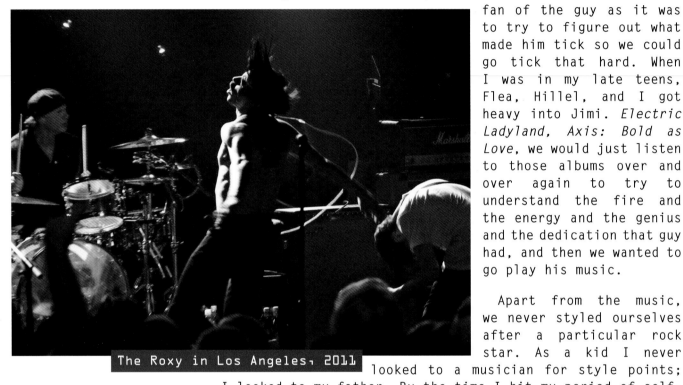
The Roxy in Los Angeles, 2011

Apart from the music, we never styled ourselves after a particular rock star. As a kid I never looked to a musician for style points; I looked to my father. By the time I hit my period of self-expression as an artist, I had my own sense of what I thought style was, and it was fairly different from a lot of other people. I loved David Bowie's style, but I wasn't a skinny little androgynous guy who could pull that off. I was like an aggro, bouncing off the walls. And even though I was more closely related to Iggy as a performer, I didn't want to buy his style either; although inadvertently, I did kind of go with the bare-chested approach, but with very different energy and very different movements.

Right after we started the Red Hot Chili Peppers, Flea and I went to New York for a CMJ Music Convention. We were amped on self-promotion; we were basically fans of ourselves at that point. We truly believed in ourselves and we wanted to spread the good word. "You've got to check us out man; we've got a funky thing happening and you never heard this before." The place was jammed and people were moving all around, and we got shoved into an elevator and I looked up and it was motherfucking James Brown in the elevator with me! I was wearing my own band's T-shirt that had graphics of us making funny faces.

"James Brown!" I said. He grunted a response. "Can you sign my shirt?"

And he signed my shirt and I saved it forever until I lost it. That was really the only time that I ever, of my own volition, decided I needed to ask somebody for an autograph. That was the one and only truly fan moment I had and I was excited all day long that I got to stand next to James Brown, because what I had for him was love, pure love. Now, if I had run into him a few years later, I wouldn't have asked him for an autograph, because my idea of showing love is to give him his space. I might give him a smile, I might just say, "Thank you." But I wouldn't ask him for anything, he's already given me too much, more than I've ever given him. How can I say, "Oh, could you give me a little bit more?" The guy changed my life, how could I ask him for more?

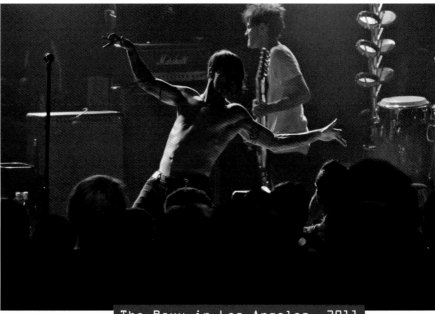

The Roxy in Los Angeles, 2011

In June of 2004, we had four big shows to play in England, two shows in Manchester and two shows in London. Our agents said, "Who do you want to play these shows?"

"Well, can it be anybody?"

"Name it, anybody, and we will get them."

"James Brown," I said.

"Done, we will get him."

Now James was older, he was over seventy by then. He showed up and played those four shows with us, full band, fully rehearsed, fully intact, fully rocking. It was a complete and utter James Brown throwdown.

Again, I didn't want to get in his face, I didn't want to ask him for anything, but I did tell his people if there was ever a time when James was comfortable with me spending a little bit of time with him in his dressing room area, I would take that opportunity. If not, don't sweat it. Don't go over there and tell the guy I need to hang out with him, but let him know that if he is into it, I would love the chance. If not, thank you for being here and playing these shows. Well, it wasn't the first two shows; it was the third show, his handlers came to me and said, "Do you want to go hang out with James?" "Yes I do." I grabbed John Frusciante and we went. We quietly sat down, we were going to let James do his thing, because he was preparing. He just started engaging, as he was getting ready. He was getting his hair done by a

hair girl; he was getting his nails done by himself; he was getting primped and preened and ready; and he just started telling us stories about his upbringing. "You know, I can croon with the best of them. I can do Sam Cooke; that is not a problem for me. I just didn't want to be a crooner," he told us. And then he started crooning for us. "I can do this; that would have been nothing. I just didn't want to do it, I had something else I wanted to do. People think I can't croon. I can croon."

It was magical. I got my twenty minutes with James Brown. I got to be around him; I got to see him as he really was. And he was in good shape. He wasn't the lost and troubled James Brown of maybe ten years earlier. He was matured and older and just centered in his body. And then two years later on Christmas morning, I woke up and got the news. James Brown had passed. And I cried my eyes out.

Now back to when we were just starting out, our first performance, which consisted of one song, was so exhilarating that the high just lasted for days and days. We got asked to come back the next week to play two songs, so Flea and I made some flyers and we decided it was time to let the world know that the world's new greatest band was now in existence. There was absolutely no shame in our game and we didn't care that we were self-promoting with the most grandiose and kind of arrogantly egomaniacal, obnoxious attitude, because A) We were twenty and B) we were nothing. So it was okay

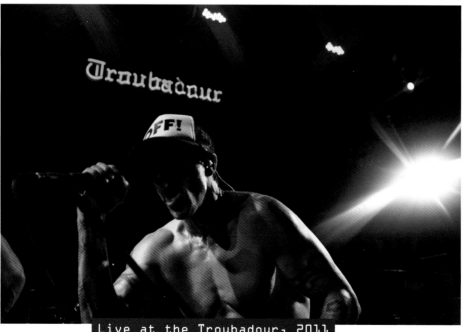
Live at the Troubadour, 2011

to promote nothing like it was the greatest and C) we actually believed that we had stumbled upon and tapped into a great motherload of music that we had been loving but not necessarily creating. Flea was in a punk rock band and a new wave band; Hillel was in the same band; Jack was in the band. But we all had love for jazz and we had love for painfully hardcore funk. We had love for dancing and we had love for sexual energy and hilarious energy and devious energy and Jimi Hendrix and James Brown. Even though Funkadelic was a great funk rock band, they weren't punk rockers from Hollywood. So when we did that first performance, we really felt like we found something that we didn't even know we were looking for, but when we found it, we realized we had been looking for that.

When we started to promote, we would go from bar to bar,

from club to club and Flea and I would belly up to the bar, next to strangers, usually female strangers. We'd present them with the flyer and we would look at them and say, "If you want the greatest musical experience of your life, be here next Wednesday night at eight o'clock." And people would look at us like we were crazy, but that's what we had to do, we wanted people to show up.

When we started playing these tiny shows all through Hollywood, half of the audience would be our very good friends. And the other half would be friends of those people. So when we would look out at these people that were taking a very initial interest in us, they were people we knew. Our fans were the girl that we were hanging out with, the girl that had the barbecue the day before, and they were lovely people. It was a really magical group that we hung out with. So often it would just be those faces that we saw. "Oh yeah, there's my dad; there's the girl I'm dating; there are her friends; there are the other guys we hang out with."

Friends and family. But it didn't stop us from feeling very consumed with this new passion that we had found, just because it wasn't commercially viable and it grew quite fast, in our opinion. I think because it was such an accidental experience, we never really had time to think "Well, we've got to get on the radio; we've got to become famous." Really to us, the end goal was just to dominate the Hollywood club scene. That seemed like the top of the ladder. Where is there to go from there? Because we weren't looking at the spectrum along the lines of a Van Halen success or anything else that was happening and it really stayed quite underground for a very long time. We had a great little following, wherever we would go to these clubs, they would be sold out, but that's because the club held 150 people. And sometimes there would be a little line outside and we'd show up and be like, "Oh my God, oh my God, oh my God, there's a line!" But again, the audience was still mostly friends and other bands that we knew.

I got my first real fan at our fourth show. We were playing at a beautiful venue called Cathay de Grande, a low-ceilinged, nowhere-to-run, nowhere-to-hide, piss-stained punk rock venue in Hollywood. The stage was a foot and a half off the ground, so you were almost eye level with the audience. It was sparsely attended, maybe thirty people, but we were performing as though it was a packed house. We felt the energy of a packed house and we played maybe four or five songs that we really loved at the time, like "Green Heaven" and "Get Up and Jump." And it was a really good show for us; we were feeling it. And then afterward I walked to the side of the stage where my father was, and he congratulated me, but then there was this exquisitely beautiful, older woman, to me because she was probably twenty-nine or thirty and I was maybe twenty or twenty-one. She had this crazy thick

> Our fans were the girl that we were hanging out with, the girl that had the barbecue the day before, and they were lovely people. It was a really magical group that we hung out with.

accent and she was all colorful and she kind of embraced me and said, "That was a great show. Let me be the first to tell you that you are going to be huge around the world." That was her wild Nostradamus moment. And it was Nina Hagen. She was so beautiful and so exotic-looking. She had her colorful, alien, superfreak look, but beyond that she was just very East German. Overbite, high cheek bones, just a radiant lady and I fell in love with her at that moment. But she truly believed, in her heart, what she said. She's like, "I'm calling it first. You all are going to be loved around the world." Mind you, it wasn't until almost ten years later that that was the truth, but she felt it in her bones and she really laid this kind of unsolicited adoration on what we were doing, I think more energetically than anything else. It wasn't like we were writing songs you could sing along with, or anything like that.

Checking out the local vintage shops in Zagreb.

That was also the beginning of a romance that sparked up for a little while. She taught me a lot about life at a young, tender age. She instilled in me the idea of giving stuff away, which later would end up in a song in 1991, because I was so poor and so without possession or food or tomorrow's rent, or anything, that I couldn't conceive of just giving something away for no reason, because I was in survival mode. One day I went over to her house and she was treating me to breakfast and blow jobs and love, affection, wisdom, and her spiritual awareness. I looked in her closet and I'm like, "Wow, that's the coolest-looking leather jacket I've ever seen." And she said, "Oh, take it." "What?" "Yeah, yeah, just take it, you can have it. The only way you're going to get good energy is by giving it to other people. I can't keep stuff, because then I'll lose the energy. If I keep giving it away, then..." I was like, "Really? What a crazy idea." But that was one of the most profound life lessons I've ever gotten. So I basically fell in love with and had sex with my first fan.

✳

Our first record, which came out in 1984, sold about ten thousand copies at the time. The next album sold maybe five or ten thousand more. But we would still go on tour, and sometimes when we showed up to the clubs, there would be people there to see us. Sometimes they were there because they just happened to be there and had no idea who we were.

As the years went on, one of the first times I realized that our music had escaped Hollywood somehow and gotten into the hands of people elsewhere was when we'd go to a town and there would be the fan guy who would show up and say, "Hey, I really love your music." Nobody was looking at us as famous people yet, so they didn't have that, "Oh, I want to be your friend because you're famous" vibe. It was more like "because my sister plays your record in the basement" or "I saw you guys playing a show in a parking lot." At the beginning it was rare to have a reoccurring guest in a town that liked us, so we did befriend them.

There was this guy in San Francisco called Butch and he wore dreadlocks. He was a little bit older and had some weird connection to Jimi Hendrix when Hendrix was hanging out in San Francisco years earlier. So Butch became our fan/friend. Every single time that we'd play San Francisco, from 1984 until now, he'd be there. And we'd be like, "Yup, let Butch in, let him backstage, he's our friend," just because he was there from the beginning with nothing but support.

We had a lot of these fanbassadors in different cities—fans who knew where the late-night places to eat were or cool places to hear music, and they would shepherd us around their towns. Because we weren't famous for a very long time, it really was a lot easier to be friends with people that we would meet at our shows. There wasn't that separation. You would just literally walk off the stage and into the crowd quite often, like, "Let's go hang out; let's go get a drink; let's go get some late-night food; let's go to the next club or party." We didn't feel famous and they didn't look at us like we were famous. There was energy. They might have been like, "Holy shit, this is fun, I like hanging out with these guys, they're different." But we weren't on TV, we weren't on the radio, we weren't on billboards, so there wasn't that awkwardness like, "Oh, I feel weird, because I think I know this person, but I really don't" for such a long time. It was actually kind of like gravy hanging out with some of these people. We were young, so we were looking for sex, we were looking for drugs, looking for excitement, and most of the time, that's what we got.

The first time that I remember feeling like we had fans all across the country was when we were on tour for *Freaky Styley* playing a club called Toad's Place in New Haven, Connecticut. We were walking down the street and we saw some kids who happened to be black, which was extra special because our world then was a little bit white and they started scream/singing:

"Nevermind the Pac Jam

Nevermind the Gap Band

Nevermind the Zap Band

Nevermind the Funk Scam

'Cause we're Red Hot Chili Peppers"

They were chanting the chorus from our song "Nevermind." We're like, "What the fuck? They know our music. That's crazy." It was great to know that we had fans way across the country because when we went on tour in England after our first record, we played a little hole-in-the-wall place called Dingwalls and we had no fans there at all, just people who were visiting the bar and who were going to watch our set, for better or worse.

> They were chanting the chorus from our song "Nevermind." We're like, "What the fuck? They know our music? That's crazy."

It wasn't until our third record that I felt the first moments of "Holy shit, these people in the audience know who we are before we get there." They were ready for us. They knew our songs, they knew the lyrics, they were our fans. We were playing in Denver, Colorado, at the end of the "Uplift Mofo Party Plan" tour and we had to move the gig to a bigger venue because it had sold out so fast. We played a great set and everyone in the audience was singing along.

After the show, Hillel and I were backstage in our cramped little dressing room and one of our roadies came back. "Hey, this girl wants to show you something. She's with her boyfriend. Are you cool with that?" I'm like, "Yeah, all right." And she comes back and she's young and pretty and she's with her boyfriend, so I wasn't trying to mack on her or anything. And all of a sudden, she drops her pants and pulls down her panties and right across her mound she had tattooed "Anthony." "That's for you," she said. And I'm like, "But, that is your boyfriend." She said, "It doesn't matter, that's for you."

She actually caught me off guard with that. I didn't know what to say. But that was a straight-up, hard-core fan move. Nothing happened. She just wanted to say, "I have true admiration for you and this is how I'm showing it." It was a beautiful scenario because she wasn't being crazy, sleazy, ho-ey. She's like, "This is my boyfriend, but I do have to show you what I have done." Later I looked at Hillel and said, "We must be doing something right."

Tattoos are a weird thing, especially when fans get tattoos of me or other members of the band on their body. Tattoos are weird-looking to begin with, so permanent, so it's almost a little bit painful to look at a tattoo that you're so personally involved with. Some people get tattoos of our logo or some of our lyrics. Some people have their entire back covered in lyrics. The coolest lyrical tattoo was a friend

of mine, who's not really a fan but he does appreciate our work, and he has a line tattooed across one of his ribs, in typewriter writing that says, "This life is more than just a read-through." Sometimes they even replicate my own tattoos on their body, including the gigantic back piece. That's a very creepy feeling. But even weirder and harder to digest are the portraits of band members. I don't think I've ever seen my own portrait but I've seen several Fleas and several John Frusciante portraitized on people's bodies. It's hard enough to capture someone in a tattoo, so when I see something like that it hurts my heart a little bit. I feel the love but I also feel the pain.

But the strangest thing I've ever seen is this guy from Italy who has the *I'm With You* Anthony-clone-look down to a tee. It's like something out of an episode of The Twilight Zone. You don't want to walk out of a hotel and see yourself. You just don't. It's upsetting the natural order of things. Parallel universes are not supposed to happen in the same place and the same time, but in a different place, same time. So God bless his enthusiasm, I know that he's coming from a place of love, but it still throws me for a loop.

Cruising around New Orleans, right before filming the video for "Brendan's Death Song."

Speaking of coming from a place of love, I'd be remiss if I didn't discuss the sexual union of performers and fans. As a young teenager, there is the pursuit of female company and many people get into a band to up their status a bit so that their menu increases. But as our fame increased, I experienced a shift in perception of these matters. The minute that I felt like a girl was interested in me because I was any amount of famous, I was no longer interested. There may have been times when I was fooled and I thought, "Oh, she just likes me for being me." But whenever I felt that it was, "I want to sleep with this guy because he's in a band or he's famous," that was just the biggest turnoff ever.

I remember once I was sitting with Rick Rubin and George Drakoulias at the back booth at Damiano's, an all-night Italian food joint in L.A. It was about 1990 and Mother's Milk had come out and we were working on *Blood Sugar Sex Magik*. Some random girl just started throwing herself at me and it was obviously a fame-driven attraction. It wasn't that I had great morals, the attraction just wasn't there—"No, that doesn't turn me on." If there is no actual spark between people and it's just based on degree of fame, then I don't feel it and I haven't ever since. It's just an energy thing, which is really contrary to this sort of cliché of what it is

to be the guy in a band growing up. But it went the other way for me. The more well-known we became, the more introverted toward the fans I became. Before we were that well-known I was comfortable mingling and just being a worker bee among worker bees. Then the more we were on television, the more we were on the radio, the more introverted I became in dealing with the public in general. It became more about just hanging with my friends, which is not necessarily a healthy thing.

I think that part of it is because when you walk into a room and people know the famous you, there is an expectation or there is a predetermined idea of who they think you are, instead of just being completely open, like, "Hey, who are you? What do you like? What do you do? Let's dance, let's talk." Unless the new people that you are meeting are unaffected people, it's kind of hard to get past that image. But I'm sure it's as much my fault as anybody else's. I do remember having those strange feelings, particularly after *Blood Sugar*, which was a very profound shift in our visibility factor.

Maybe part of this whole dynamic was our perceived image at that time. We were literally naked before our fans. For the first ten years, if you asked someone, "Tell me the first thing that comes to your mind when I say Red Hot Chili Peppers?" They would say, "Naked guys on stage." Our first shows were in front of our friends and we used to go out on stage in the very beginning wearing just our tube socks in a very strategic area. Our friends would then try to pull the socks off. There was no perceptible change because they were people that we knew.

Hanging out in Talin the day before a show.

But then we did that iconic poster, a poster that at that time became more well-known than us or our music. It was taken by this outstanding female Japanese photographer and she made it into a poster— just the four of us, naked except for our tube socks, standing there with a stoic, deadpan expression on our faces, as if we were sailors leaving for war. It instantly became, "Yeah, I know you from that poster!"

We really couldn't escape that image, especially after we started taking a little more pride in our songwriting and our musicianship. "Uh, yes, we do play naked sometimes. But there are songs and rhythms and notes and harmonies and lyrics, did you happen to notice those as well?" So we were typecast as those wild and crazy naked guys for about ten years.

All that made us more approachable to strangers. There is something about our personalities that definitely made people feel a little more comfortable getting in our faces at the weirdest times. Whether we were eating or in a conversation, they felt like, "Oh no, it's okay to talk to these guys."

Another factor in this was that when we started playing music, the most popular music going was hair metal: Poison, Ratt, Warrant, all of that stuff. And they were such posers, God bless them, I don't take anything away from them, they were having a great time and they were causing other people to have a great time, but their shtick was to have a very handsome guy made up like, "I'm so handsome I'm almost as pretty as your girlfriend."

Our image was a stark reaction to that posing. We would just distort our faces into the most contorted and ugly masks that we could and that was how we presented ourselves—drooling and dirt and cum and mud and paint splattered all over the place. We wanted to make ourselves as unattractive as possible and there was a comedy to it and there was a knucklehead factor to it. It...was all those things. I think that that made people feel like, "Oh, I can talk to these guys. They're just knuckleheads like me." Approaching us was much different than approaching a man in a fine suit with lipstick on.

As we progressed in our careers, I would meet people who began to play the bass because they were inspired by Flea. Girls, boys, not necessarily successful musicians, but people that were happy to play music. Later on, we ran across John Frusciante, who was a huge fan of the Red Hot Chili Peppers, as well as Frank Zappa, King Crimson, and many other musical entities. He didn't just learn our guitar parts, he learned the bass parts, the drums, and the vocals. When we met him, there wasn't this wall between us, like, "I'm your fan, so we can't communicate." He was like, "Yes, I am your fan, but I also am one of you and I would like to play music with you." Not necessarily be in your band, but, "Let's go jam right now." He was so confident in his own musicality and he wanted to test himself. He jammed with Flea when we still had Blackbyrd McKnight from P-Funk in our band and it wasn't as if we were trying to get rid of Blackbyrd, but John just wanted to play with Flea and they had a couple of jam sessions.

And then the buzz on John just took hold and we thought: Wait a second, maybe this is the guy we're supposed to be playing with. Then I went to see him audition for Thelonious Monster, since we already had a guitar player. He was so amazing and that was the moment that I realized, this has to happen. I think Flea had already sort of had that moment when he played with John.

Some years ago I published my memoir entitled *Scar Tissue* and it generated a whole new category of fans. I had revealed a lot of personal information in the book and I was

so unprepared for the response. I was so stupid to think I could say all of that stuff and not have people trip out on me. But immediately people rolled up on me with these incredible expressions on their faces talking about how they read the book or they couldn't put the book down, and telling me the effect that it had on them, the effect that it had on a family member. It got to be like, "Oh my God, I'm talking to a person who knows a lot of intimate details about me. It's like they've read my diary." And at first it really set me off, I was like, "What have I done?" I thought I was going to tell tales and paint the colors of the different decades and the relationships and the drug abuse, just basically tell as many stories as I could and weave it all into this life.

It turned out the book had a meaning and a purpose that I don't know if either myself or my collaborator, Larry "Ratso" Sloman, were really conscious of as we were putting it together, and that was really a much more noble endeavor than I ever had in mind. I didn't set out to see if I could help people get over their hurdles and their struggles. I just wanted to tell my story. What ended up happening was something way better because after people got over the details of the sex or the drugs or the whatever, what it was seen as was: Here's a guy who was really messed up, going downhill, crashing hard and somehow—with the help of many others—managed to completely right the ship that was going down. And they were like, "If this fuck-up can right his ship, why can't I right mine?" Or "Why can't I help my family member figure out how to get their shit together?"

Grandpa Kiedis was from a small village in Lithuania.

I would say that that is what fans of the book have become. They come up to me now and they're like, "I read your book, thank you." Either "You helped me get on track" or "You helped somebody I love get back on track." And it continues to this day. A week doesn't go by without someone rolling up on me and thanking me.

That's one of the most rewarding experiences of being in a position to help other people. Since the very beginning of our band, some very sick and even terminally ill people have come to our shows to get a dose of cosmic energy from the music and the performance and the camaraderie of the band. And we have always welcomed that and we always have appreciated that exchange with anybody, whether they are close to the end or just permanently physically ill, we love that.

Obviously it feels good to make somebody happy, to make somebody feel the spirit and I can think of so many beautiful occasions where very, very sick people have come

to our shows. Some of them can't talk, some of them can't move. I remember there was a guy on one of those horizontal wheelchairs, completely immobile, but for sure feeling all of the goodness that we had to offer. And that's a pretty moving experience for us, to see that somebody thought it was important to get that person into our show. They thought that it would do them some good to be present for the music.

I can't remember when it started, but for a very long time we've had a relationship with Make-A-Wish Foundation and maybe every five or ten shows somebody will show up whose wish it was to get to a show. And they can range from ten years old to thirty years old, and they usually come with a chaperone or maybe a family member and we're all extremely happy to have that experience and to let them into our world and treat them like a king or queen for the day, because it's just a great reminder of the give and the take and how lucky we are to be in a position to touch people and that they can come and touch us. You can become a very bitchy, self-centered little brat on tour, like, "Where's my shake?" And then some kid walks in and they've been fighting for their life for the last two years, you're like, "Whoa, let me just slow my roll real quick and get back to basics and remember why I'm here."

Because in the end, I am here to serve. We have a great life, we make a good living, but really we are here to serve. At our best moments it isn't about the money, it's not about the fame, it's not about the chicks, it's not about the cash and prizes. The best moment we will ever have is the moment of serving, they're the real moments. Like when you get to the gates of Saint Peter, he'll be like, "Well, did you serve? Were you nice? Were you kind? Did you give it up to someone else?" He's not going to say, "Were you rich? Did you get that limited edition convertible?"

❋

One of the things that we've discovered as we've toured the world many times over is that there are real differences in nationalities as far as fans go. Because we're an L.A.-based band we've always had a very cool relationship with the different ethnic groups that inhabit our city of angels. I've noticed that if you go to a Morrissey show, his audience is about 80 percent Mexican. They are the most emotional, passionate, colorful, and committed fans you could ever want to perform for. They just give themselves entirely to the music, to the lyrics, to the person performing. There's this link, this bond, this oneness, because they are not trying to be too cool, they're not trying to put on anything, they're just like, "This music takes me out of myself to a better place." I think we have a bit of that same good fortune with our Mexican or Mexican American fans. That connection led us to the writing of the song "Cabron," which directly acknowledges how great it is for both us and for L.A. to have Mexicans in our mix. For one thing, Mexicans are ridiculously loyal and they won't like you for the year that you are

popular, they'll like you for the thirty years that you are up and down, which is a good thing.

Then I have to acknowledge the black gangster, not the typical black element in L.A., but the slightly harder black gangster element. I'll be driving down the street sometimes and I'll hear "Under the Bridge" cranking out of a low rider, loud. And I'll kind of peek over and it will be a car full of heavy gangster-looking dudes. And they'll see me and they'll give me the most casual acknowledgment, but it's a strong acknowledgment. It's not like, "Oh whoa, look who is there, oh my God, hey, get out them flip phones and take a picture!" It's like, "That's right, we're down." That's a pretty cool feeling.

When we get out of the country it's always interesting to see how different countries respond to the record you just put out. Invariably, every time we put out a new record, a different country will react stronger than it ever has before. Italy has always been a very passionate place in general when it comes to life and music and food and loving and automobile design and many other things. I know they were super into *Blood Sugar Sex Magik*, but it wasn't until we put out *Californication* that I realized Italy was The Country that was their record. *Californication* sold more records in Italy, by far, than anywhere else in the world. For whatever reason, that struck a chord with the Italians. I could tell, because we were doing press tours and we were there the day that record came out. And everywhere we went, on the very day it came out, people were singing along with the songs on that record. And I'm like, "How the fuck does anyone know ... They've heard it for like ten minutes, they're singing along." But everywhere we went, people on scooters, people at the sidewalk cafés, wherever, it was that way from day one.

Then we put out *By the Way* and *By the Way* was England; Italy cooled off. They're like, "Eh, it's no *Californication*." For the next two or three years that we were involved with By the Way, we should have just moved to England, because that's where it was hot and that's where we did our thing. Then Stadium Arcadium was Germany. We should have moved to Germany.

My first inkling that South Americans reacted differently to rock music than any place else probably came with the Ramones. Rick Rubin always had the Ramones as one of the top three greatest bands of all times. And if you listen to the records, they qualify for that conversation. Their songs, their textures, their look, their performances, the magical chemistry of those guys, they had it in spades and they never sucked. America didn't embrace them with the same kind of enthusiasm as they did the Beatles or the Rolling Stones or Led Zeppelin. But long after they had cooled off in the USA, they could still go down to South America and sell out stadiums and create their own version of Beatlemania. South Americans really don't care what's popular in America, or

what is popular globally, they care about what is popular to them. If they decide that it's the shit, it's the shit and they will behave accordingly.

And then we got our first taste of it. We went on a tour to Brazil with Nirvana, Alice in Chains, and L7 and it was the first time we had been anywhere where there was no getting out. We checked into the hotel in Rio and you were not going to get out of the hotel because it was literally sequestered by a ring of five thousand human beings that would just as soon rip you to shreds as to let you go for a walk on the beach.

It was the first time we had ever been to a country where no matter what, you had to have security guys with you wherever you went, which is really not that fun. So, that was pretty weird. You could go out on the balcony and a thousand people would instantly start singing one of your songs to you. It was like that classic scene where Martin and Lewis, I think, come to New York City and they open their window and it's just mayhem. I didn't really feel like we deserved that much attention from anybody but it was coming with such a loving spirit, they weren't obnoxious about it, and it was kind of novel the first time around. But eventually you could see how this could be a bit of a problem. I'd want to go surf or look at the shops, or walk around and we'd literally have to escape. There was a routine to even getting the car out of the parking lot or out of the driveway of the hotel, so you could go off in the jungle somewhere and take that walk.

A little graffiti fun on the road.

One time when we were there, I was given a security officer who was a cop. He was like Tony Baretta, an undercover cop, young, cool, a jujitsu black belt. He carried a gun, but he knew Rio de Janeiro like the back of his hand. I was there with a friend of mine from L.A. (we'll just call him "Mr. J"), and we wanted to go see the mean streets of Rio de Janeiro, the favelas, the colorful side of Rio. We were staying in this opulent, ritzy area, which is always the most boring part of town and we figure, "Okay, we're with a cop who knows his way around; we'll be safe. Take us to the real spots where things could get dicey." He's like, "Okay, let's go, that's where I work. I got no problem up in there. I get a lot of respect." I'm in the backseat of a compact car and he

drives us off into the night, maybe it's midnight. My friend Mr. J is in the front seat. And there were hookers everywhere; there were drug dealers everywhere; there were kids running around, bike-riding, dancing; there was the smell of food; and people thronging in the streets.

So we see this fantastic, six-foot-two-inch, black-skinned transsexual hooker, wearing just a fluorescent bikini, a beautiful specimen of a human being. Attractive, but straight-up transsexual. And the cop pulls over and the transsexual recognizes him and she's like, "Fuck, I'm busted." And he rolls down the window and he says, "Hey, come here." And she kind of stalls, she's like, "Oh God, the night's just getting started, I really don't want to get busted right now." He's like, "No, no, no, you're not in trouble, come here. I want you to say hello to my friends." So the expression on the tranny's face just changes drastically from "fuck" to like, "Oh! This could be fun." And she looks in the car, she sees Mr. J in the front seat, she sees me in the backseat, and I'm like, "This is beautiful, this is a real moment." And then the cop gets a little bossy with her and he says, "Turn around, turn around." So she turns around and he smacks this big, taut, black ass a few times. He knows that she's fun and not going to be worried. It wasn't like he was scaring this person or anything. She was enjoying this.

About to get in the water in Rio.

And then she turns around and she sort of reaches into the car, over my friend and puts her hand on his leg and grabs his dick and you can tell by her reaction that he's got a hard-on. And she's like, "Oh, you like that smacking." He got so embarrassed and he's like, "No, no, my cock's not hard. My goodness, you should see it when it's really hard. That's nothing." But he really got turned on by this tranny getting her ass spanked by the cop.

So the Brazilians were the most fanatic of our South American fans at that time, but since then the Argentinians have given them a run for their money. They don't post up in huge numbers in front of the hotel but when they show up for the show, they show up ready to let it all hang out.

We did an interesting thing in Argentina about ten years ago. Their economy was basically going bankrupt and their money was near-worthless. At the same time, they were

getting hit with the worst floods ever in Buenos Aires. We had scheduled a show for Argentina, but suddenly no one had any money, literally overnight. So our management called and said, "We've got to cancel, they've got no money in Argentina." And we were like, "Fuck that, we're in South America. They want to come see us, we want to play for them. Let's just go and play."

We ended up playing basically a free show in a big outdoor place in flooded conditions where you had to go through streets that had turned into deep rivers to get to the show. I feel like they'll never forget us for that; we'll always be the band that came to play a free show in the flood. We realized that there was a lot of love coming from that country. I feel like the goodwill has just snowballed continuously since then and we've also been to Peru, Chile, Colombia, Paraguay, Uruguay, and Venezuela.

Then there are our Japanese fans. We got our first call to play Japan in the late '80s. It was shortly after Hillel Slovak had died and John Frusciante had joined the band and we wrote and recorded Mother's Milk. Our manager at the time, Lindy Goetz, said, "We've got some gigs in Japan. They are not big gigs, basically little club gigs in Osaka, Nagoya, and Tokyo." At the time, the word on the street was that you would be dismayed at the lack of reaction by Japanese fans. They would treat you like you are a ballet performance. They would sit down. They are by nature so polite that they would not want to raise their voice to interfere with the performance. They would wait until the song is completely and utterly finished before giving you a little, gloved clapping. And then they would all stop simultaneously and wait for you to proceed, so don't plan on getting your energy from the crowd. And we're like, "Whatever, it's time to go to Japan." It seemed so exotic and we had read books and we wanted to see the geisha culture and Tokyo. Back then, post-Internet globalization hadn't brought all of that to your doorstep, so it really was going to the unknown.

We're like, "Fuck that, we're in South America. They want to come see us, we want to play for them. Let's just go and play."

So the first stop was Nagoya, the smallest of the three towns. When we got to the hotel there was a fan waiting to meet us, which was kind of an unusual thing for us; at that point in time we did not have fans waiting to meet us in hotels. He was a teenage boy, extremely sullen with sort of a non-expression on his face and he was carrying all kinds of items. He did not speak English, but he had a little translation book that he was clutching in his hand like it was his life support system. And he started thrusting drawings at us. One was a very recognizable portrait of Hillel Slovak. Then the boy started weeping uncontrollably as he gave us a picture of Hillel. So we're like, "Whoa, this guy is a real fan. He loves Hillel, he's like a little teenage fan guy." And we quickly embraced him and said, "Hey, man, it's okay, don't cry. Hillel is okay. He had a great life."

He met us all and he told us that his name was Kenji, and that he was getting his foot in the door. For the next fifteen to twenty years, we would have something to do with this guy every single time we went to Japan and it was an absolute roller coaster. He could have fixated on John, the new guitar player; he could have fixated on Flea, the wild and crazy personality of the band; he could have fixated on the lead singer; but instead he fixated on Chad Smith, the big rock city, blue-eyed drummer from Michigan. And we instantly hooked him up with tickets for the show, which was happening the next day. We took him under our wing and basically said, "Hey, do you want to join us for dinner, do you want to hang out, you want to come to the show? It's all good. We don't know anybody here in town."

Kenji took those offers as though he was expecting that to happen and he became hyper-possessive of us. Whenever girls would come around he would stand within inches of us with this look of disapproval on his face. Like, "Don't you dare! Don't you dare infiltrate my special circle that I have now with these boys." We were kind of like, "Kenji, it's all good, everything is good." And then he ran away and he came back with gifts. It's a very Japanese thing for a fan to present their persons of admiration with gifts. But he made the hierarchy of his fanship clear with his gifts. Flea was very low and I want to say he got like a pencil. I was maybe next in line and I got something like a scarf. John was probably next in line and he got something a little bit nicer. But Chad, who was clearly the top of the order, got a beautiful electronic piece of equipment. So it was his way of letting us know like, "Yup, like, like, like, love."

He followed us around for the next few days. You'll find in the Japanese train stations that the more obsessive fans somehow get your travel information and they'll be waiting for you on the loading dock for the trains. It becomes a bit chaotic, because they've got the gifts, they've got the cameras, they want a little love and attention, and they're all on the platform waiting. And again Kenji was very aggressive and very cocksure of his place as our number-one fan, and he was kind of pushing other people out of the way. We had to tell him to chill out a few times.

He ended up following us to Tokyo where, after our show, sometime in the very middle of the night, Chad was raising a little hell in the hallways of the hotel. There may have been some other female Japanese people involved in the hallway antics. And Kenji, in no uncertain terms, did all he could to send all of the other fans home at that point. And then he went through a very emotional period of trying to explain to Chad, with the translation book, that he wanted to be Chad's man. I don't even know if Kenji was gay or straight, or a little bit of everything, but he was so enamored with Chad that at that moment, he expressed his deep and carnal love for Chad Smith. And even though he behaved very poorly and almost violently toward these other people, we couldn't let

him go. He had touched us with his early portrait of Hillel and his tears and his dedication, so we didn't discard him even for his irresponsible behavior. And he became a bit of a mascot, not in the condescending way, but like, "When we're in town, you're around. You're our buddy; we'll hook you up with the tickets."

Over the years, our trips to Japan would always be colored with a variety of different Kenji appearances. And they were never predictable and sometimes they were downright ludicrous and edgy. I think the very next time we came he had undergone a testosterone-fueled growth spurt and he was bigger and stronger and a little bit more whiskery and acne-ridden and he was clearly in his angst years. And I don't know if we accidentally overlooked him in some way, but he basically broke into our show (which was still at a smaller venue), ran up to the merchandise booth, grabbed everything he could get his arms around, and bolted for the door. It was almost like some shocking display of his need for attention at all costs. And he was fuming mad the whole time, smoke coming out of his ears. I don't know if he was caught, but we weren't going to prosecute Kenji. We wanted to confront him and say, "What's going on, what's the matter?" and talk. And time went by and all

A little guitar jam before the show in Alabama.

was forgiven and we ran into him on a train. He might have even gone a little bit Rasta, like complete mellow peace vibes later on. I don't know where he's at today, but I have faith that he is in a good place.

Going back to our first trip to Japan, our first show was in a tiny theater and the kids got up to dance, moved by the spirit of the music, and they were not out of control or violent or anything, they just got up to dance, which was a very pleasant surprise. We were like, "Yeah, we got them up and moving" at which point the cops showed up and wanted to shut down the show, calling it a riot. Their idea of a riot was kids getting out of their chairs to dance at a rock show. And at one point they did shut down the show and Lindy Goetz, our manager, showed his best Jewish Brooklyn accent to talk to these Japanese-speaking cops like, "What's the problem here officer?" We finished as much of that show as we could, but I will say that the next couple of shows we did see slightly more tame behavior than we were familiar with.

If we played the Ritz in New York City, people would be jumping off the balconies. The dance floor would look like a whirlpool, filled with body parts, when we played the Cheetah Club in Tokyo the first time around, people were moving and grooving, but there was that sense that they did not want to be seen acting too crazy. The minute the music stopped, they were right back to crossing their arms and clapping and containing themselves. But over the years, this whole kind of stigma of the Japanese being too tame has really gone away with the globalization of mankind.

The Sea Shepherd team toured with the band, setting up at each venue.

When we go to Japan now and we play a festival at Mt. Fuji or something like that, it's absolute mayhem, chaos, but in a beautiful way. People are going completely bonkers and becoming one with the mountain and the music. So we definitely saw that, from 1989 to current times, the Japanese have caught up with the rest of the world as far as being exuberant, dancing, jumping, shouting, wild things.

On any given night, any given country can explode. Minus Turkey. Flea and I definitely have an argument going about this. We played Istanbul for the first time on our last tour. It is without question one of the greatest cities on Planet Earth. That place is like New York City in the '80s on a creative level, but it looks like San Francisco times fifty in terms of size and population. And it's right on the Bosphorus strait, which separates the continents of Europe and Asia. So the amount of energy and life in the air is just off the charts—the food and the style and the behavior of the people, it's alive. So I was expecting our audience to reflect all that energy that I felt in the city, because I walked everywhere. It's hilly, it's old, it's groovy, there are cafés, and the people are smart and communicative and they dance well. I was like, "This is going to be one for the ages here."

But the audience was like Japan in the '80s. They didn't dance; they didn't go nuts; they had the appreciation factor of a jazz audience. They had the intellectual connection, but they just didn't cut loose. Now Flea says it was because the place had lost its liquor license and he contends that every other audience that we've had for the last three hundred shows had to have been intoxicated to act the way they did. I just don't buy that argument.

On a few occasions we've played in places where the people were under the yoke of the government, and that's always an interesting experience. We played Russia in 1999 when things were just beginning to turn, but the problem was that we played Red Square. It was a free show for all of Moscow and I think because it was a very oppressive government, they were terrified at possibly losing control of the situation. So they brought out the Russian army, which is no joke. There is no humanitarian give with those guys at all. They didn't get to be the Russian army by having humanitarian give. It was just black and white. They were like, "If you do something that we told you were not allowed to do, we will shut you down with brute force, including the back of our rifles."

So we played the show, hundreds of thousands of people as far as the eye could see, it's free, they're curious, they are not necessarily even Red Hot Chili Peppers fans—maybe some of them are. But really it's just Russians wanting to go out and do something different. And it got very out of hand quickly with the army. The army got very brutal on the crowd, who was doing nothing more than dancing. Watching this from the stage we were like, "Help, please, let's not have a scene here." It was our Altamont moment. Normally we would have control over this, because it was our security guards. And even if it was the Orlando police, I spoke their language and I could tell them from the stage, "Let's keep it peaceful. These people are okay; we got your back. It's all good; we are here to have fun." The Russian army was not trying to hear any of that, especially in English. So that was a very discouraging experience, to see fans get hurt.

We went back twelve years later with Josh and played St. Petersburg and Moscow. And before we got there, there was a YouTube video circulating where some Russian fans had done an incredible self-made video to our song "Look Around," where they were basically asking us to come to Russia and telling us that they could not wait until we got there. It was just beautiful—the faces, the emotion; they were dancing, it was choreographed.

The shows went great. There was no violence this time around. But outside of a stadium in Moscow where we played the Russian army did make their presence known. They had their guys on horseback and they just have to show themselves like, "Listen, we run this place, keep things in line and there won't be a problem." But at least they have come to a point where they let the people go and have fun.

Back in 1986 we played Northern Ireland with Hillel Slovak. That was a place that did not have a lot of Western visitors then. They were very sequestered; it was a very violent time for Northern Ireland. They were surrounded by the English military, which was made up of babies—eighteen-year-old boys. We pulled up in a little van and they had guys with machine guns and pillboxes pointed at us. And then we looked a little closer and those guys weren't even

shaving yet. Baby-faced, English army kids who had been told that they had to point machine guns at whoever came or went over the border. Very disconcerting, but they realized we were a band and they took their fingers off their triggers and said, "Hey, who are you guys? What's going on? Hello! What's happening?"

So we go into Northern Ireland and we play for a packed house of maybe four or five hundred kids and for the longest time, on the Richter scale of audiences, they were, pound for pound, the most intense audience ever. Those five hundred kids were fifty thousand kids in a room because they just didn't get entertainment over there. It just didn't happen; they weren't on the circuit. And the Irish are very profoundly spirited people to begin with, let alone the Northern Irish, let alone kids that were hungry and thirsty for something. They knew that that was their night and they weren't going to leave anything unturned. So for years to come that was our benchmark of mania. And it was such a good feeling to be in that room, rocking out for these people.

We almost had a chance to play a concert for the oppressed people in Ukraine. Vitali Klitschko, the former WBC heavyweight champion, is one of the voices of the opposition in the Ukraine now. We're friendly with his brother, Wladimir, the current undisputed heavyweight champion of the world, who's a big fan of ours. We found out that he would do his ring walk to "Can't Stop" blasting from the speakers, so we were honored that he would use our song. We met him when we were touring Germany, and he's very smart and thoughtful, not at all an aloof or arrogant champion. He comes to see us whenever he can and he brings us heartfelt swag like boxing gloves and hoodies, so it's a real mutual admiration society. There's a nice picture of us with him in this book.

Wladimir called us out of the blue a few months ago, a couple of weeks before the violence erupted in the Ukraine. He must have sensed that this kind of revolution was about to happen because his brother was so central in the opposition movement. He asked me if we would go to Ukraine and play a show. And he didn't say what for and I was like, "Okay" and he said, "Yeah, like a peaceful protest." But I never heard back from him, which was unlike him because he was usually quite punctual and communicative. I wrote him two weeks later and he said, "It's okay. It's past that point." By then his brother had been water-cannoned into a corner at a demonstration, and things quickly took a turn for the worse, and it's still getting worse every day in that country. So it wasn't a good time for us to go play there.

As we got more and more popular and famous our relationship to our fans naturally changed. And the whole nature of a fan/star interaction changed, too, with the change in technology. At the beginning of rock and roll nobody knew how to be a fan of rock energy. There was no blueprint for it, like there was no blueprint for a little girl screaming

her lungs out at a Beatles show or Chuck Berry show. It wasn't like today where the Internet kind of dictates this too-much-information about everyone and everything and every place. It takes away the hunt and it also takes away the individualizing of how you identify with a band, whether it was the Ramones or whether it was Buddy Holly or whether it was Devo. If you were a fan of that band, that was kind of your deal and that was something special because you would have to use real mail and real records and you would have to travel distances to go to record stores to get the music and then you would meet other people. And it all still happens, but in a completely different way.

I'm talking about the scourge of selfies, one of the most painful things that an artist has to deal with. Instead of a wonderful human being coming up to you and saying, "Wow, did you hear that new record" or "Did you see that basketball game?" or "How about that sunset?" or whatever, they're like, "Hey, can I take a picture with you?" This beautiful human walks up to you and you're like, "That's some good coffee in here, isn't it?" They don't want to talk about the coffee; they don't want to smile or make a joke; they want a picture. Every human being on Planet Earth now carries around a camera in their phone, and all they want is proof that they saw you so they can put it on their social media outlets, but they don't want to have any actual loving, warm encounter. I see it all the time with actors that I know who live in Malibu. They just want to cruise, they want to hang out, they want to meet girls, they want to pet dogs. But in today's society it's so much more important for people to just have the proof. It doesn't matter what sort of exchange takes place.

Freak Surf in New Zealand.

The problem with this kind of interaction is that it creates separation. It's like the fan is saying, "You're different than me, I'm different than you, but I need a picture of you." Implicit in that is that we're not on the same level. That's just an alienating feeling. If I'm talking to somebody, and they suddenly go, "By the way, I've been to twenty of your concerts and I really need you to talk to my wife on the phone right now," I no longer feel like I'm on

the same level with that person and I just want to get away. I know they're looking at me like something other than just another person.

Plus, once the camera comes out, it's like a virus. Now everybody else is going to get their camera out and you have to spend the next thirty minutes of your life saying, "Oh no, no, I've got to go." While they go, "Oh, just one, just one, just one more. Just one for me, just this one." I hear "Just one" fifty times a day. Why can't we just say hello? I'm not saying that it happens to me every day of my life, but I've seen it constantly happen to, God bless him, Owen Wilson. You never saw a guy go from being so happy when a cute girl walks up to him and he's like, "Yeah, hey, how are you, boy are you cute." He's about to make a funny joke and she says, "Can I have a picture?" His face falls off his head. It's like someone pulled the plug. He's like, "Ah, okay, a picture." And then he'll leave. It's that dehumanizing.

Trick-or-treating with Everly Bear, on tour in Minneapolis.

I was in the farmers' market last weekend with my girlfriend, checking out the dried fruits and these two cute girls—they looked a bit punk, they had on the heavy cat-eye makeup and singlet T-shirts—came over, and of course, they wanted to take a picture. And my thing now with the picture-taking is, I look at them right in the eyes with a lot of love and I'm like, "Thank you for the support, but I've retired from picture-taking." And they look at me with a look of disbelief, like, "Certainly you must be joking." And then I give them the next look, which is, "I'm not joking; it's nothing personal; it's really nice to meet you. Where are you from? How are you doing?" But I just can't, because if I take a picture, A) It's going to get weird and B) The person over there is going to come walking over and going to go, "Oh, picture-taking, well I'll get one, too, while I'm here," and then another one and another one. If you happen to be in an area where there are fans, then your day will revolve around taking pictures.

These girls were from Moldova and it was kind of cool to meet two young fans from Moldova, an obscure little spot that we've never been to. So I made a joke. I said, "Had you been from Albania, I would have gladly taken the picture." And they started stomping around and said, "Well, my mother is from Albania!" I said, "Go get your mom, I'll take a picture." But that's a moment that I've repeated many times and it's amazing to see the reactions of disbelief when you tell someone you've retired from taking pictures, because

there's an expectation in the air that if you own a camera, you are entitled to take a picture of anyone or anything at any time. But the good news is my refusal usually starts a little conversation and then I end up feeling better, because I get to actually say, "Hello, what's your name? How are you? What's happening?" So at least a little real human interaction ensues.

What's the worst is when you're interrupted when you're eating to take a picture or give an autograph. If a kid does it, it's okay. But if you're a large human being and you interrupt Flea while he's eating his Mexican food to ask him for some autograph shit, you're going to get the look of shame. "Really? Your getting an autograph is more important than me putting sustenance in my little body right now?"

I far prefer to celebrate the joyful and the earnest and the loving fan, but unfortunately for every hundred joyful fans there might be one slightly deranged fan, or bitter fan or mentally disturbed fan. And over the years we've had all of that and I don't want to give too much energy or power to them, because that's kind of what they live for. They just seek out any connection and they'd rather have the negative connection than no connection. I've had the weirdest people obsess or fixate on me.

I've never been threatened by these people, but I've had them spend all of their life trying to get to me by way of disturbing my very extended family. One time my stepfather's father's brother was in a hospital bed, fighting for his life in Michigan and his phone was ringing off the hook in the hospital with this woman from Italy who was looking for me. So here is a man who is ninety years old in the hospital who I have only met maybe once in my life, not even a blood relative, but she is stalking him to try to get to me. And God bless a good friend of mine who worked security, because she once flew into L.A. and he had let the L.A. airport police know to keep an eye out for this person. And they pulled her aside when she flew into LAX and they're like, "Okay, we're just going to make sure that she is mentally sound to enter the country." And independent of me, they instantly assessed her to be mentally incompetent to enter the country. They put her right back on a plane and sent her home.

So I've had good luck. It's an unfortunate thing that people don't always acknowledge your need for privacy, especially when they have love for you or they have admiration for what you do, you would think that would be built-in. Like "I really like this person, I'm going to let them have their peace and quiet."

I had people that flew here from Germany and they came to my door and they wanted to talk and take pictures. One time a father came with his daughter and he was like, "We have come all the way from Germany." And I'm like, "Yes, but I cannot welcome you. I cannot pretend like it is okay that you came to

my house. This is my family, I have to protect my family and my space." And normally when there is a parent with a child, I really try to make an exception and go the extra mile to accommodate them. But in this instance, I felt like the best lesson was to show the girl that that's not okay. You can't just show up at someone's house, because everybody needs a little sanctuary.

Thanks to the Internet, people find my address and phone number. I get texts like you wouldn't believe from unrecognized phone numbers, a lot of not very nice stuff. Sometimes it's just weird, perverted, freaky shit from men and women, including the most bizarre pictures you've ever seen, which just makes me go, "Ugh. Eww. How did that person get my number?" But sometimes it's like, "Fuck you punk, you ain't worth shit." I'm like, well that's nice. I don't know why people waste their time, their breath, and their energy wanting to deeply disturb you.

<p style="text-align:center">✳</p>

I like people. I like interacting with people and I love watching people's crazy transformations in their journeys and their struggles and their pain and their pleasure and their horrible defects of character and their amazing qualities and their expressions. I'm really a fan of fans. I look at these people and they knock me out because they are so enthusiastic about something. When I look at a person that can cry out of joy for what somebody else has done, that is pretty admirable. At the same time, it's so easy to go through periods of life without seeing what's around you, to get caught up in a small picture and for whatever reason get stuck seeing only that which you've decided is worth your focus. It could happen with a social life, an intimate relationship, a work situation, or God knows what other realm of restricted consciousness.

Well, it happened to me. The longer that we were in the band and the more difficult the schedule got and the more traveling we did and the bigger my life got, all contributed to it, and then I had a son that I had to dedicate a lot of time and energy to. As a result I became less connected with the people that love what we did, for sure. I can't go out in the middle of our audience and hang out. It will be a bad experience for me. So I stay away and I concentrate as hard as I can on giving of myself and doing my best to have a moment with these people when we play our show. We don't phone shit in, ever.

The realization of this separation happening to me occurred a few years ago while we were on tour in Japan. After reinventing our band the Red Hot Chili Peppers with Josh Klinghoffer as our guitarist and vocalist, after writing fifty-some odd songs, recording them, rehearsing them, and becoming who we were as a group, I had lost touch with some of the other essential elements of what it is to be part of a

musical entity. Our second show of this new foray into touring with Josh was at the Sonic Festival in Osaka, Japan. We were still developing as a live act but I could feel in my heart and soul that we were on our way to discovering a new and beautiful power as a band. As is typically the case with us playing a large festival show, somewhere out there in this music-loving world, we were rather sequestered literally a half a mile away from the stage where the good people of Japan had gathered to hear music. We were in our backstage, air-conditioned cocoon universe with its fruit trays, stereo system, fine rugs for stretching on, separate rooms for stretching and doing vocal warm-ups, notebooks for set list writing, all of our tinctures and potions and lotions neatly laid out, all of this giving us the peace to prepare for us unleashing our passionate wrath during the show. But meanwhile, half a mile away there were a hundred thousand people in the sun raging and having this very communal experience together. But I didn't see any of that; I was not feeling it, because I was in my own bubble.

AK's taped foot in Spain, and a note to a loving fan.

Enter Dave Mushegain, a visiting friend of mine, who was known for taking photographs and traveling the world without much fuss. He was excited to be there and after chatting with me through his lively Armenian smile, he said, "Okay, I'm going to go out into the middle of the crowd and see what's going on." So off he went, in his oversized tie-dyed T-shirt and with his overweighted backpack full of camera equipment, into the summery throngs of the great festival unknown.

I didn't see Dave again until after we played, about five hours later. He was a sweaty, dusty, sunburned mess with a memory stick full of pictures. With his distinct Los Angeleno sense of exuberance, he opened up his laptop.

"Look at some of these cool pictures I got," he said.

He started showing some of the hyper-colorful characters from deep in the bowels of a big festival audience. I saw these and I'm like, "That's here? Those people are like, camped out?"

I was immediately touched in a way that moved me more than I could have expected. In some weird way I had forgotten how much people really cared for and loved what we do as a

band. There were families that had come with their babies and camped out together dressed in matching RHCP paint jobs; there were groups of teenage girls who looked like they were having religious experiences; and the loveliest bunch of Asian faces, some of which had "tears of connection" written all over their cheeks.

Their dedication and ecstasy blew me away. It's not that I hadn't felt their intensely warm energy during the show. It's not that I had ever lost gratitude for them arriving en masse to sing along with tunes that were born in the back of a broken down garage. It's that I hadn't seen the up close and personal details of their experience in a long, long time. It made me wonder who they were and how they came to be here with us on this day.

I was particularly taken with a photo of a Japanese dad with a rad Mohawk holding up his adorable little baby. Just to see the love in that dad's face, bringing his little daughter to experience our show caused a tiny, incandescent light bulb to flicker over my old beat-up head that proclaimed, "Whoa, this is the year of the fan. It's time to honor these people, take the camera off our faces and put it on their faces and find out who they are, why they are here, where they come from, what brought them to this point in life, and what kind of an interaction we can have." That was twenty thousand pictures and almost three years ago.

Anthony catching up with Scottish fan Nick Millson in Seattle.

Dave jumped wholeheartedly into the process. Our fans are like Deadheads. They assemble hours before the show to get their preshow mingle on. In fact, we actually wanted to call this book "The Redheads," which is such a great steal from the Deadheads. And then frickin' Sammy Hagar, of all people, throws an absolute tanty because I guess his nickname is Red or something. He's like, "No! I call my fans the Redheads, you can't do that. I am Sammy 'Mr. Red' Hagar." And I'm like, "What!?" I never heard that. And then Chad, who plays with Sammy, is like, "Yeah, don't do that, it would really upset Sammy." I was like, "Well, Sammy is really upsetting me."

Dave would show up at the venue early and put himself into the mix. He would start finding out, like, "Who are you? What is your connection to the Red Hots? Where do you come from? What songs do you like? What records do you like? Which lineups did you like? What do they do for you? Why do you care? What does it make you feel like?"

But he wouldn't just confine himself to the venue. Like an anthropologist, he went to these fans' houses and met the whole family. They might have come to a concert in Madrid, but he'd follow them eighty miles to where they lived and photograph them in their houses. A lot of times he did the portraits in their rooms, which were like shrines, decorated with a huge collection of memorabilia.

Dave was tireless during the whole two years he toured with us. And it's awesome to shine the light on these people. They are so dedicated and so giving and loving and they're so romantic about their enthusiasm for a band. Whether you like us or you don't, you have to admire somebody's enthusiasm. There's this one girl, Julia, from Spain, who is a pauper. She has a minimum-wage job at best, but she has not missed a show for two years. It doesn't matter if we play in Greenland, she'll be there. She sleeps on park benches. Dave would go out in the middle of the night, clubbing or whatever and he'd be walking home and he'd find Julia on a park bench and go, "Julia, why are you on a park bench?" "Because I don't have any money." She had spent it all on a plane ticket. Now we comp her tickets because we know she's coming, but it took us months to figure out that this young Spanish girl was following us around the world.

Doing this book literally connected us to our fans again. Dave would round up the most interesting of his subjects and bring them backstage or we'd meet them in a hotel or at a park. He was able to see their beauty, who they really were, and he wanted us to know that they weren't just another face in the crowd. And so we took the time to start meeting these people, and it was great. It changed the energy, it made it even better.

Dave Mushegain emerged as an amazingly compassionate ambassador to people in dozens of countries around the world, from old to young, from mothers to sons. He diligently strove to get to know these enthusiasts at the expense of his own sleep, comfort, and energy. And, in the process, I had my own awakening to the fascinating kaleidoscope of people who give their love to our mission as a band, and I'm truly grateful for that experience.

Anthony

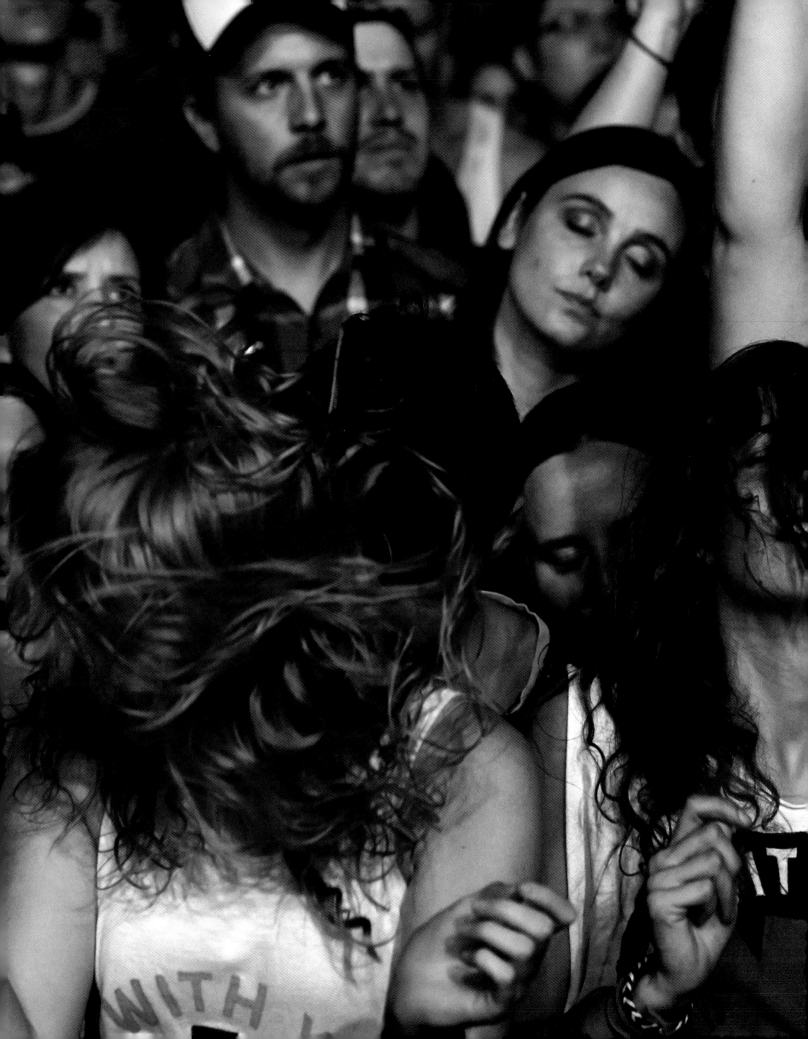

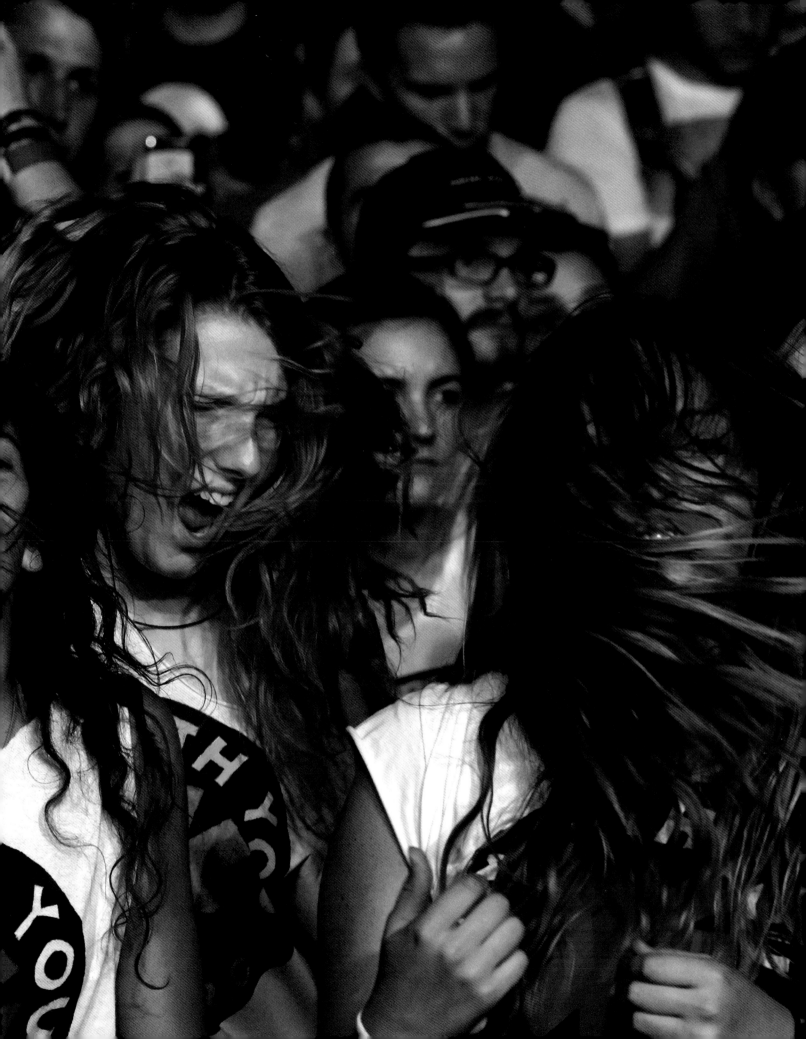

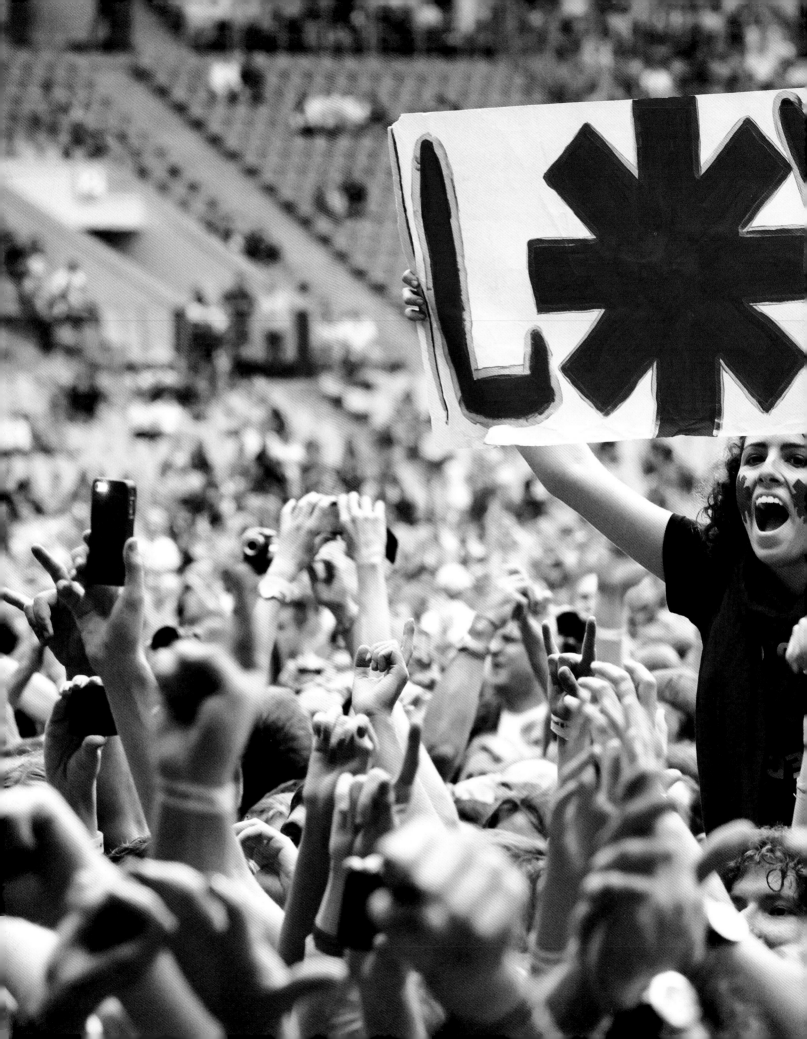

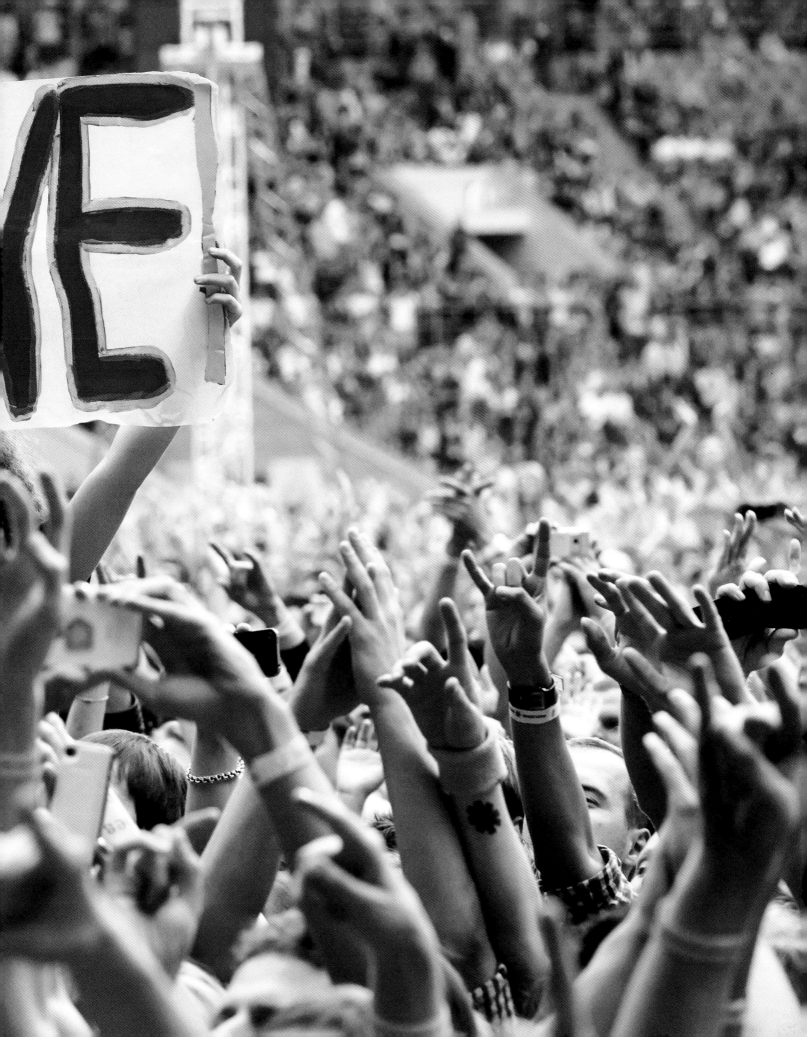

Chifumi (Al) Soga, 43
Fuuko Soga, 3
Japan

I ACCIDENTALLY FOUND MY FIRST RED HOT
CHILI PEPPERS ALBUM AT A RECORD SHOP.
IT WAS AN IMPULSE BUY BECAUSE I LIKED
THE ALBUM COVER ART. BUT IT WAS NOT THE
SOUND I EXPECTED. I WAS AN OLD-SCHOOL
PUNK TEENAGER AT THE TIME. I LISTENED
TO IT ONLY ONCE AT THE TIME. OF COURSE,
NOW I HAVE THAT ALBUM AND LISTEN TO IT
AGAIN AND AGAIN.

LATER MY FRIEND RECOMMENDED *MOTHER'S
MILK* TO ME AND THAT'S WHEN I MET THE
CHILI PEPPERS AGAIN. I GOT TO GO TO THE
"CALIFORNICATION" JAPAN TOUR AND AFTER
THAT I BECAME A CHILI PEPPERS FREAK. I
HAVE A TATTOO OF FLEA'S FACE ON MY ARM.
FLEA IS MY HERO. IT IS THE SAME AS JIMI
HENDRIX TO FLEA AND PROBABLY THE SAME
REASON FLEA GOT HIS JIMI TATTOO.

ON THE "BY THE WAY" JAPAN TOUR I SAW ALL
THE SHOWS IN THE FRONT ROW. AFTER THE
TOUR FLEA WROTE ABOUT ME ON FLEAMAIL.
IT WAS AN UNBELIEVABLE THING! IT WAS
AWESOME! AT THE TOKYO "STADIUM ARCADIUM"
TOUR I GOT A PASS AND SAW FLEA ON THE
SIDE STAGE. THEN CAME THE "SUMMERSONIC"
SHOWS, WHICH WAS MY DAUGHTER CLARA'S
FIRST CHILI PEPPERS EXPERIENCE. SHE TOOK
OUR PICTURE UNEXPECTEDLY. WHAT LUCK!

Lucrecia Fontes, Timeless
San Francisco

What first connected me to the band? Flea's butt. I named my goldfish Flea after Flea. Do I have anything else to say? Yes, but I'd like to whisper it in Flea's ear.

Laura Gray, United Kingdom

I love the music and this is what obviously spurred me to follow the band on tour. But now after sixty gigs, the greatest gift I have gained is friendship. I have made friends across the world, some of whom I have been hanging out with and going to shows with for years.

Flea approaching me to play the opening note for "Under the Bridge" was one of the most overwhelming moments in my life so far. There are plenty of funny stories too, such as the time Chad found the finger of a rubber glove in his fried rice at a Chinese restaurant.

"Addicted to the shindig" is engraved on the back of one of my iPod. The opening lines of "Road Trippin" remind me of the fun times I had driving around California during the "Stadium Arcadium" tour. And the lyrics to "Venice Queen" and "I Could Have Lied" mean a lot to me for personal reasons. Oh, and "Emmit Remmus" is talking about my hometown.

BUENOS AIRES

Valentina, 17
Argentina

Red Hot Chili Peppers, they are not just a band, they are LOVE. I think all who hear them feel a magical connection. Their music is genuine and crazy, full of feelings, power, adrenaline, emotions that vibrate the spirit of everyone.

I have friends I met through them and their music, people who I never imagined knowing, and I'm grateful to know. We're a great family.

It's hard to imagine a world without the Red Hot Chili Peppers.

Roger Adrian Williams, 29
South Africa

I've practiced full-contact karate for twenty years and before training sessions and tournaments I would always listen to the Chili Peppers to build energy. The music always got me into the right headspace and I believe it actually directly helped me to become physically faster and stronger.

I'm an illustrator, animator, and karate teacher. I've always loved art, music, and martial arts. My childhood dreams included competing in the world karate championships, training with the best in Japan, doing solo art exhibitions, and rocking out with the Chili Peppers in my hometown of Cape Town. Having done all this before the age of thirty, I am totally amped for what's next.

Danielle Thornes, 22
Michigan (Right)

I had an obsession with downloading and listening to music when I was in elementary school. I came across RHCP and they became one of my favorite bands of all time. The Red Hot Chili Peppers are better than all the rest and I noticed this fact of life early on.

I consider myself to be strange and like to surround myself with other weird individuals. I'm all about connecting with others on a deeper level, so I don't do well with small talk. I have moved a lot and am never satisfied with where I decide to land. I enjoy constant change and new life experiences.

My dreams are to attend the University of Michigan for grad school and to later become a world-traveling DJ with my best friend, Cristen Crew.

Daniel Zugaj, 18
Spain

I WENT TO THE MADRID CONCERT WITH ONLY €15 THAT HAD TO LAST FOUR DAYS. I TRAVELED 600KM AWAY FROM HOME. ONE DAY I WAS SLEEPING IN THE PARK, THE SECOND BY A CASH MACHINE, AND I ONLY HAD ENOUGH MONEY TO EAT CANNED FOOD. BUT OVERALL IT WAS A GREAT EXPERIENCE BECAUSE I GOT TO SEE THE RED HOT CHILI PEPPERS.

I'M A COMPOSER AND I LIKE EVERYTHING THAT HAS TO DO WITH PLAYING MUSIC, ESPECIALLY WITH OTHER PEOPLE. I WANT TO BE A MUSIC PRODUCER. I WANT TO FORM A BAND, RELEASE ALBUMS, AND TOUR. I WANT EVERYONE TO HEAR MY MUSIC BECAUSE I THINK THE SONGS THAT EACH PERSON DOES IS THEIR WAY OF LOOKING AT MUSIC. I WANT TO TELL THE WORLD HOW I SEE MUSIC.

Jess Chong, 16
United Kingdom (Left)

I first connected to the Chilis when I heard "Can't Stop" on the radio when I was about nine years old. Now I'm a typical teenager in my first year of college. I'm about living life in the moment, living each day to the fullest, enjoying life as it comes—and enjoying my favorite band.

My favorite lyric is from "Wet Sand": "Right on the verge, just one more dose, I'm traveling from coast to coast. My theory isn't perfect but it's close."

My dreams in life are to live without worry, to be happy, healthy, and to keep rocking out to the Red Hot Chili Peppers.

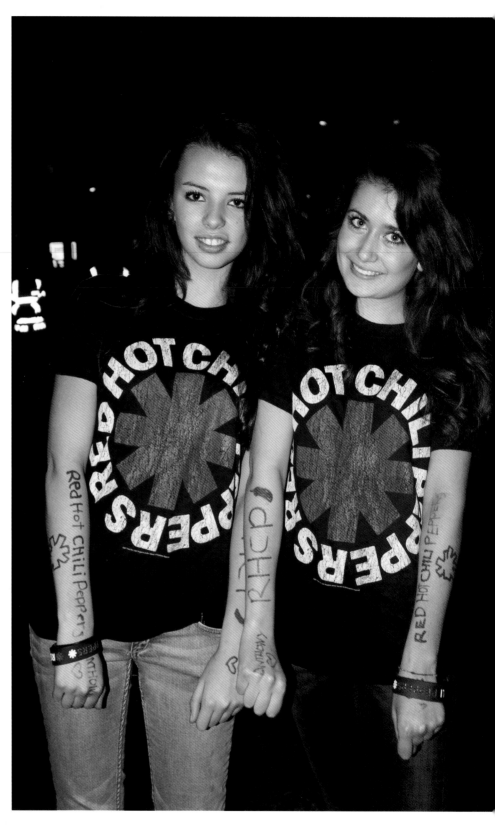

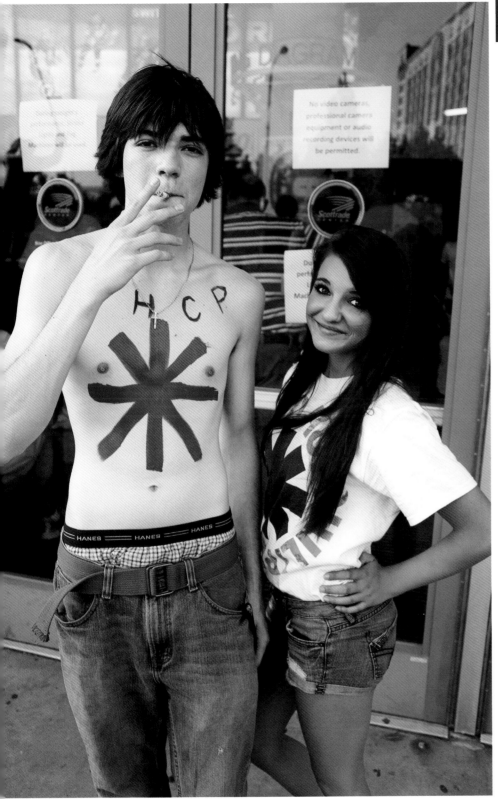

Tyler Murphy, 16
Iowa (Left)

My greatest experience with the band was probably when I saw them play at the Scottrade Center in St. Louis, during the "I'm With You" tour. A girl I know is a big fan and was dying to see them live. She asked me if I would drive. I was more than willing, so in exchange for the ride she bought me a ticket and we headed to St Louis. I will never forget that concert. It was so much fun.

Right now I am getting the last of my credits and going to graduate high school. I work at a steakhouse. I play guitar and spend time with my girlfriend. I have been into music ever since I can remember hearing it, from B.B. King on my dad's stereo to the first time my mom made me listen to Jimi Hendrix. Nirvana was the first band I fell in love with and to this day they are still a solid favorite of mine. The Chilis became a favorite soon after. Music helped me through a lot of tough times.

As a guitar player an obvious dream of mine is to be on stage performing. I would love to send out that energy in music to the crowd and feel the energy in return. Sort of like a game of energy catch, bouncing back and forth. To move people through songs and sound; to help them if they are going through a tough time—just like music did for me.

Thank you, RHCP, for all the music you have brought to my ears!

Kasia Gaweska, 17
Poland

I BELIEVE THAT EVERYONE CALLING THEMSELVES A FAN RELATES TO THE MUSIC OF THEIR FAVORITE ARTISTS IN MANY DIFFERENT WAYS. YOU CAN'T BE CONSCIOUS IN ALL OF THESE SITUATIONS. THE MUSIC IS JUST THERE AND IT MAKES YOU FEEL BETTER, WHETHER YOU REALIZE THAT OR NOT. THE SHOWS I WENT TO IN WARSAW AND PRAGUE ARE WORTH MENTIONING. I GOT TO MEET THE AMAZING PEOPLE WORKING FOR THE BAND, WHICH MADE IT POSSIBLE FOR ALL THE MAGIC TO HAPPEN AND TO MEET THE GUYS THEMSELVES. I GOT THE OPPORTUNITY TO STAND ON THE STAGE AND SEE THOUSANDS OF STRANGERS IN FRONT OF ME DURING THE SHOW. THEY WERE ALL BECOMING ONE, SINGING THE WORDS OF THE SAME SONGS. IT MADE ME FEEL LIKE EVERYTHING IS POSSIBLE, LIKE I CAN STAND ON THAT STAGE AGAIN ONE DAY, AND THE PEOPLE WOULD BE THERE FOR ME. I FELT LIKE THAT WAS EXACTLY WHAT I WANTED TO DO. TO MAKE PEOPLE FEEL WITH MY OWN MUSIC.

BEING AN ARTIST IS MY MAIN GOAL IN LIFE. WHENEVER I CAN I READ BOOKS, I WRITE SONGS OR POETRY, I LISTEN TO MUSIC, AND THINK ABOUT HOW BEAUTIFUL THE WORLD IS. I WANT TO BE WILD. I WANT TO BE FOREVER YOUNG. I WANT TO BE FREE. AND LAST BUT NOT LEAST, I WANT TO MAKE MY MOM AND BROTHER AND STEPFATHER PROUD.

I WANT TO THANK THE RED HOT CHILI PEPPERS FOR MAKING ME FEEL OKAY WHEN I AM SO FAR FROM FEELING OKAY. AND DAVID MUSHEGAIN FOR BEING THE COOLEST PERSON I'VE EVER MET IN MY LIFE AND FOR INSPIRING ME TO AT LEAST TRY TO EXPLORE THE WORLD AND MEET PEOPLE AS COOL AS HIM. CHRIS WARREN, DAVE RAT, THE WHOLE CREW. YOU GUYS SEEM LIKE THE BEST TEAM ON THE PLANET.

P.S.: DEAR CHAD, I AM SO SORRY I GAVE THE POLISH FLAG TO ANTHONY INSTEAD OF YOU AS I HAD PROMISED. YOU ROCK.

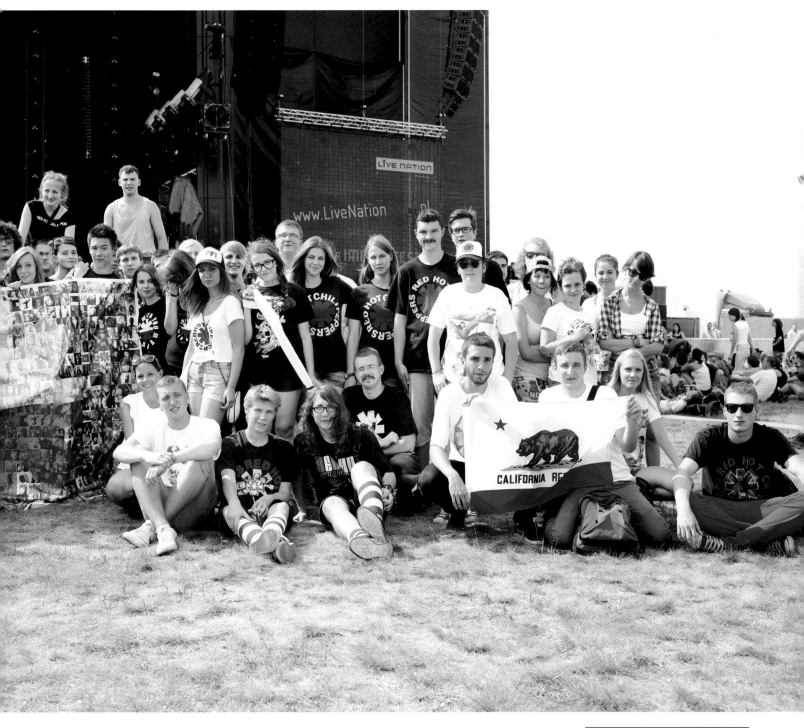

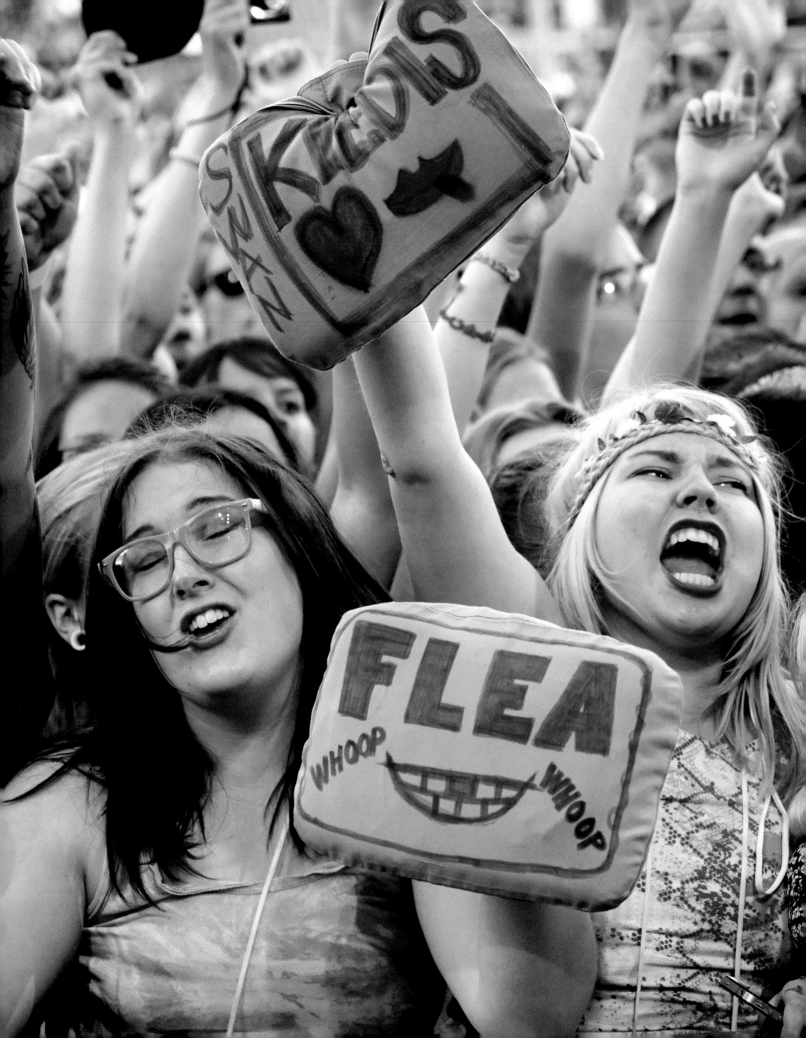

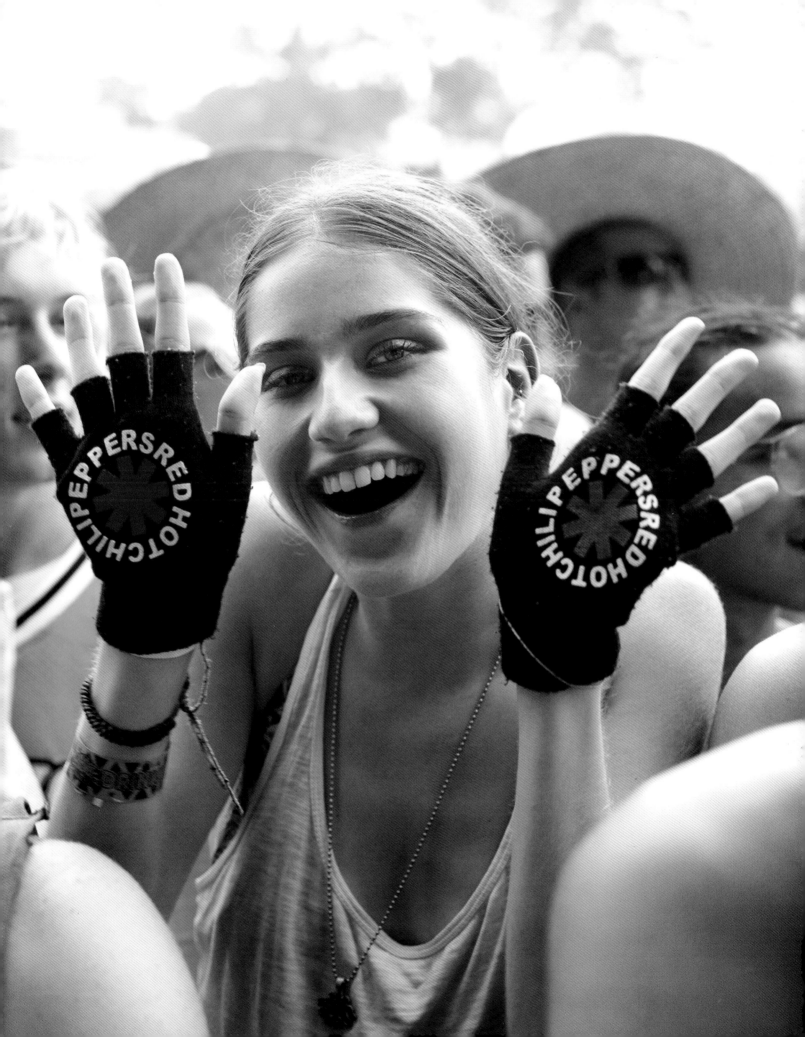

Elisa Makovcova, 14
Czech Republic

WHEN I STARTED TO PLAY THE GUITAR
I SAID TO MYSELF "WHEN I CAN PLAY
'SNOW' I WILL BE A GUITARIST." IT
WAS MY GOAL. NOW I CAN PLAY IT. IT
IS ALMOST IMPOSSIBLE!

I REALLY WANT TO BE SELF-CONFIDENT.
I WANT TO BE HONEST. I NEVER WANT
TO BE WITHOUT MUSIC BECAUSE. IT'S
EVERYTHING TO ME.

Kassia, 22
Poland

I was fourteen when I first saw the *Californication* album cover. From that moment on I just knew that I found something that matches me perfectly. It was like a missing piece of my personality.

I feel a deep unexplainable and piritual connection with the album *Blood, Sugar, Sex, Magic*. Then I found out that we—the album and I—were both born in the year 1991. I know it's not just a coincidence.

In my life I've struggled with many difficulties. Anytime I feel lost or uncomfortable with where I am I just need to play some music and it instantly reminds me of who I am and what my destination in life is. I'm a dreamer, a wanderer, an outsider.

My dreams in life are to travel the world, take photos of beautiful places, play bass and drums, to fall in love, to have my best friend by my side forever, and to enjoy a sunset on the Californian shore. And to hug Flea, of course!

Sehnaz Ugur, 23
Turkey

When I was really young I found the *Californication* album at my aunt's house. As soon as I started to listen to it I felt what I always wanted to feel. It sounded like a lost tune that I had finally found from the past. It was weird. I felt joyful and bitter at the same time.

My first gig was in Paris. I was so excited. I couldn't sleep after the show. I felt so good but also so bad. I wept all night. I had never been to such a great concert and I have seen and worked in so many concerts. It sounded so real and deep. I felt it so deep inside me that when I got back home from the concert I felt really sad. I thought I would never feel that feeling again. It was the first time and the first time is always the best, I thought. But later, when the Chili Peppers came to Istanbul, my experience was even better. I had the chance to meet Anthony.

I'm a political science student and I have worked as a backstage manager since 2008. I get the best feeling ever when a gig that I work ends and the audience claps. It makes me really happy to be part of something that lots of people dream about.

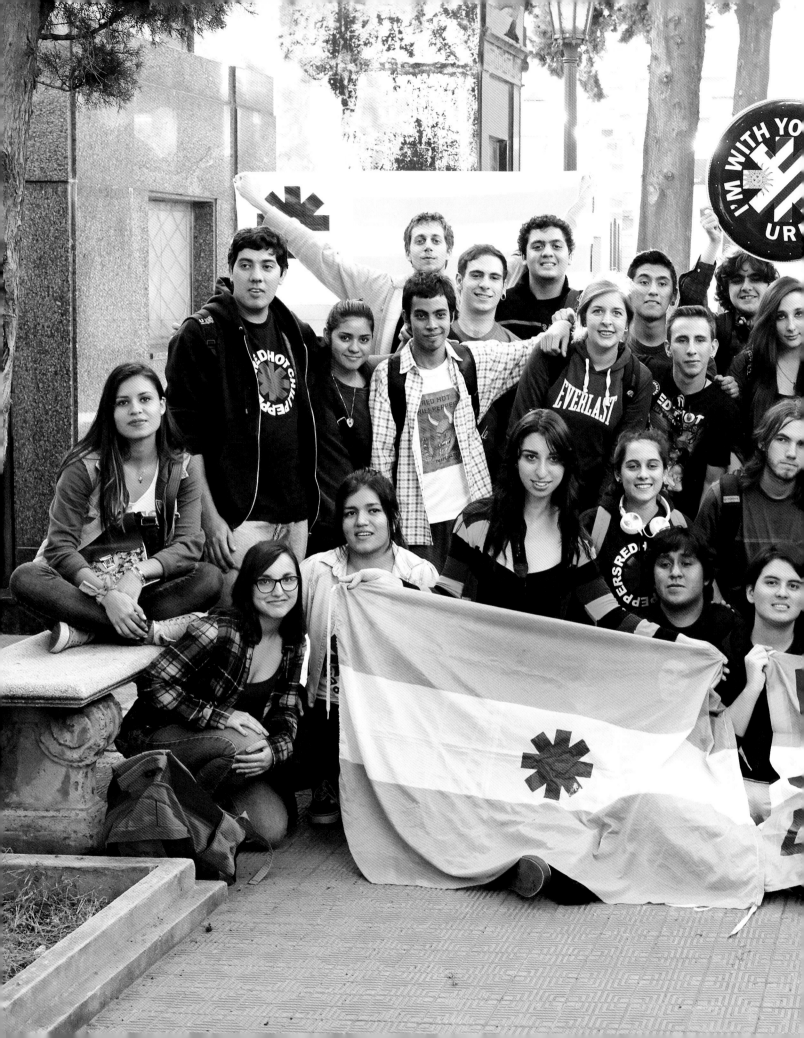

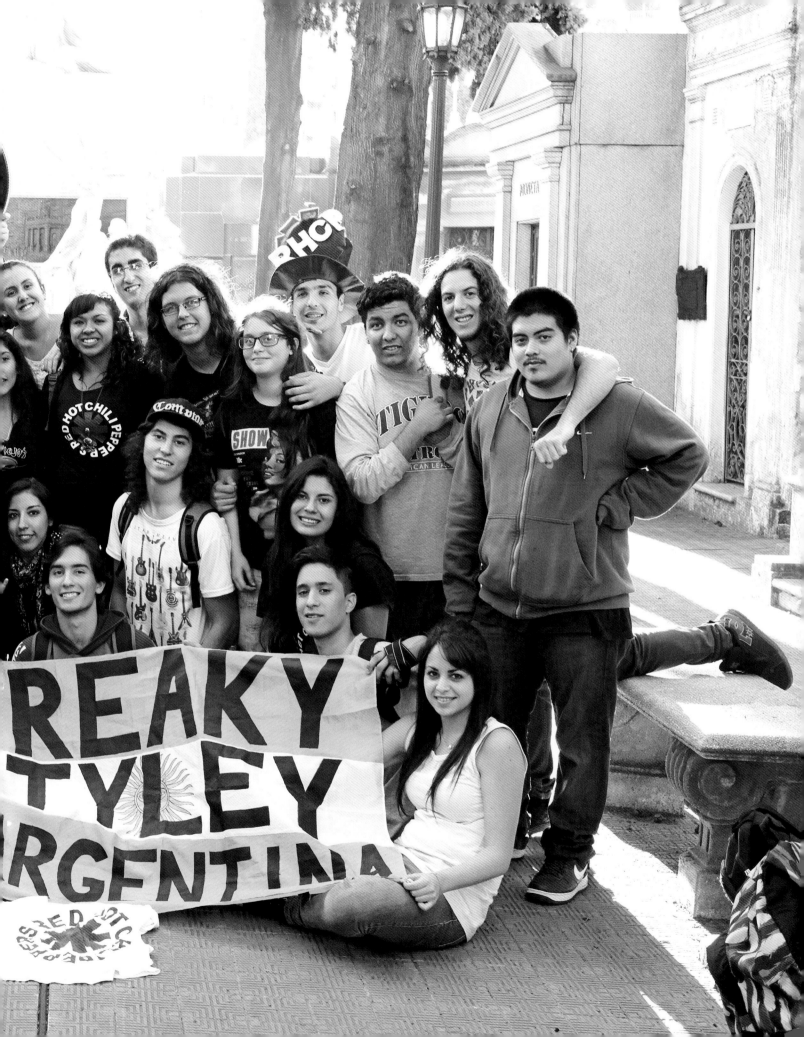

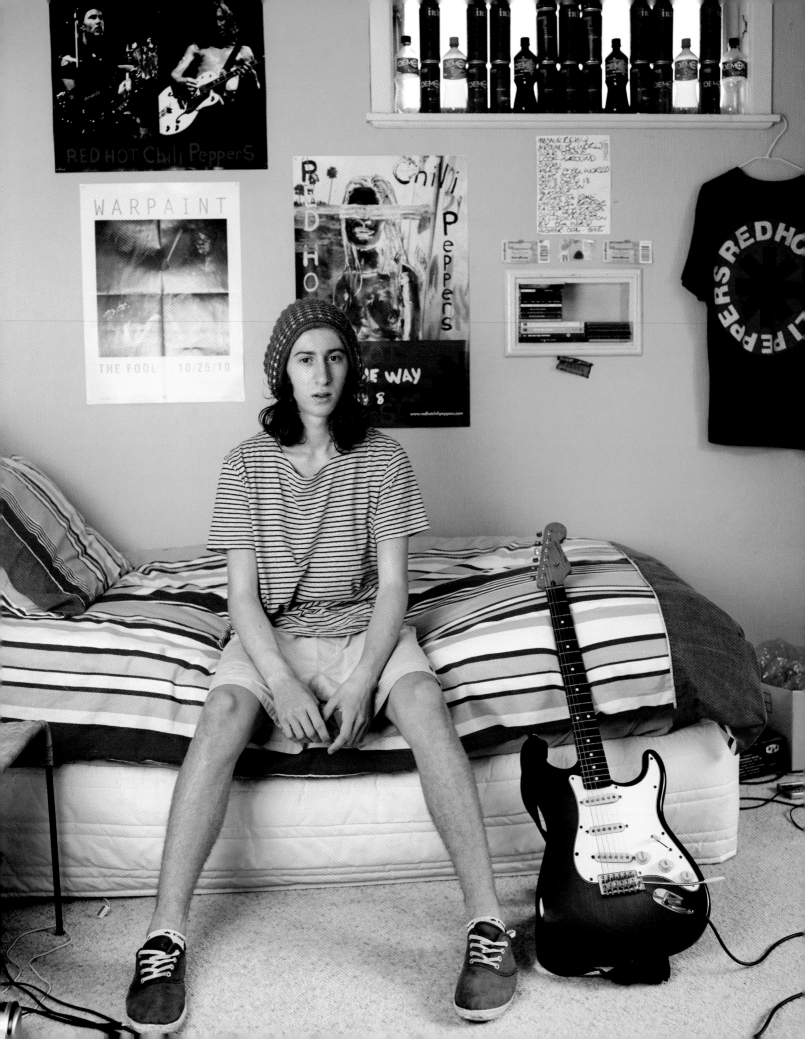

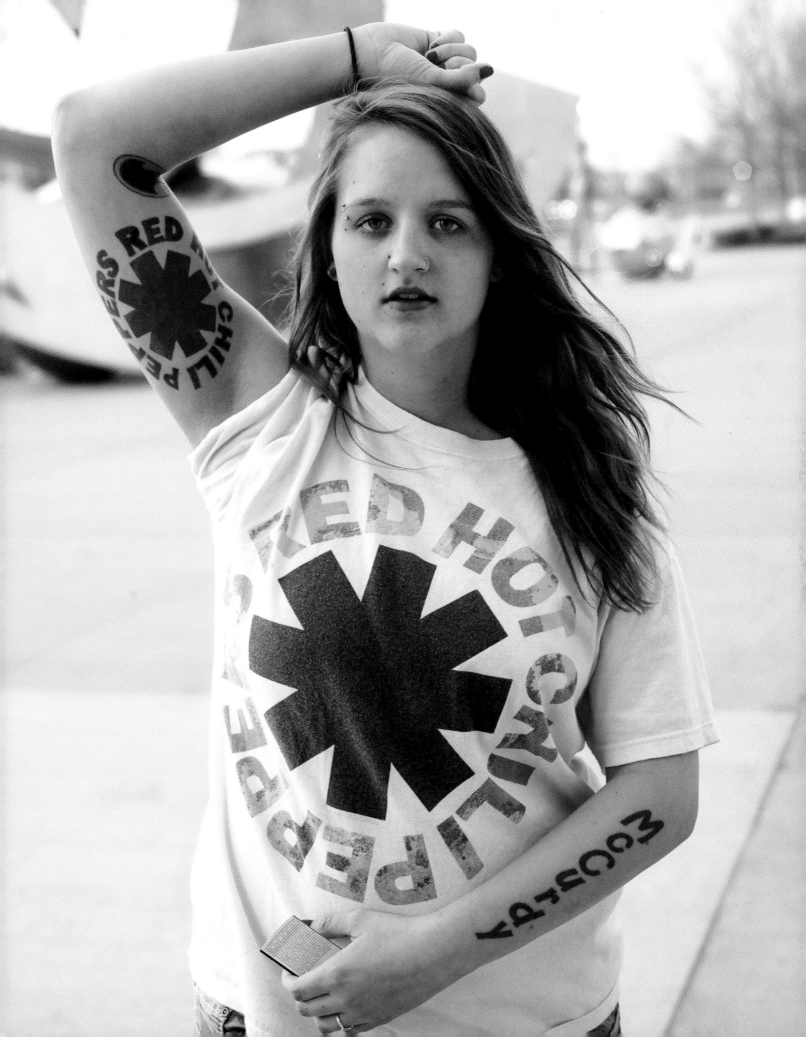

Marta Lanzillotta, 23
Italy

It was May 26 2002. It was an extraordinarily hot day in Italy. That evening I went to my grandma's house with my mum to have some icecream. We were in the kitchen and they were talking about something they had read in the newspaper. The TV was on and suddenly there was this incredible rock and roll coming from it. I really don't know who put on the channel, but Italia1 was transmitting the Chili Peppers' performance of "By The Way." There were four handsome naked guys on the stage, what the hell!! The bass player had blue hair!!! They were all tattooed!!! It was too much for an eleven-year-old Catholic school girl, wearing pink eye shadow and playing with Barbies and listening to Kylie Minogue. HA! I loved the Chili Peppers from the first note that I heard from the television! I immediately asked my dad to buy me the "By The Way" single, he came back with the whole album. Song after song I fell into another world and that world became my second family, my life. The red blood in my veins turned hot and chili!!!!

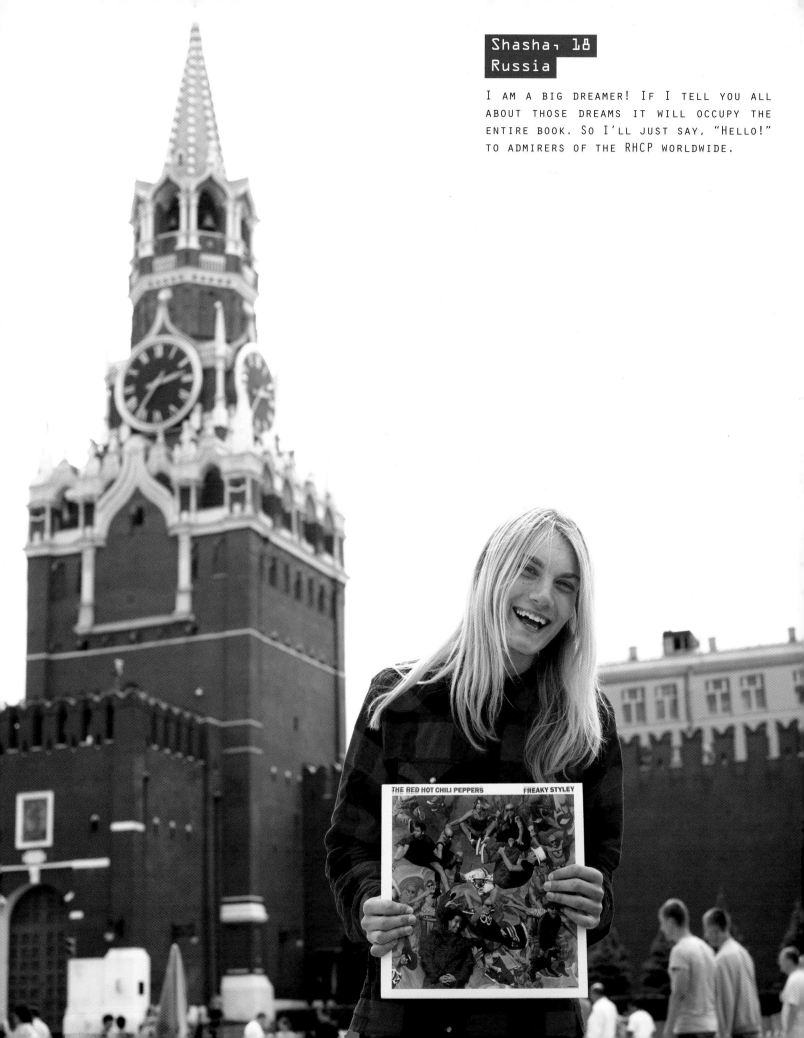

Shasha, 18
Russia

I AM A BIG DREAMER! IF I TELL YOU ALL ABOUT THOSE DREAMS IT WILL OCCUPY THE ENTIRE BOOK. SO I'LL JUST SAY, "HELLO!" TO ADMIRERS OF THE RHCP WORLDWIDE.

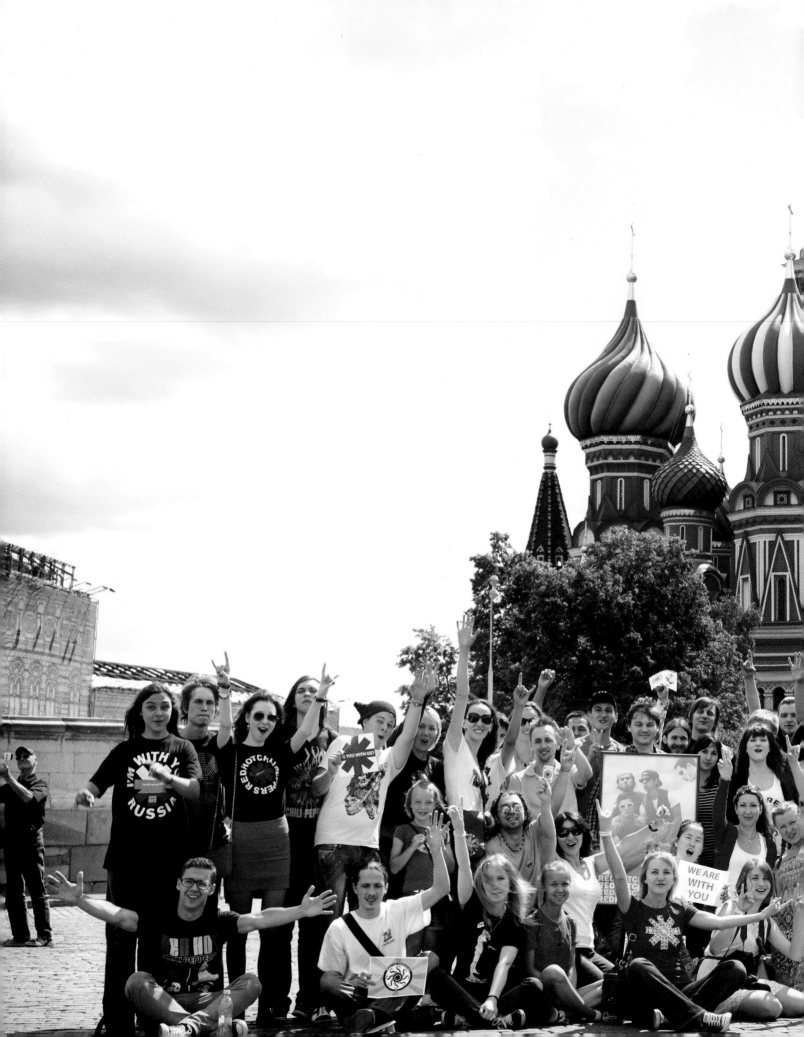

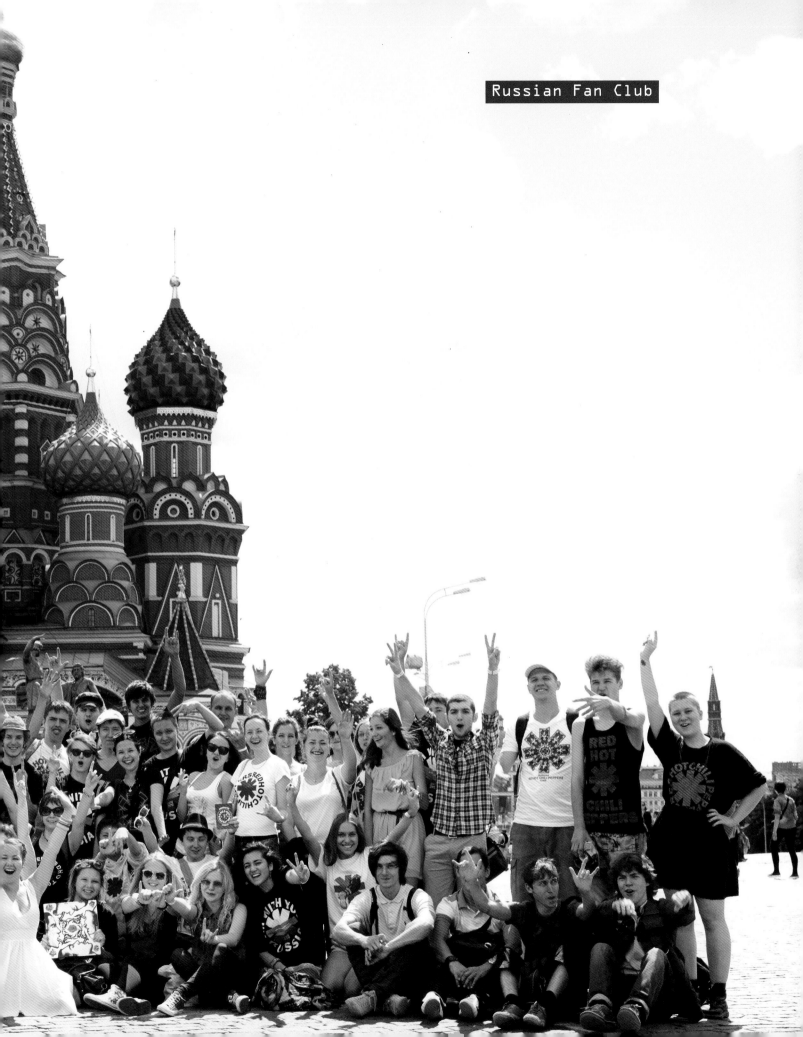

Emilie Vidal, 17
Cape Town

My family and I were on a road trip and the magical lyrics of "Snow" began to blare out of the CD player. The sound was turned up and the singing along began. Soon enough I was shouting along with the rest of the family, half an hour of repeats later. I was in love and the Red Hot Chili Peppers had managed to win over yet another devoted fan.

Nabeel— "Growing up is tough in South Africa because even though apartheid is over it's still very racist. The blacks hang with the blacks and the whites hang with the whites. How you imagine it kind of is, blacks do one thing and whites do another. I remember coming back from a mate's house one day with a flash drive full of music and movies. I will never forget that night, I watched *The Matrix*. I was 10 at the time and my parents didn't allow me to watch films like that, so I watched it in secret. And I listened to *Californication*. When "Around the World" came on the intro was just a bunch of noise to me and then Anthony's scream. It was bliss. The guitar and the bass line, it was perfect. I went to a predominantly white school and I'm not sure if they intended it, but the Peppers helped me transcend race barriers."

Tyler Bramwell, 20
Minnesota

The Peppers have been a stable source of sanity for me for seven years now, and will be infinitely. They are present in my life no matter what the situation. It's a symbiotic relationship, a give and take, something otherworldly yet so comforting. You know just that moment, when the music hits your ears and sounds just like you imagine everything is supposed to sound? Their music works for me no matter what. I get it.

Angy Fernandez, 22
Spain

I am a singer and actress in Spain. More specifically, I sing pop, as well as act on Spanish television and movies. I've always wanted to be a singer. Sounds typical, right? It's who I am. I was born to sing and make music. I'm from a small island off the coast of Barcelona called Mallorca. The Chili Peppers had come to Madrid and Barcelona in the past, but I was too young to see those shows. I attended Rock-n-Rio in Spain in 2012. I waited in line with friends for hours but I did not care. I just knew I wanted to be in the front row. We got sun-burned, we met great people, and every hour we waited we got more and more excited. One of my friends saw a guy with a RHCP T-shirt, a RHCP hat, a RHCP pass, and a big camera, so she goes up to him and says that I am famous in Spain, have been waiting all day to see the RHCP, and that I am their number-one fan. We talked a little bit and he took some pictures of me with my new *Californication* tattoo. He then told me he would like to introduce me to the RHCP before the concert. I was like "Wait! No Way!" I tend to be negative so I thought the man in the RHCP gear and camera would never come but he did! Before the concert started he found me and took me backstage. When I got back there they had super healthy food all around. Flea and Chad were getting ready for the show. Josh had on his huge headphones. Anthony was waiting to meet me. I had ran to him once before for a picture and he was so nice. He asked me some questions but I was so nervous that I couldn't talk, so I just showed him my *Californication* tattoo. He said "So Sweet!" Kisses and lots of love from Spain. You guys make me feel so happy!!

Nicole Dodds, 19
New Zealand (Right)

I find the RHCP have a song for everything I do. I can clean to them, drink to them, sleep, wake up, go for a run, dance, work, etc. They have a perfect combination of chill and heavy rock that fits my life.

I'm a caregiver by day and a groupie by night. I work for a healthcare company, taking care of disabled people and I am in training to be a nurse. But as soon as I get home from work, the uniform changes to band T-shirts, black jeans, and bandanas. The music gets turned up and the bourbon gets poured. That is my sanctuary and rock concerts are my heaven. My father raised me on this music and I thank him for that. He is in a wheelchair, which has motivated me to continue in the healthcare profession. Music is such a big part of my life. I play the piano and attempt to cover RHCP songs. They are so fun to play!

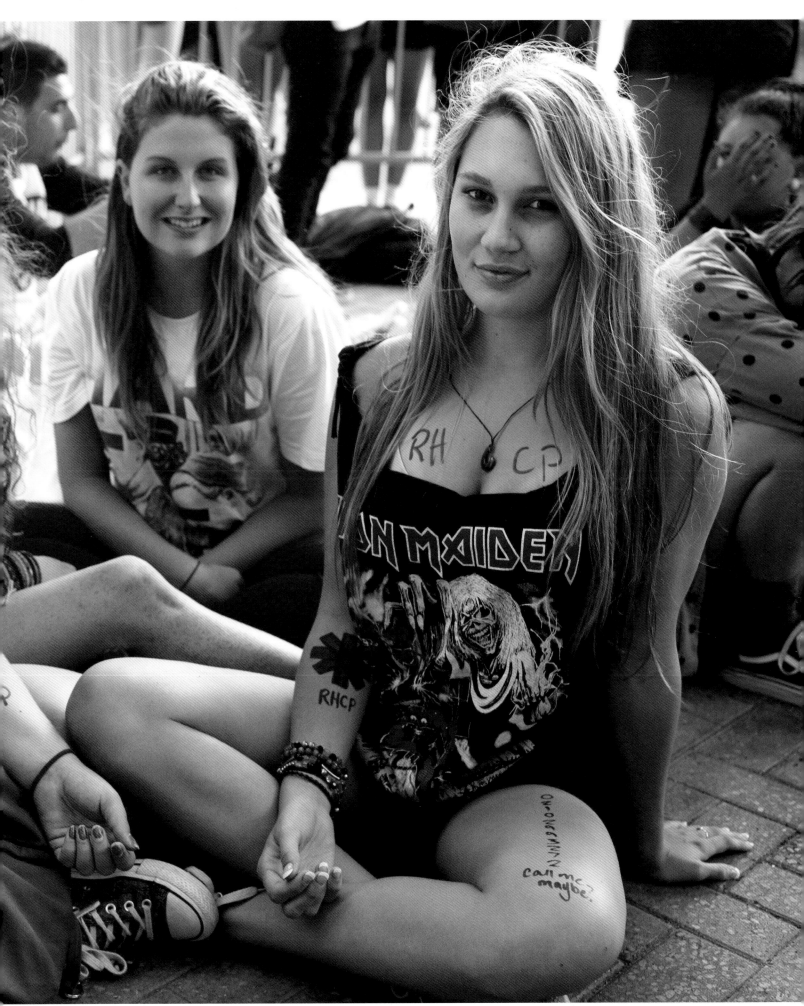

Leandro de Carvalho Correa, 28, Brazil

I WORK WITH SHIPPING CONTAINERS AT THE PORT OF SANTOS. I WAS BORN IN THE CITY OF SANTOS, WHICH IS IN SÃO PAOLO STATE. I LIVE WITH MY PARENTS AND WORK IN THE LARGEST PORT IN LATIN AMERICA. I SPEND THE WHOLE DAY LISTENING TO THE RHCP. I FOLLOW THE NEWS THROUGH THE INTERNET AND FAN CLUBS AND I HAVE MADE FRIENDS AROUND THE WORLD THROUGH THE MUSIC OF THE RED HOT CHILI PEPPERS. AS I LIKE TO SAY, I BREATHE RED HOT CHILI PEPPERS. THE MUSIC MAKES US FEEL BEAUTIFUL. WE KNOW DIFFERENT PEOPLE AND PLACES BECAUSE OF THE MUSIC.

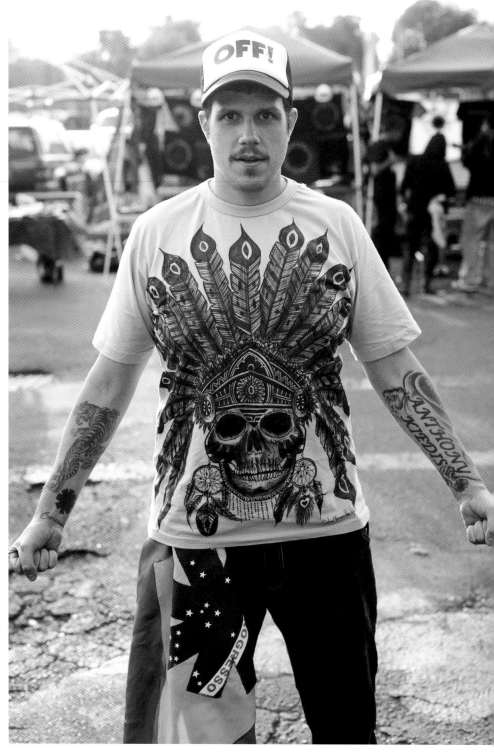

During the *I'm With You* tour I traveled alone from Portugal to Barcelona to see the guys. I spent twenty hours on the street, practically frozen in the Park Montjuic. I sat there in about 2 degrees Celsius temperatures with the group of first twenty people in line at Palau Sant Jordi.

During the wait I met photographer David Mushegain and told him that I had a bus ticket from Barcelona to Madrid to watch the next show but I had no ticket to enter. I asked him if it was possible to sell me a ticket and he said he'd see what he could do, so I went ahead to Madrid. Once there, I saw an online post from Flea about a ticket hidden in a small bar called La Castellana. I took a taxi to the address but my money ended 300 meters before the bar. I ran, ran, ran but lost the tickets to a group of Spanish guys who'd gotten there only a few seconds before me.

After this I arrived at the stadium and made part of the group of first fifteen in line. Among them I met Henrik Lewandowski, #1 fan of the RHCP and took my "famous" photo with the Portuguese flag. I met many good people there and did everything I could to try and get a ticket. Then David appeared looking for me, just a half hour before the doors opened. He had a guest pass in hand and handed it to me. I could not believe it—made me feel it's worth believing and being persistent in life. To end the week (the best of my life) in the best way, nothing was better than being front row at the concert. To top it off.

Charlotte, 23
Lithuania

My older and wiser brother Robert found the band. He was listening to them like mad. And me, the curious little sister, had to know what was so cool about them. So it began! I was thirteen at the time. Learning from my brother how to play the main riff of "Otherside" is one of my great memories.

In my early teens I had little understanding of the English language but the power of RHCP songs transcended this barrier. By growing up, experiencing life, and learning from my mistakes, I was able to understand not only the music that I so enjoyed but to recognize its deeper meaning, tapping into the emotional side of songs, making connections to my life, and growing as a human being.

I was born in Lithuania to a middle-class family just before the independence of my little country from the Soviet Union. You could say I was privileged by being born at that precise time, because during my childhood, the grey, brown, and beige wool clothing was substituted by colorful and very fancy western sports suits. And throughout my teens a tidal wave of western TV series brought ashore such hits as *Baywatch*, *Sponge Bob*, and many others. This programmed me for the western world and now I feel I am a citizen of the world.

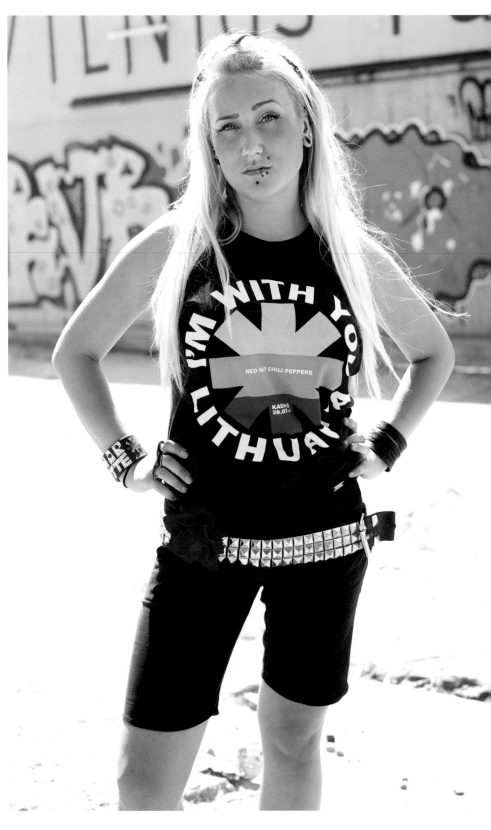

I REMEMBER IT VIVIDLY: THREE YEARS BACK; I WAS ON MY WAY HOME FROM SCHOOL IN MY DAD'S CAR WITH MY BEST FRIEND, CASS. "DANI CALIFORNIA" WAS PLAYING ON THE RADIO. WE BOTH LISTENED SILENTLY WITH HUGE-ASS SMILES ON OUR FACES AND NEAR THE END OF THE SONG CASS SAID TO ME, "LET'S GO HOME AND DOWNLOAD EVERY FUCKING RED HOT CHILI PEPPERS SONG EVER MADE." AND THAT'S EXACTLY WHAT WE DID.

I HAD A SEVERE BOUT OF LOW SELF-ESTEEM WHEN I HAD SCARS ALL OVER MY FACE FROM PREVIOUS SKIN ISSUES. I WAS CONSTANTLY MORBID AND DIDN'T LOOK IN THE MIRROR FOR OVER A YEAR. I FOUND SOLACE IN ONE THING: THE MUSIC OF THE RED HOT CHILI PEPPERS. I'D SIT BY MY BED AND LOATHE MYSELF. BUT I'D ALWAYS PUT ON THE MUSIC OF THE RHCP AND MY PERPETUAL LOATHING OF LIFE WOULD TURN TO BLISS BECAUSE THEIR MUSIC WOULD SEEP DOWN INTO THE DEPTHS OF ME AND NUMB ANY FEELINGS OF NEGATIVITY. ANTHONY'S VOICE NEVER LEFT MY HEAD. I LIVED ON THEIR MUSIC. ON A DAILY BASIS I FED IT TO MY EARS LIKE A STARVED ANIMAL. THEY DEFINED EVERY PIECE OF ME BECAUSE THEY CONSUMED MY LIFE WHOLLY. THEIR MUSIC ACTED AS AN ANTI-DEPRESSIVE SUBSTANCE AND GAVE ME LIFE WHERE THERE WAS NONE, AND I FUCKING LOVE THEM FOR THAT. SO IF YOU GUYS READ THIS: THANK YOU FOR EXISTING.

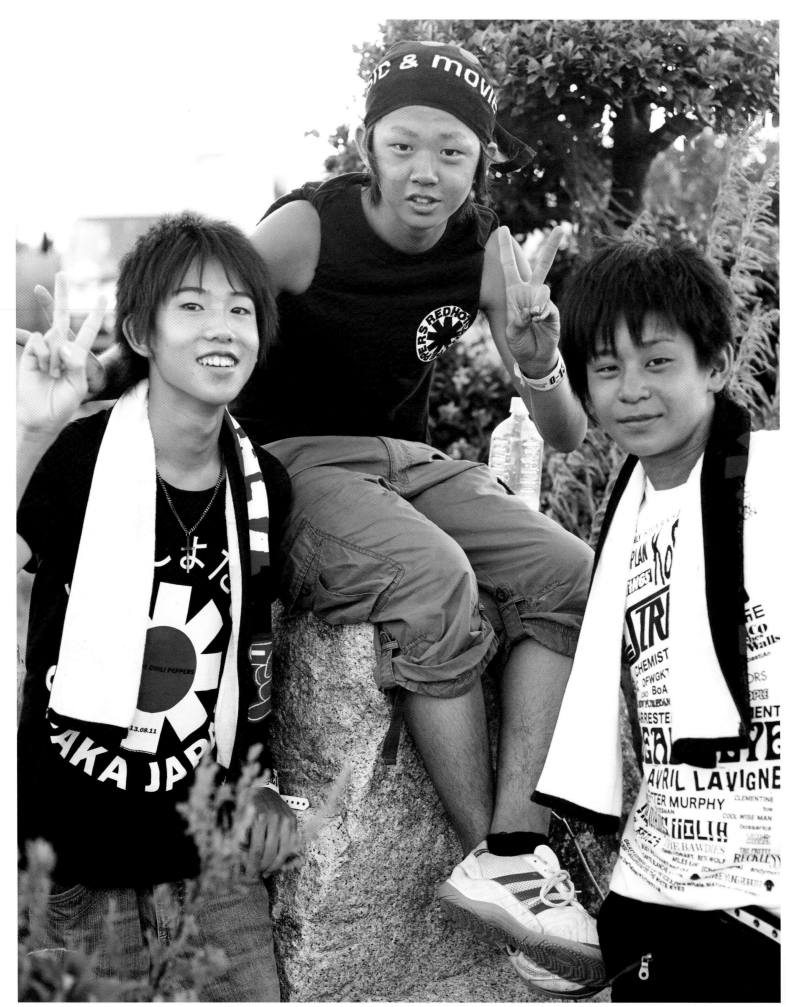

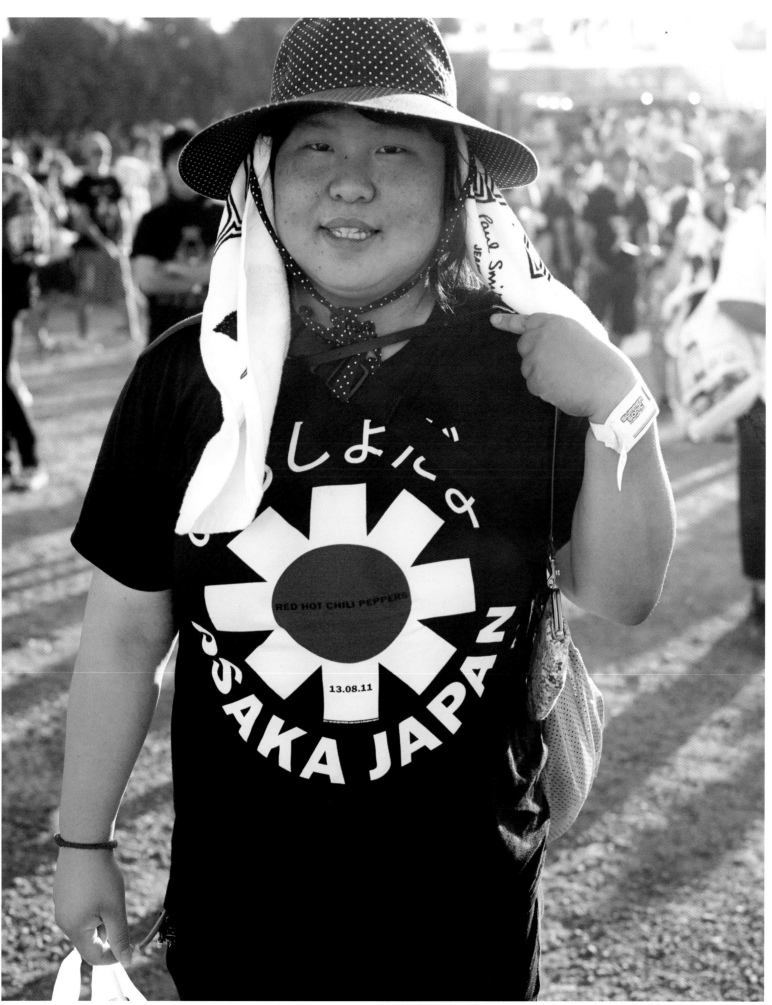

Raphaelle Macaron, 23
Lebanon

The first time I went to a Peppers show was in October 2011. I live in Lebanon and they haven't been anywhere near my part of the world in a very long time, so when the *I'm With You* European tour dates were announced I decided to go to Paris to see them live. My friends and I waited ten hours in line to get a good spot on the floor. It was totally worth it. Outside the venue I met David, who told Anthony that a few fans from Lebanon were there. Later that night, Anthony dedicated "Otherside" to us. At that point I thought it was the coolest thing a band could do. I was wrong, because a year later I got to meet and spend time with them in Lebanon. What a humbling experience it was to meet the human beings behind the music. They are exactly what they sound like. I've seen the band three times and every time something amazing has happened. I like to believe they are a flow of good energy.

Kate Calway, 17
Australia (Right)

IT TOOK ME ABOUT TWO AND A HALF HOURS TO PUSH THROUGH THE SWEAT AND DEHYDRATION TOWARDS THE FRONT OF THE CROWD. STANDING AGAINST THE BARRIER, FRONT AND CENTER, LISTENING TO YOUR FAVORITE BAND HAS GOT TO BE ONE OF THE MOST EUPHORIC EXPERIENCES ANYONE CAN ENDURE AND IN THIS CASE THERE WERE TENS OF THOUSANDS OF PEOPLE TO SHARE IT WITH.

"Luna.

No one writes letters anymore! I'm gonna get back into doing it. So you are my first! I'm in a hotel in Madrid, Spain. Last show of this leg tonight. It seems like ages ago we met in Dublin. Time is a tricky little thing! I want to thank you for making the journey to Ireland to see us play. I used to do that a lot. It's wonderful to see someone so moved by music that they packed a bag, got on a plane, and covered many miles to enjoy it somewhere far from home. Thank you also for the lovely note. It's an honor to play in this band and I'm happy to be able to make people smile just by doing what I love to do...

Lots of love...
J"

Ben Kaley, 26
Indianapolis

I HEARD "SCAR TISSUE" AT 11 YEARS OLD ON THE RADIO. IT WAS THE SUMMER OF '99. I HAD NO PRIOR KNOWLEDGE OF RHCP AND FELL IN LOVE WITH THAT SONG AND THAT ALBUM. IT WAS THE RIGHT SONG ON THE RIGHT DAY THAT AFFECTED THE REST OF MY LIFE.

ONE CRAZY STORY IS HOW THE SONG "OTHERSIDE" SAVED MY LIFE. I WAS LISTENING TO THE ALBUM *CALIFORNICATION* AND "OTHERSIDE" WAS PLAYING. I HAD HEARD THE SONG A THOUSAND TIMES BEFORE BUT I STAYED AND LISTENED TO THE SONG END BEFORE I LEFT TO GO TO THE GAS STATION. ON MY WALK THERE A CAR ACCIDENT TOOK PLACE RIGHT NEXT TO WHERE I WAS STANDING. LESS THAN TWO FEET IN FRONT OF ME A CAR SMASHED THROUGH THE BRICK WALL NEXT TO THE SIDEWALK. I GOT SPRAYED WITH BROKEN BRICK AND GLASS. IF I HAD LEFT WHEN I WAS READY INSTEAD OF LISTENING TO THE END OF THE SONG I WOULD HAVE BEEN IN BETWEEN THE CAR AND THE BRICK WALL. LITTLE DECISIONS HAVE BIG CONSEQUENCES.

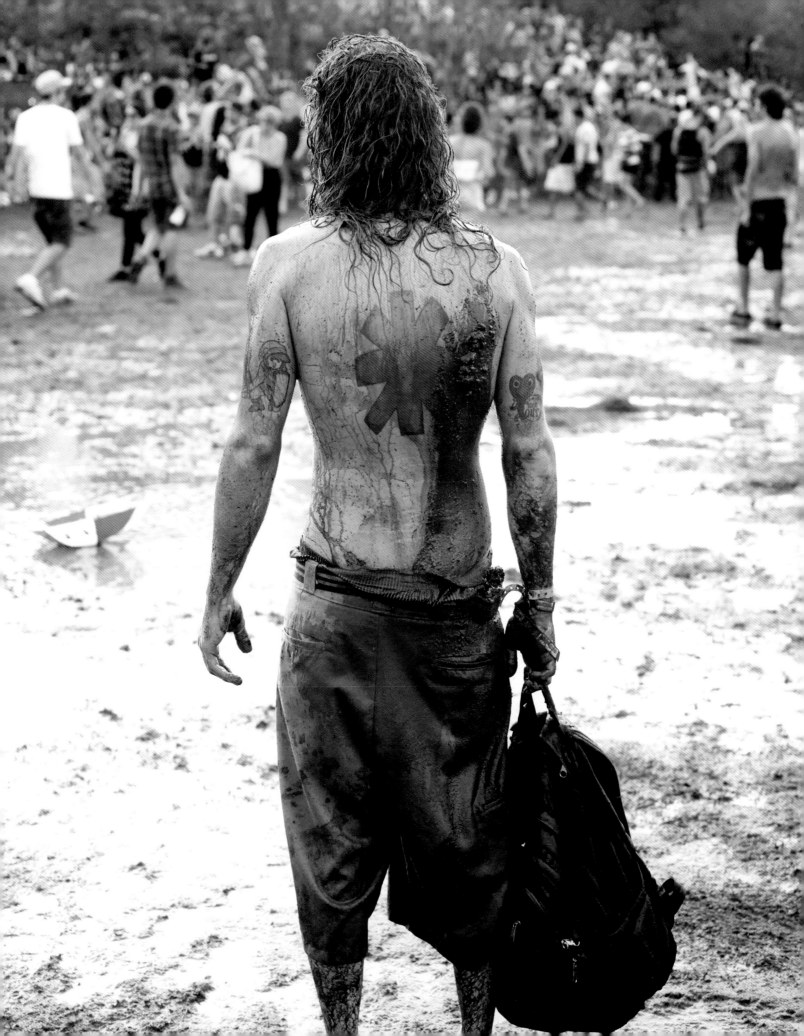

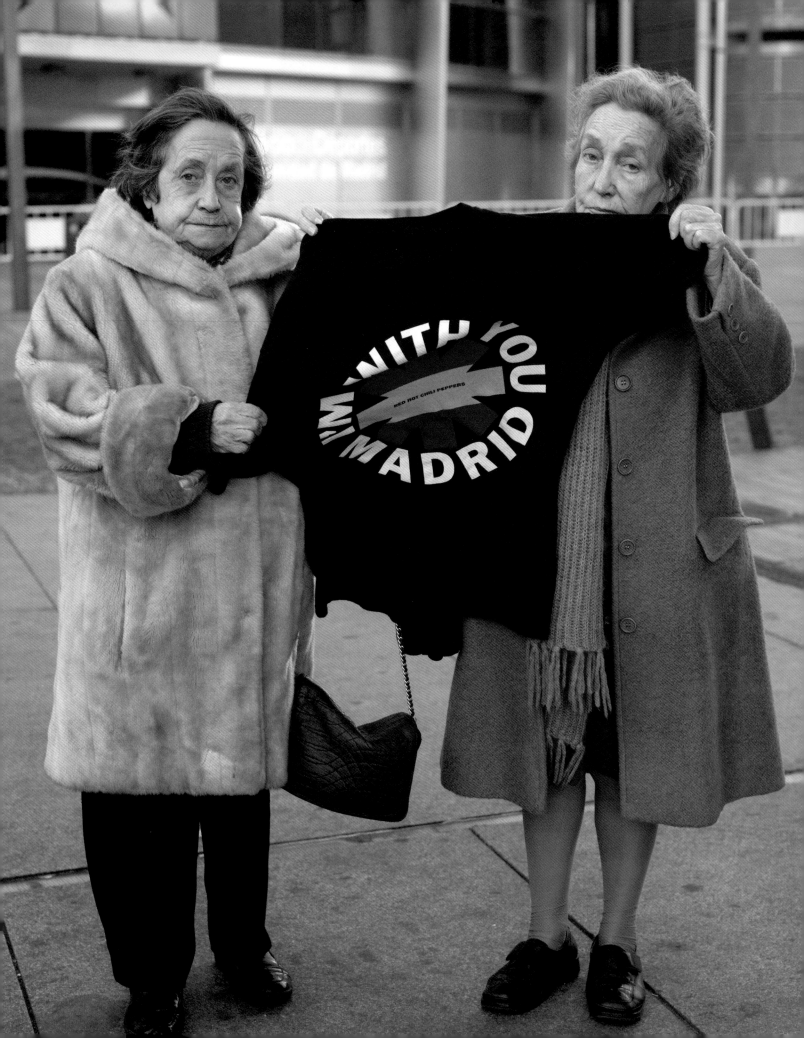

Hala Tufail, 24
New Orleans

I had the pleasure of seeing the Red Hot Chili Peppers at the Voodoo festival in 2006. It was my first time ever seeing the band live. It was the most electric and surreal experience. The brotherhood and energy between the men of this band is amazing. When they played "Apache Rose Peacock" I got chills. From the crowd-surfing to singing along with the band, it was more amazing than I could have ever expected.

In 2005 my family had to move from New Orleans to Texas due to Hurricane Katrina completely ruining our home and the whole city. It was one of the most devastating things I have ever experienced, but I'm actually thankful for it. These experiences led me to where and who I am today. I learned to never take anything for granted and I'm enjoying life to the fullest and focus all my energy on making positive things happen.

I will always be thankful to this band. They have made such a positive difference in my life. The Red Hot Chili Peppers are one of a kind, and no other person or band could ever come close to them.

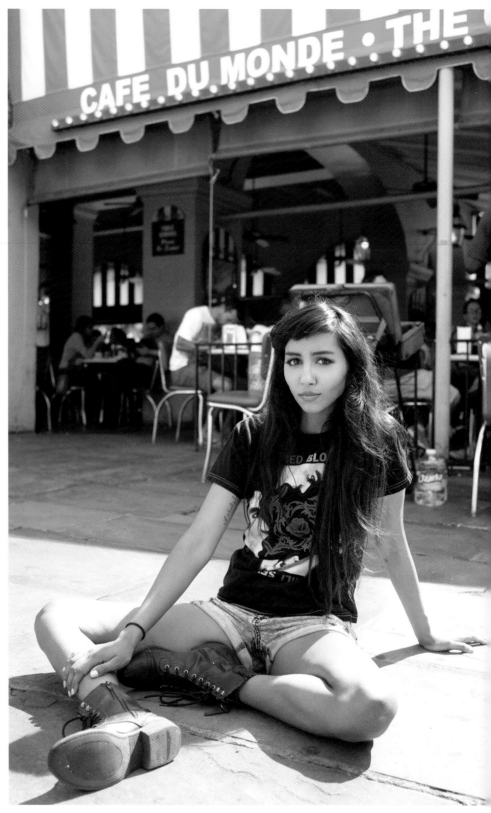

Amanda Rose Halkias, 22
New Jersey

GROWING UP LISTENING TO ROCK FROM AN EARLY AGE I WAS ALWAYS ATTRACTED TO THE RHCP SOUND IN A MAGNETIC WAY. IT MADE ME FEEL EVERYTHING; SADNESS, TRIUMPH, HEARTBREAK, RELIEF, EXCITEMENT, AND MOSTLY EXTREME HAPPINESS. THERE WERE MOMENTS WHEN I THOUGHT NOTHING IN MY LIFE MADE SENSE WITHOUT THEIR MUSIC AND I STILL BELIEVE IT TO BE TRUE. (IT DOESN'T HURT THAT ANTHONY IS THE SEXIEST MAN EVER.) BUT BEST OF ALL, THE CHILI PEPPERS CONNECTED ME TO ONE OF MY BEST FRIENDS OF ALL TIME.

IN HIGH SCHOOL I MET ALYSON CERBORNE, THE CRAZIEST CHILI PEPPERS FAN I'VE EVER KNOWN AND WE INSTANTLY CONNECTED, MOSTLY BECAUSE OF OUR LOVE FOR MUSIC AND ALL THINGS RHCP. WE'VE BEEN ACROSS THE COUNTRY TO SEE THEM LIGHT UP THE STAGE AT THE BONAROO MUSIC FESTIVAL AND EVEN DROVE TO CLEVELAND FROM NORTH JERSEY LAST YEAR WHEN THEY WERE INDUCTED IN TO THE HALL OF FAME. THAT NIGHT WE SPENT THE DURATION OF THE INSANELY UNFORGETTABLE CONCERT INSIDE THE SOUND BOX ON THE BANDS EQUIPMENT TRUNKS JUMPING UP AND DOWN AND SINGING ALONG TO EVERY FUNKY, AMAZING SONG AFTER ANOTHER. ALONG WITH THE SIGNS I HAVE PAINTED OF ANTHONY AND FLEA, I HAVE EVERY ONE OF THE PEPPERS *ROLLING STONE* MAGAZINE COVERS ON MY BEDROOM WALL BESIDE A FRAMED COPY OF MY FAVORITE VINYL, "BY THE WAY." MY FAVORITE LYRICS ARE FROM "CAN'T STOP": "LIVE NOT A LIFE OF IMITATION." AND FROM "CALIFORNICATION": "DESTRUCTION LEADS TO A VERY ROUGH ROAD BUT IT ALSO BREEDS CREATION." I HOPE ONE DAY I CAN MEET ANTHONY AND FLEA AND TELL THEM HOW MUCH THEIR MUSIC AND INSPIRATION HAVE CHANGED MY LIFE.

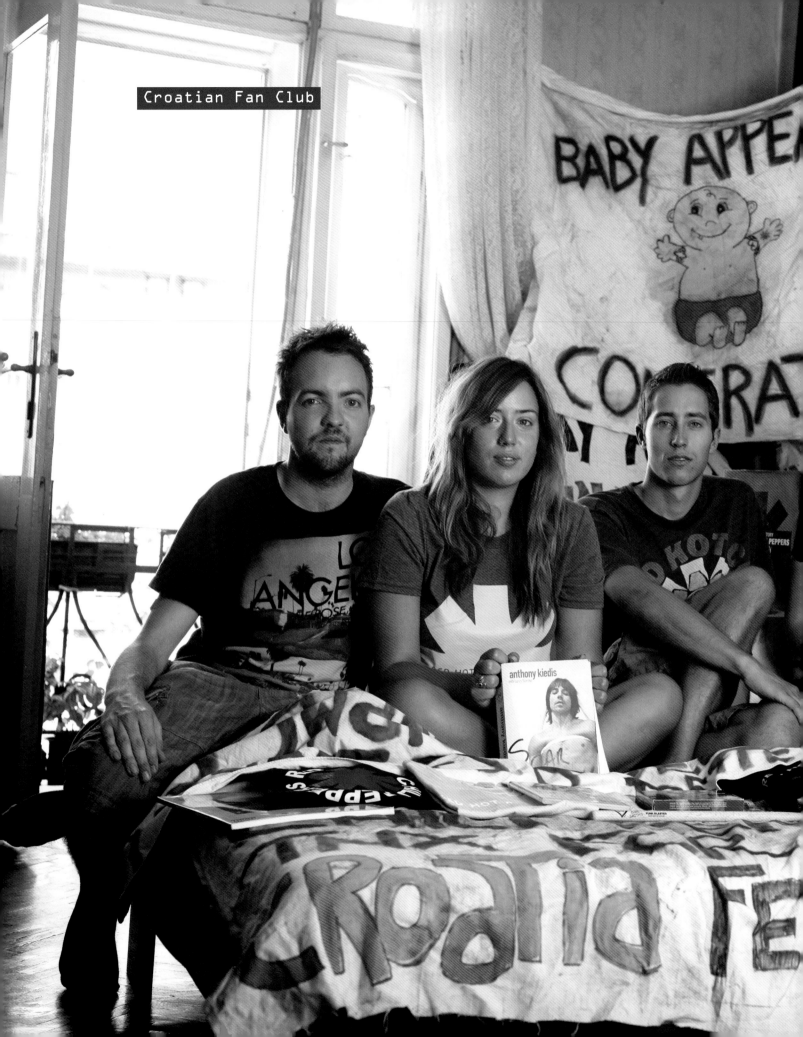

Croatian Fan Club

Andrea Franco, 23
Italy (Right)

I LOVE YOU ALL. THANK YOU FOR EXISTING,
THANK YOU FOR ALL THAT YOU DO, AND FOR
THE MUSIC YOU GAVE US. THANKS ANTHONY,
THE PROPHET, AND THE WHOLE BAND!

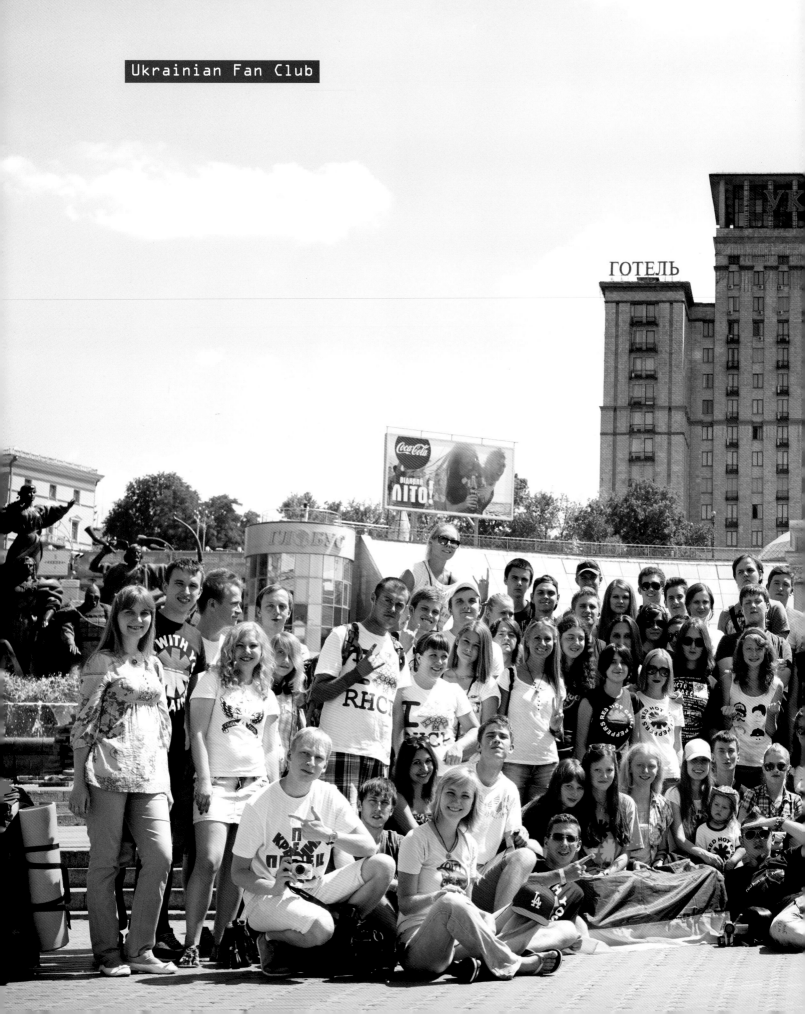

Ukrainian Fan Club

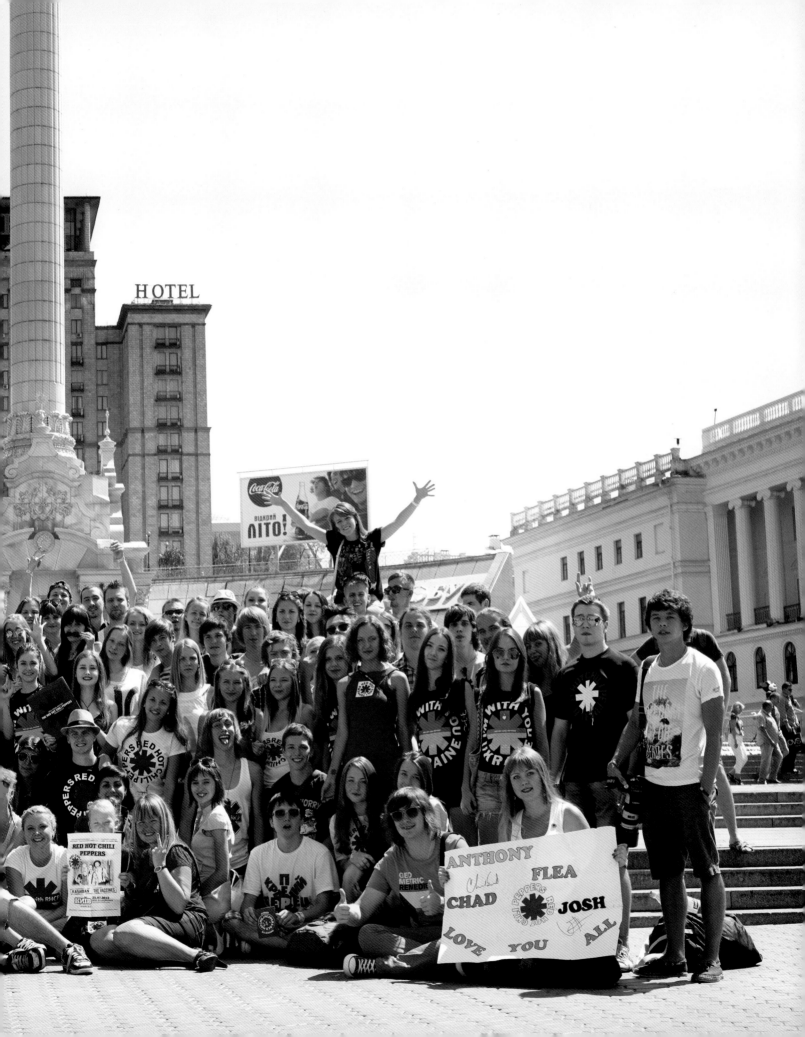

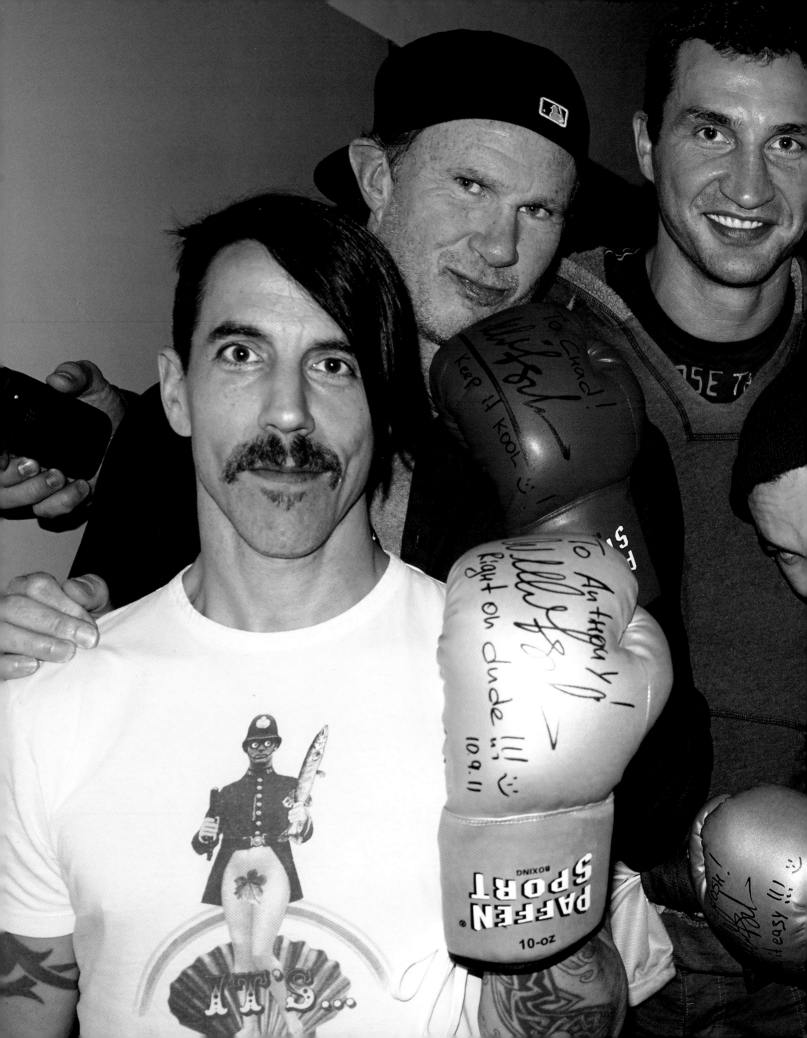

Wladimir Klitschko, 38
Kazakhstan and Ukraine

The music of the RHCP—the song "Can't Stop"—helped shape my boxing career and my life. For that I say "thank you" to the band. Your music continues to inspire. Greatest band ever. Cheers from a training camp in Austria.

Daniel Shields, 22
South Africa

WHENEVER I GET INTO SOMETHING I DON'T SETTLE FOR ANYTHING OTHER THAN THE BEST. I BELIEVE THAT'S WHY I CARE SO MUCH FOR THE RHCP. THEY EXEMPLIFY TRUE MUSICIANSHIP, MUSIC FOR THE SAKE OF MUSIC AND NOT FOR FAME AND MONEY—MAKING MUSIC BECAUSE THEY LOVE IT.

BLOOD SUGAR SEX MAGIK IS MY FAVORITE RECORD. IT WILL NEVER GET OLD. IT'S EASILY THE BEST FUNK ROCK ALBUM EVER MADE.

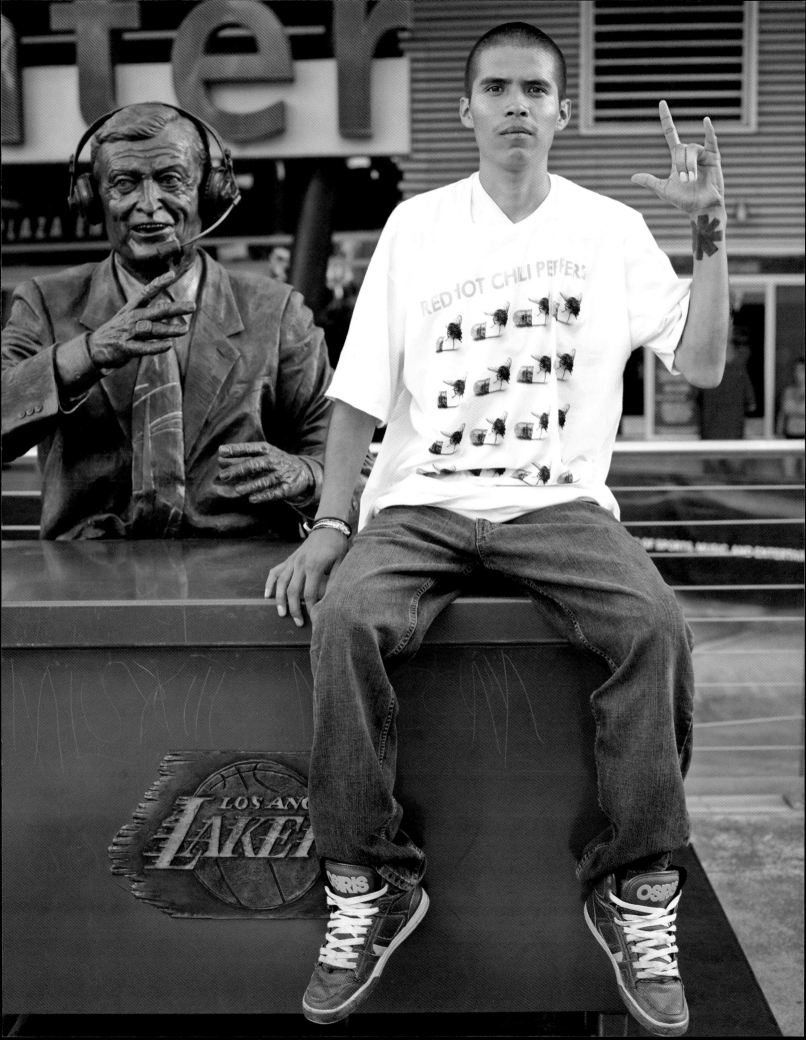

Julia De La Cruz, 29
Spain (148 RHCP Shows)

I HAVE FOLLOWED THE BAND AROUND THE WORLD AND I HAVE MANY MEMORIES OF EACH OF THE SHOWS. THE LAST TOUR WAS VERY SPECIAL FOR ME. I MET THE BAND BACKSTAGE IN MADRID. IT WILL ALWAYS BE THE HAPPIEST DAY OF MY LIFE. I REMEMBER WHEN I WENT TO SEATTLE AND I BROUGHT A SIGN THAT SAID "PLEASE PLAY THE SONG 'HEY.'" ANTHONY TOLD ME THEY WOULD SING IT IN VANCOUVER. TO LISTEN TO THAT SONG IN CONCERT WAS GREAT, ALTHOUGH I SPENT THE WHOLE SONG CRYING BECAUSE OF THE EMOTIONS I FELT.

I ALSO REMEMBER IN VANCOUVER, I WAS WALKING DOWN THE SIDE OF THE ROAD AND THE TOUR BUS CAME BY. IT PULLED OVER AND I WAS INVITED TO BOARD THE BUS. I DIDN'T REALLY BELIEVE IT WAS HAPPENING. BUT ANTHONY AND JOSH HAD SEEN ME AND TOLD THE DRIVER TO PULL OVER AND PICK ME UP.

I LOVE GOING TO CONCERTS. I'M THE HAPPIEST PERSON IN THE WORLD WHEN I SEE THEM ON STAGE. IT TAKES A LOT OF EFFORT TO MAKE AS MANY TRIPS AS I DO. IN MY DAILY LIFE I DEPRIVE MYSELF OF MANY THINGS TO ATTEND THEIR SHOWS, BUT FOR ME, TO SEE THEM PERFORM AND LISTEN TO MY FAVORITE SONGS—IT'S THE BEST THING EVER.

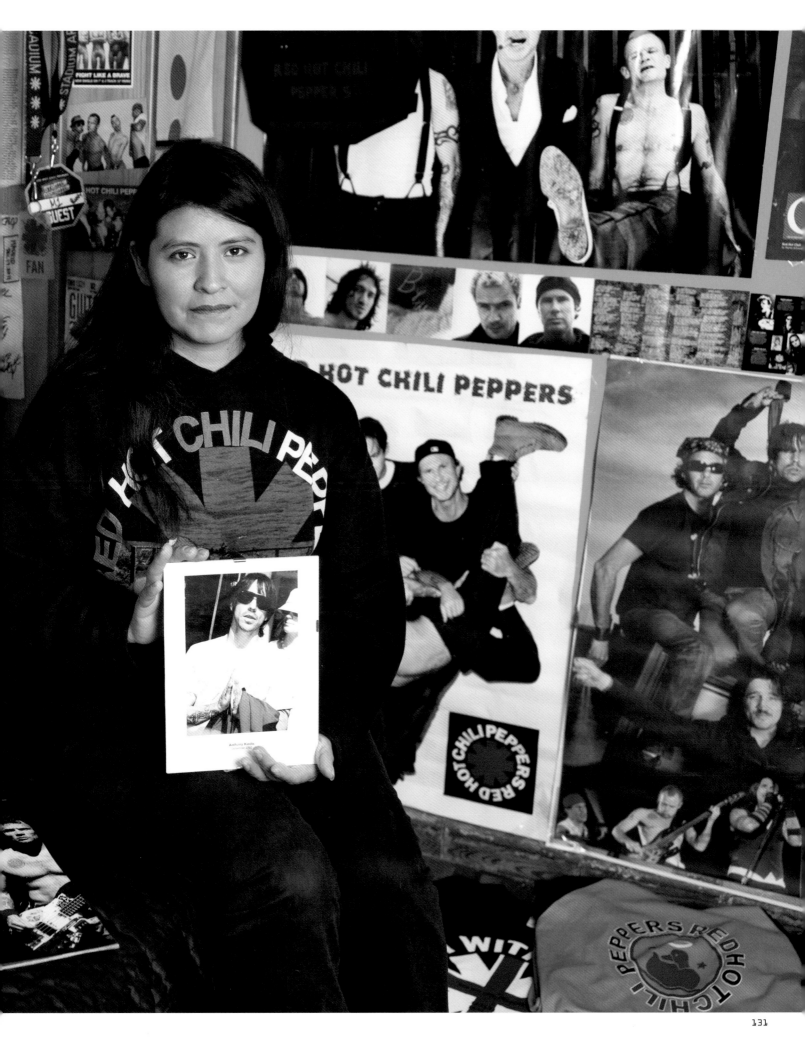

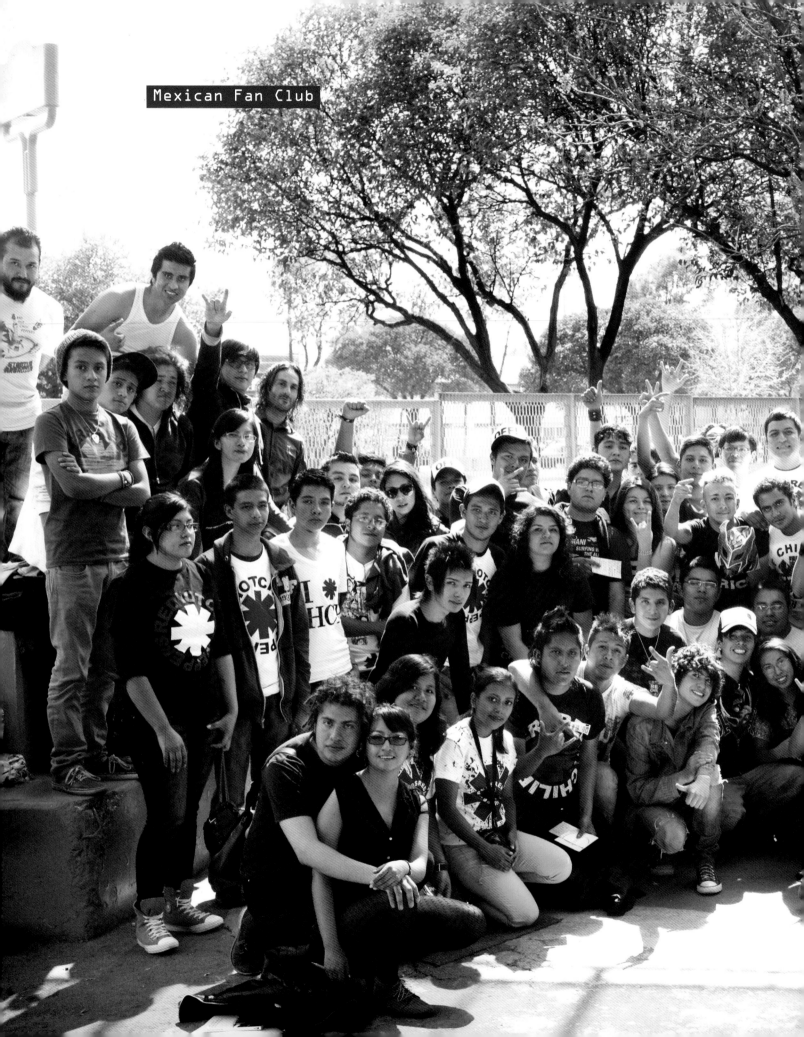

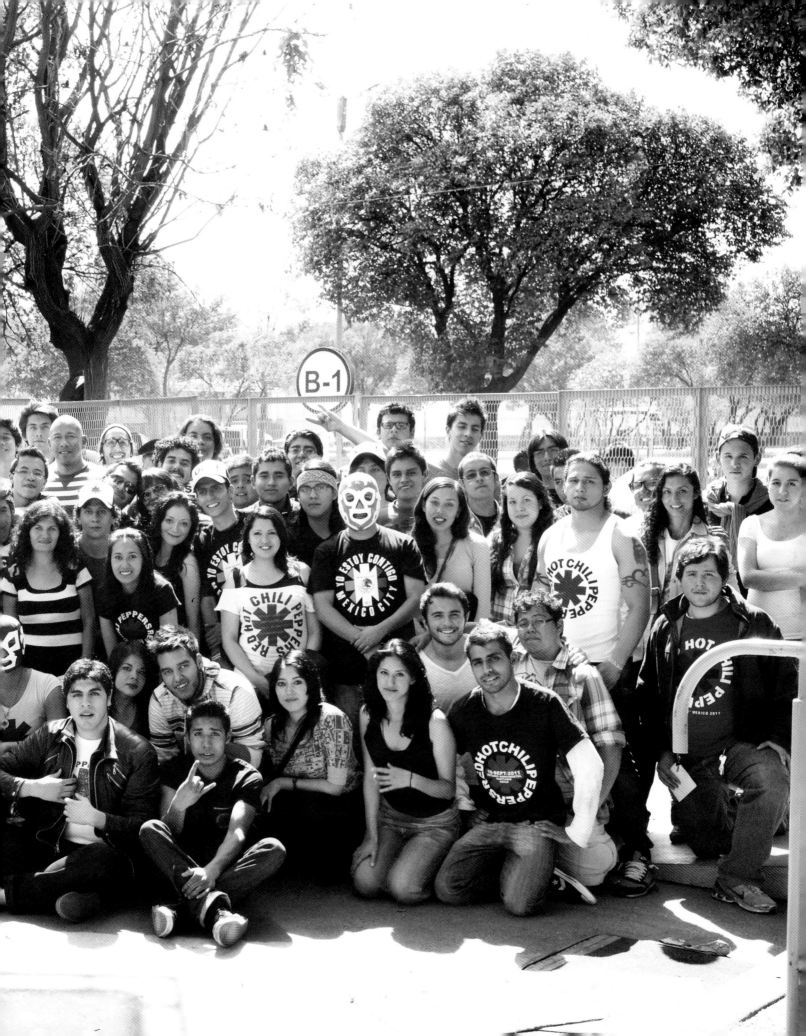

Andres "Ranafonk" Medina, 37
Argentina (Left)
Ra Diaz, 30
Chile (Right)

ANDRES— I SAW A RHCP MUSIC VIDEO FOR THE FIRST TIME IN 1990. IT WAS "TASTE THE PAIN." I HAD NEVER BEFORE SEEN A BAND WITH THAT STYLE AND VIBE, AND THAT MADE ME CONNECT WITH THEM IN A VERY STRONG AND PARTICULAR WAY. SINCE THEN I STARTED LOOKING FOR INFORMATION ABOUT THEM. IN ARGENTINA NO ONE KNEW MUCH ABOUT THE RHCP. I SAW THE BAND PERFORM FOR THE FIRST TIME IN BUENOS AIRES IN JANUARY 1993, WHEN I WAS SIXTEEN. THEY WERE PRESENTING THE ALBUM *BLOOD SUGAR SEX MAGIK*. IT WAS THEIR FIRST VISIT TO SOUTH AMERICA AND THAT EVENT LEFT AN IMPACT ON ME FOREVER.

ALMOST TWENTY YEARS LATER, I READ THAT THE RHCP WERE ABOUT TO PLAY IN BELGIUM. I IMMEDIATELY THOUGHT, "I DON'T KNOW EUROPE, BUT THIS IS A GREAT EXCUSE TO GO THERE FOR THE FIRST TIME!" I PLANNED MY SCHEDULE AROUND THEIRS AND VISITED AS MANY COUNTRIES AS POSSIBLE, WATCHING THE SHOWS. I FOLLOWED THE BAND THROUGH ENGLAND, THE NETHERLANDS, FRANCE, SPAIN, BELGIUM, AND RUSSIA. BY CHANCE, I EVEN CROSSED ROADS WITH CHAD SMITH TWICE—ONCE IN PARIS AND THEN IN ST. PETERSBURG. IT WAS ONE OF THE BEST EXPERIENCES OF MY LIFE.

MY FAVORITE ALBUM IS *BLOOD SUGAR SEX MAGIK*. I CARRY THAT NAME TATTOOED ON MY ARM. IT'S THE RECORD THAT CHANGED THE WAY I LISTEN TO AND UNDERSTAND MUSIC. I'M ABOUT TO BECOME A FATHER FOR THE FIRST TIME AND ONE OF MY DREAMS IS TO PASS ALONG THAT PASSION FOR THE MUSIC TO MY SON.

My father was a Marine. I was raised strict. As I got older and had my own son, I started to understand why my father was so strict with me. He would say "Rich, I lived my life and I want you to live yours." He passed away on November 23rd, 2001. *By The Way* dropped the next summer; I was really connected to the song "Dosed". "All I ever wanted was your life."

My father's name was Charles and his family called him Charlie Boy. So again when *Stadium Arcadium* dropped and there was the song named Charlie. It blew my mind.

Dani Gaitan. 24
Francisco Fernandez, 24
Argentina

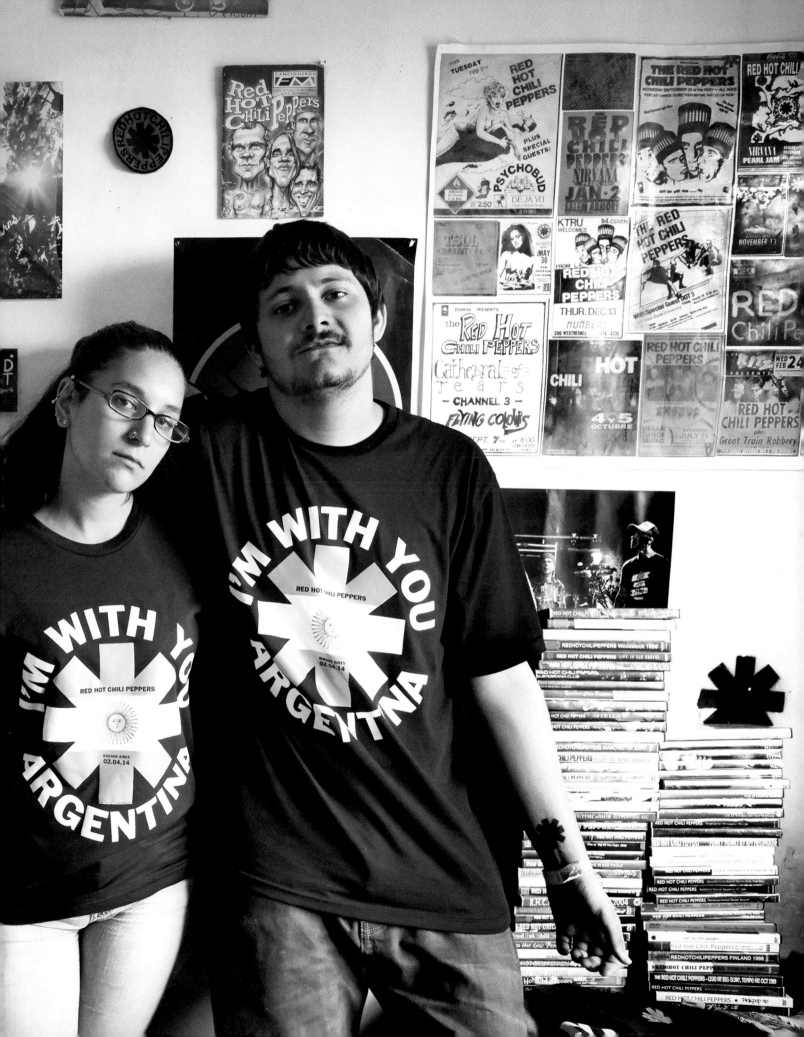

Erin Gibson, 24
Pittsburgh

I BEGAN READING *SCAR TISSUE* IN 2008, FRESH OUT OF REHAB. I HAD NO IDEA HOW INTENSELY IT WOULD DESCRIBE DRUG ADDICTION AND THE PERSPECTIVE OF TRULY SEEING ONE'S PAST WHILE IN RECOVERY. IT WAS, OF COURSE, EXACTLY WHAT I NEEDED AT THE TIME. IT TOOK ME ALMOST A YEAR TO FINISH IT. I REALLY DIDN'T WANT IT TO END. I COULDN'T BELIEVE THAT SO MANY OF THE SONGS THAT I HAD COME TO LOVE AND ARE INGRAINED IN MY HEAD FOREVER ARE ABOUT ADDICTION AND RECOVERY. THERE WAS AN INSTANT CONNECTION AND RHCP ABSOLUTELY BECAME MY "HIGHER POWER." IT REALLY HELPED ME TO KNOW, THAT IF THERE ARE ROCK STARS OUT THERE THAT COULD DO ANYTHING THEY WANT, YET ARE ABSTAINING FROM DRUGS AND ALCOHOL THERE IS NO REASON WHY I CAN'T. IT REALLY KICK-STARTED MY SPIRITUAL JOURNEY.

Wil Vrijhof, Over 50
Holland

I've loved the Red Hot Chili peppers since their beginning in the eighties. The first time I saw them live was in 1989 on Dam Square in Amsterdam and they were amazing. The music, the lyrics, the fun... they were and still are unbelievable. Their talent, craftmanship, energy, and madness have been contagious all those years. Because they love what they're doing so much, they fill me with joy, energy, love, and admiration. They did so in the eighties and they do so now. These are just some of the reasons why I have been to so many shows. Every time I hear the band play, I can feel how much they love it, and I just can't help but love that too. Thanks to these amazing guys I've traveled the world and made many, many friends. I'm proud to be part of this RHCP family.

Aude aka Moustache Girl, 37
Zozan, 22
Calbrese Nunziata, 40
France

MOUSTACHE GIRL— I'M A MARRIED HOUSEWIFE AND MOTHER OF TWO KIDS. MY DAUGHTER LILI IS 10 AND MY SON TITOUAN IS 4. TITOUAN SHARES MY LOVE FOR THE CHILI PEPPERS. HIS FAVORITE SONG IS "IF YOU HAVE TO ASK." WHEN HE SINGS IT HE SAYS "POKEMON POCAWAWAWAWA" INSTEAD OF "MOTHERFUCKERS" AND ACTUALLY I HAVE TO SAY THAT SUITS ME BETTER!

ZOZAN— I WAS BORN IN PARIS. I AM OF KURDISH AND SYRIAN ORIGIN. I WORK IN A NURSERY WITH BABIES. I LOVE WORKING WITH CHILDREN, IT'S ANOTHER WORLD.

CALABRESE— I WAS 7 MONTHS PREGNANT BUT I COULDN'T MISS THE CONCERT!! AT STADE DE FRANCE IN JUNE 2012, WE WAITED AT THE FRONT ENTRANCE SINCE 7 IN THE MORNING. HOPING TO BE THE FIRST IN LINE WITH ALL MY FRIENDS. WE ARE A GROUP OF TWENTY FANS, FROM EVERY AGE, COMING FROM EVERY PART OF THE COUNTRY, ALL LINKED BY THE PEPPERS. WHEN THE DOORS OPENED I RAN AS FAST AS I COULD AND I MADE IT TO THE BARRIER. PRACTICALLY THE WHOLE GROUP WAS GATHERED IN THE FRONT LINE. WE SHARED AN INCREDIBLE MOMENT TOGETHER, BREAKING OUR VOICES ON OUR FAVORITE SONGS. THE MOON LIT THE WHOLE STADIUM. IT WAS A BEAUTIFUL NIGHT. THE DAY AFTER WE DROVE TO WERCHTER, BELIGUM. WE BARELY SLEPT BUT WE GOT TO THE BARRIER ONCE AGAIN!

Miia Tuominen, 20
Nora Kosunen, 20
Finland

MIIA— IT WAS PROBABLY AROUND 2003. I WAS WATCHING *MTV* AND SAW AN OLD PEPPERS GIG. I STILL CLEARLY REMEMBER ANTHONY'S APPEARANCE. HE HAD THIS CRAZY LONG HAIR AND WEIRD FLAMED LEATHER PANTS. INSTANTLY I THOUGHT THAT RHCP WAS A HEAVY METAL BAND. I HATED METAL MUSIC SO I HATED THE RED HOT CHILI PEPPERS. I CHANGED THE CHANNEL AND FROM THAT MOMENT ON WHENEVER I SAW THE NAME I REMEMBERED THE FLAME PANTS AND TOLD PEOPLE I DIDN'T LIKE THE BAND. ONE DAY I EVEN FOUND A RHCP PIN FROM OUR CLOSET AND THOUGHT ABOUT THROWING IT AWAY. I DIDN'T DO IT, I DON'T KNOW WHY BUT I'M GLAD I SAW IT BECAUSE IN 2006 I FOUND MY FAVORITE BAND. I SAW THE VIDEO OF "DANI CALIFORNIA" AND FELL IN LOVE. I COULDN'T BELIEVE IT WAS THE SAME BAND I HATED FOR A COUPLE OF YEARS. THE MUSIC, THE VIDEO, IT WAS LIKE NOTHING I'VE EVER EXPERIENCED. THEN PROBABLY A WEEK LATER I BOUGHT *STADIUM ARCADIUM* AND BECAME A SUPER CRAZY FAN GIRL.

NORA— MY FAVORITE LYRICS ARE "SAY IT LOUD I'M FREAKY STYLEY AND I'M PROUD." THAT'S PRETTY MUCH MY LIFE'S PHILOSOPHY, BE YOURSELF AND BE PROUD."

Ivan Rerat, 21
Switzerland (Right)

I remember exactly the first time I heard the Red Hot Chili Peppers. I was thirteen years old and I was watching TV when suddenly I heard the first notes of "Dani California." I immediately got inspired and since then I have been following the band's every step.

When I knew the band was going to play in Bern I promised my little brother—a huge fan—that I would take him to the concert. My little brother plays drums and the bass guitar. He was wondering if there would be any chance of getting Chad Smith's sticks after the concert. I told him I would try. I painted a poster of the group. After the concert I offered the poster to the band and my little brother actually got Chad's sticks! This was highly important and symbolic to him.

I have many dreams. The first is to create a cover for a Red Hot Chili Peppers album. I also wish to see my little brother jamming with the Chili Peppers. That would be amazing! Sometimes you feel happier giving something to someone than if somebody gave something to you.

Katja Kilman, 19
Croatia

I was first connected to the Red Hot Chili Peppers by the song "Californication." I remember it so well. I was about five years old and just realized how to use the VHS recorder. I would sit in front of the TV, waiting for my favorite songs so I could run and hit "rec." Then I could listen to the songs I loved whenever I wanted to. "Californication" was one of the first songs I recorded and I never stopped listening to it! It's been fifteen years and I'm still in love with that song.

Without them even knowing it, the RHCP are following me through every phase of my life. I even quit a job once so I could attend their concert in Zagreb. It was totally worth it! Crazy? Some people call me crazy for having sixteen piercings on my body, some gag when they hear I actually pierced my own ears at least five times when I was thirteen. According to most people, I'm also crazy because I tattooed myself twice with a needle and ink when I was fourteen. I'm nineteen and not a party person at all (well, not anymore). I actually care about my education (also called crazy because of that). So you tell me, who is crazy? Probably each and every one of us.

I don't think I will ever stop listening to the Chili Peppers. I can see myself as an old, ugly granny singing, "Give It Away, Give It Away, Give It Away now."

I would quit my job to see the Peppers on stage anytime.

Alexandra Klepper, 19;
Maria Veldman, 19,
Maggie Wyntjes, 18
Canada

ALEXANDRA I AM A NINETEEN-YEAR-OLD GIRL FROM RED DEER, ALBERTA, WORKING TO SAVE UP AND LEAVE BEHIND MY HOMETOWN TO TRAVEL THE WORLD BY MYSELF. MY WHOLE LIFE I HAVE FELT LIKE AN OUTCAST IN ALBERTA AND RHCP HAS HELPED ME ACCEPT MYSELF. I AM AN OLD SOUL WHO LOVES THE RED HOT CHILI PEPPERS MORE THAN LIFE ITSELF AND WHO FINDS HAPPINESS IN THE SIMPLE MOMENTS. I LOVE TRAVELING, GOING TO AS MANY CONCERTS AS I CAN, AND BEING BY THE OCEAN. I ENJOY DOING YOGA, RUNNING, AND MY FAVORITE PLACE IN THE WORLD IS THE CALIFORNIA COAST. I AM HAPPIEST WHEN I AM AT A RED HOT CHILI PEPPERS CONCERT.

I THINK WHAT FIRST CONNECTED ME TO THE RED HOT CHILI PEPPERS WAS HOW UNIQUE AND SPECIAL THEIR SOUND WAS. I FELL INSTANTLY IN LOVE WITH THE FUNKY BASS AND ANTHONY'S AMAZING VOCAL SKILLS. I HAD NEVER HEARD SUCH POWERFUL MUSIC IN MY ENTIRE LIFE AND ONCE I HEARD MY FIRST SONG BY THEM I KNEW THEY WOULD FOREVER CHANGE MY LIFE.

IN SEPTEMBER OF 2012 I DROPPED OUT OF COLLEGE FOR PERSONAL REASONS. I HAD NO IDEA WHAT I WAS DOING WITH MY LIFE. I STARTED TO SUFFER FROM SEVERE DEPRESSION AND ANXIETY. I ALSO GOT TO BE SUICIDAL. I WAS SO SCARED AND FELT LIKE THE SADNESS WOULD LAST FOREVER, BUT I CAN HONESTLY SAY THE ONLY THING THAT KEPT ME GOING AND WAKING UP EVERY DAY WAS THAT I HAD TICKETS TO THE EDMONTON AND CALGARY RED HOT CHILI PEPPERS SHOWS. EVERY DAY I WOULD CONSTANTLY BLAST THE PEPPERS AND KEEP COUNTING THE DAYS TILL THE CONCERT WAS HERE. WHEN THE DAY CAME FOR THE CONCERT I WAS IN TOTAL BLISS. I GOT THE CHANCE TO MEET DAVID MUSHEGAIN AND HE REALLY CHANGED MY WORLD BY GIVING ME THE OPPORTUNITY TO MEET ANTHONY KIEDIS, CHAD SMITH, AND JOSH KLINGHOFFER. IT WAS SUCH A LIFE-CHANGING EXPERIENCE TO SEE MY FAVORITE BAND LIVE AND RHCP MADE ME START TO LOVE MYSELF AND EVERYTHING LIFE HAS TO OFFER AGAIN.

MY FAVORITE RECORD OF ALL TIME IS *CALIFORNICATION*. I COULD LISTEN TO THAT ALBUM FOREVER AND NEVER GET SICK OF IT. EVERY SINGLE SONG ON IT HAS A DIFFERENT MEMORY ATTACHED TO IT AND WHENEVER I PLAY IT I FEEL NOTHING BUT HAPPINESS. I LOVE THE VARIETY OF SONGS ON IT: FROM THE SADNESS YOU CAN HEAR IN ANTHONY'S VOICE IN THE SONG "PORCELAIN" TO THE CRAZY FUNKY BASS IN "AROUND THE WORLD." MY ALL-TIME FAVORITE SONGS ARE "SCAR TISSUE," "SLOW CHEETAH," AND "CAN'T STOP." EVERY TIME I HEAR "SCAR TISSUE" I GET GOOSE BUMPS. JOHN FRUSCIANTE'S GUITAR MAKES ME CRY ALMOST EVERY SINGLE TIME. "SLOW CHEETAH" HAS SAVED MY LIFE SO MANY TIMES. NOW, ON A HAPPIER NOTE, WHEN I HEAR THE BEGINNING OF "CAN'T STOP" I GO CRAZY. THAT SONG JUST MAKES ME WANT TO DANCE AND IT'S JUST THE BEST FUNKY JAM EVER.

MAGGIE I'M TRYING TO BE A HAPPY AND POSITIVE PERSON. MY MOM HAS BEEN AN ALCOHOLIC ALL MY LIFE AND MUSIC HAS REALLY HELPED ME THROUGH THE HARD TIMES. ANTHONY TALKS ABOUT ISSUES WITH HIS DAD IN HIS BOOK AND HOW HE DEALT WITH IT. I'M A NEGATIVE PERSON BECAUSE I'VE ALWAYS HAD SOMETHING TO DEAL WITH AND NOT HAVING A MOM THERE FOR ME—ESPECIALLY BEING A GIRL—IS HARD. THE SONGS THAT THE RED HOT CHILI PEPPERS CREATE MAKE YOU FEEL A CERTAIN ENERGY THAT THEY HAVE ALL BEEN THROUGH SOMETHING AND YOU WILL ALWAYS FIND A WAY TO GET THROUGH IT. THEY DON'T HAVE TO SAY IT BECAUSE YOU CAN FEEL IT THROUGH THE ENERGY THEY CREATE WITH THEIR INSTRUMENTS.

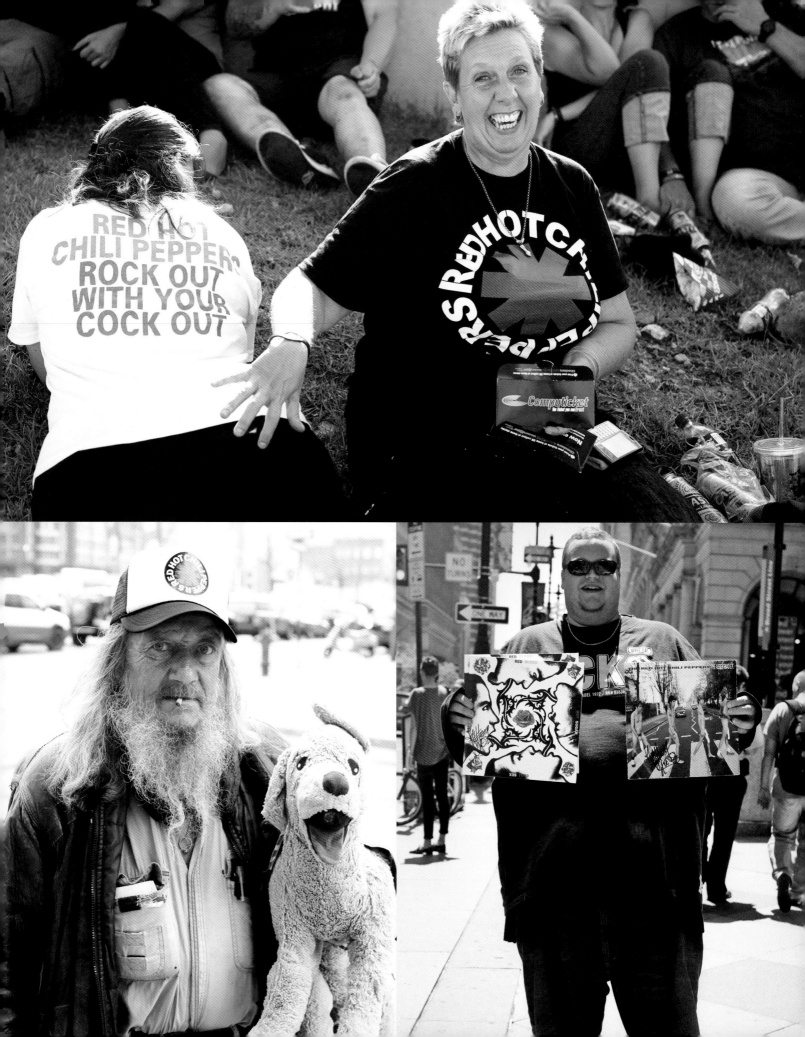

Thankyou for
all of your musical
inspiration!
We love you!
—Chantae
Wilson

"The one condition we
have is she can
cheat on me with
Anthony"
Jarryd Scully
+
Chantal
Wilson

FUCK ME
U R God

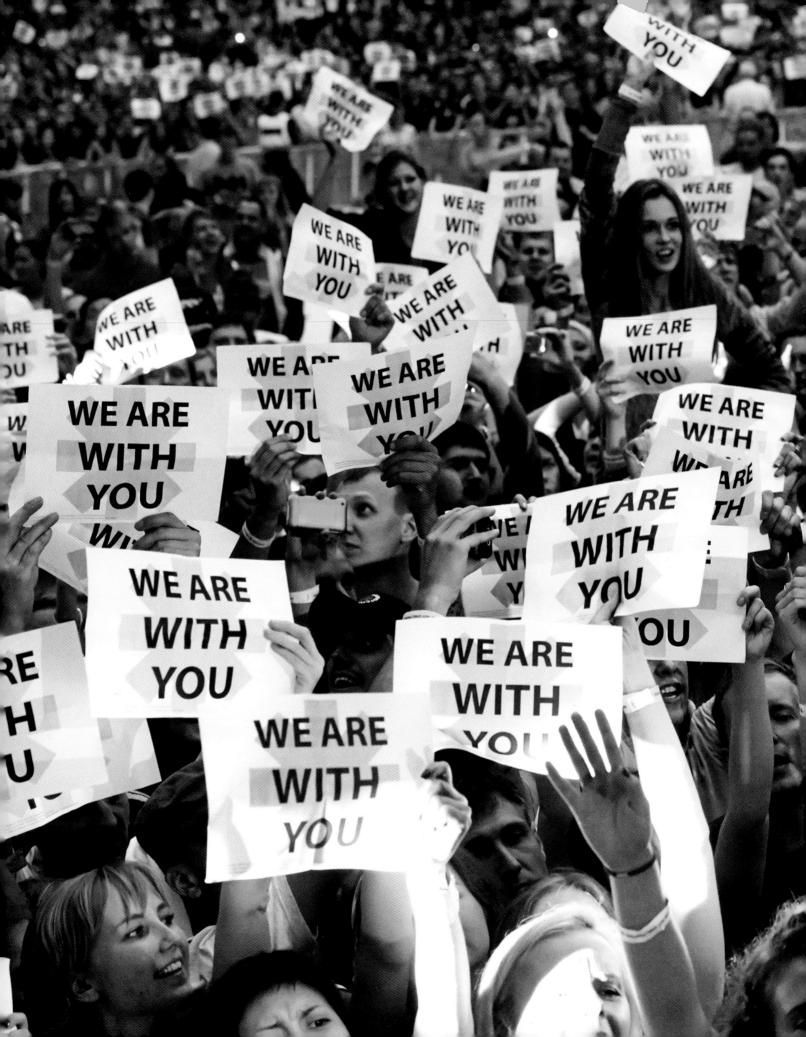

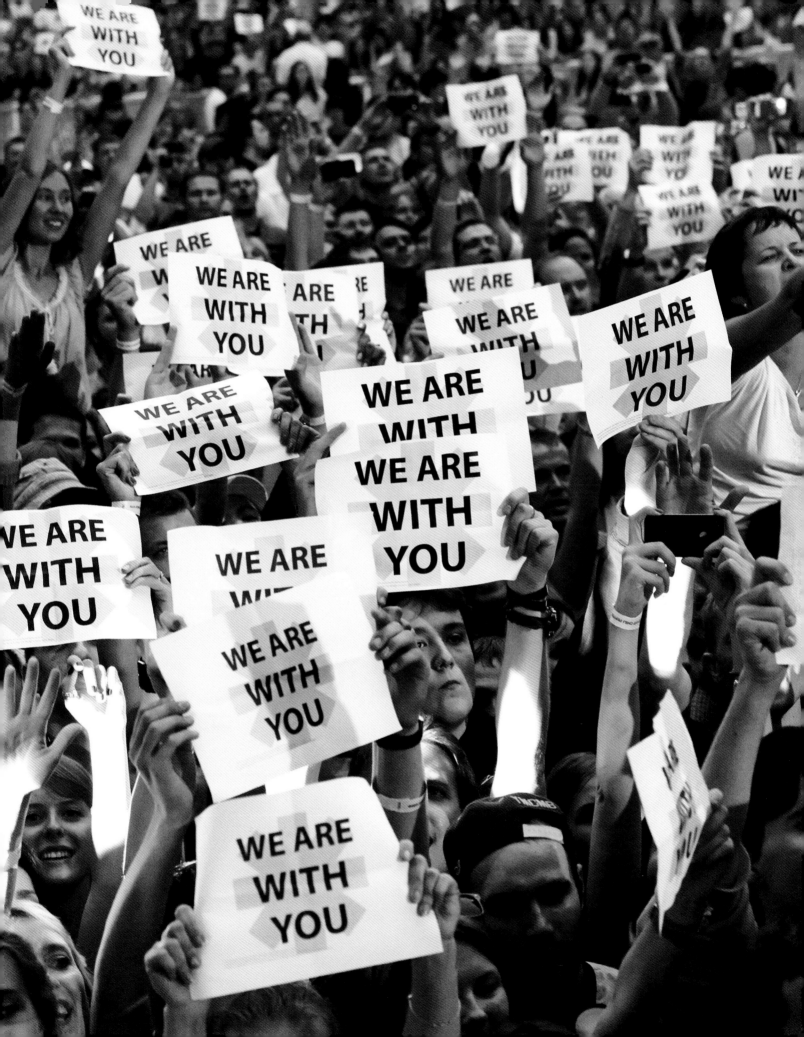

Henrik Lewandowski, 40
Berlin (84 RHCP Shows)

A girl asked me to dance in a night club. "Under The Bridge" was playing. Immediately I fell in love with the sound and lyrics. I asked her what the band's name was. That was June 20, 1992.

The Peppers were on a TV show in Cologne, Germany on April 26, 2006. They were being interviewed and they pointed at me and Chad said "He follows us everywhere! Everywhere!"

I love sharing with the RHCP fan community. I upload live updates from shows on Twitter and Facebook and always upload Anthony's handwritten set list right at the end of the concert. My favorite record is *Blood Sugar Sex Magik*. I would say my dream is to go to RHCP shows all Around The World. I just want to join the show and meet all the lovely fans!

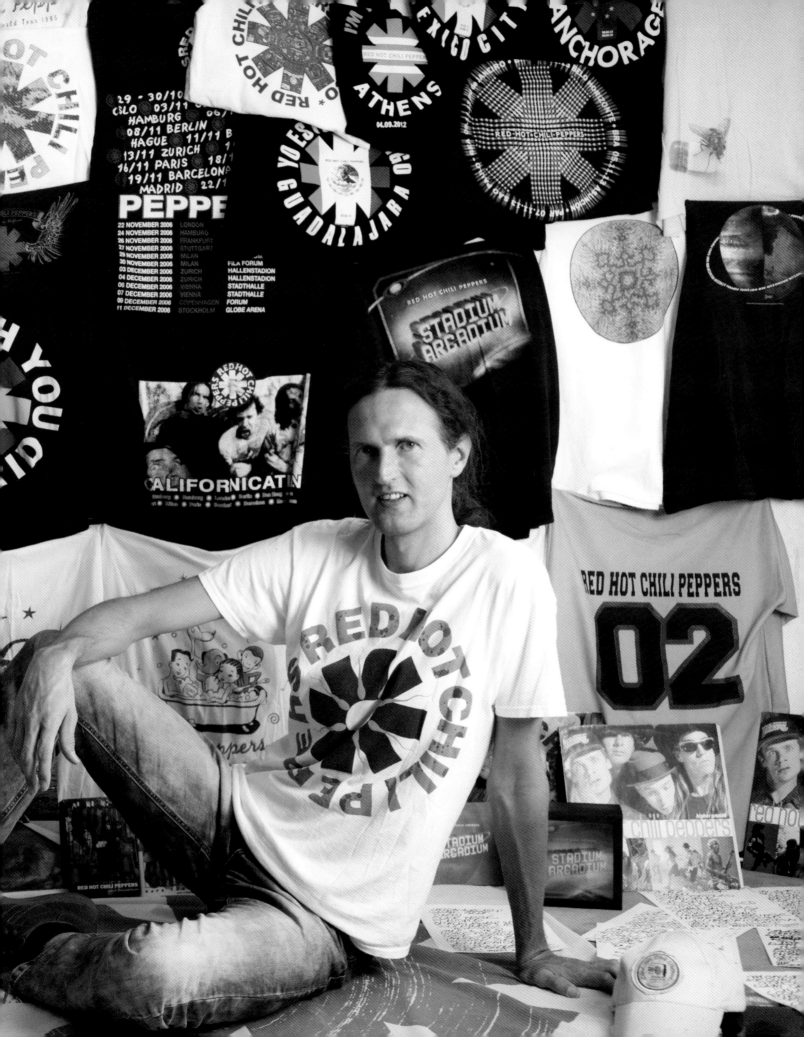

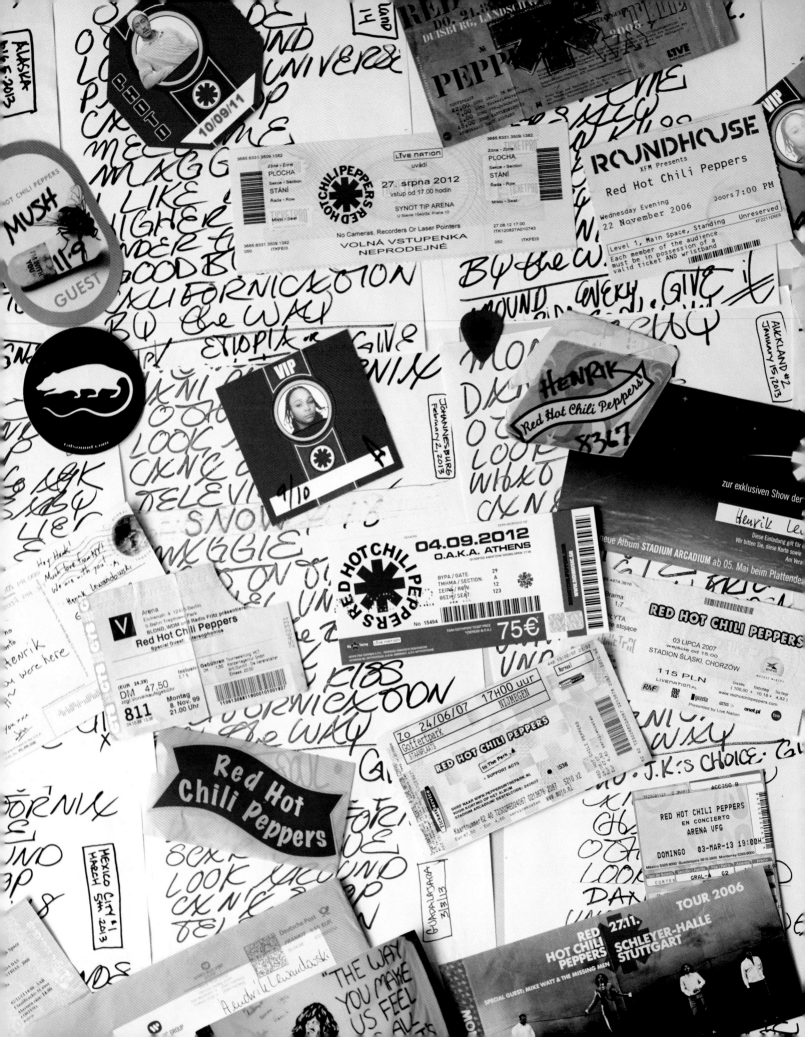

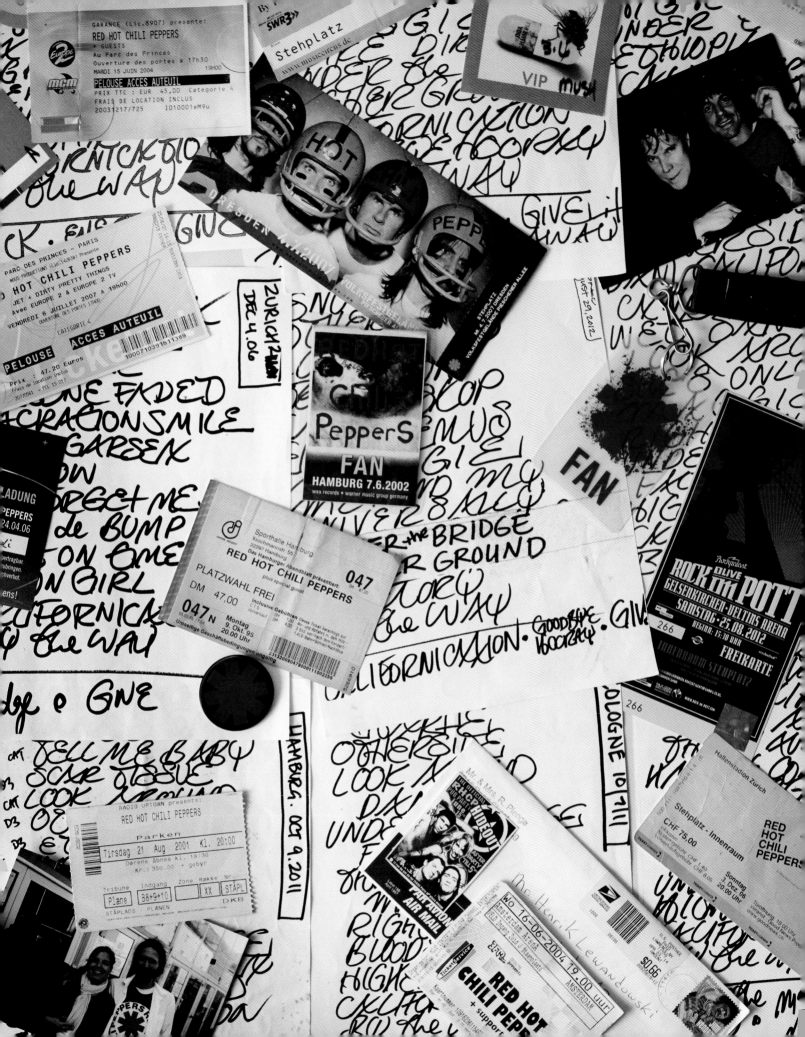

Vojtech Coufel, 28
Alena Rakova, 28
Tereza Tersova, 24
Martin Rak, 24
Prague

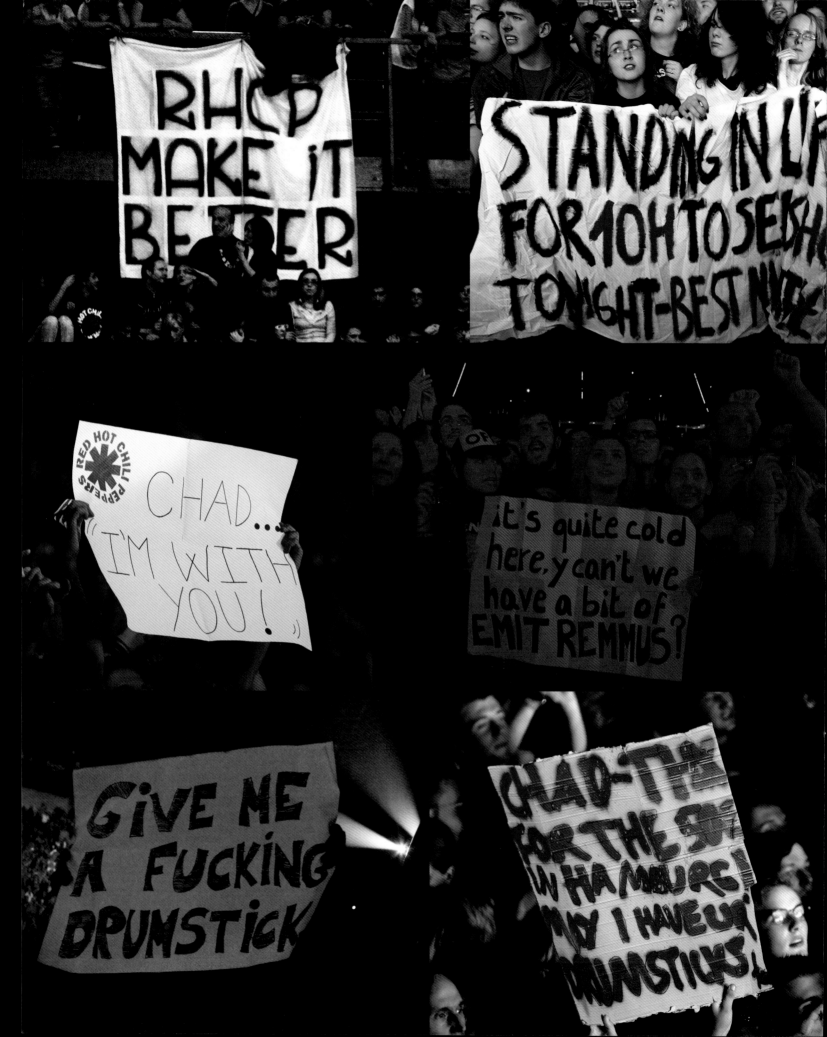

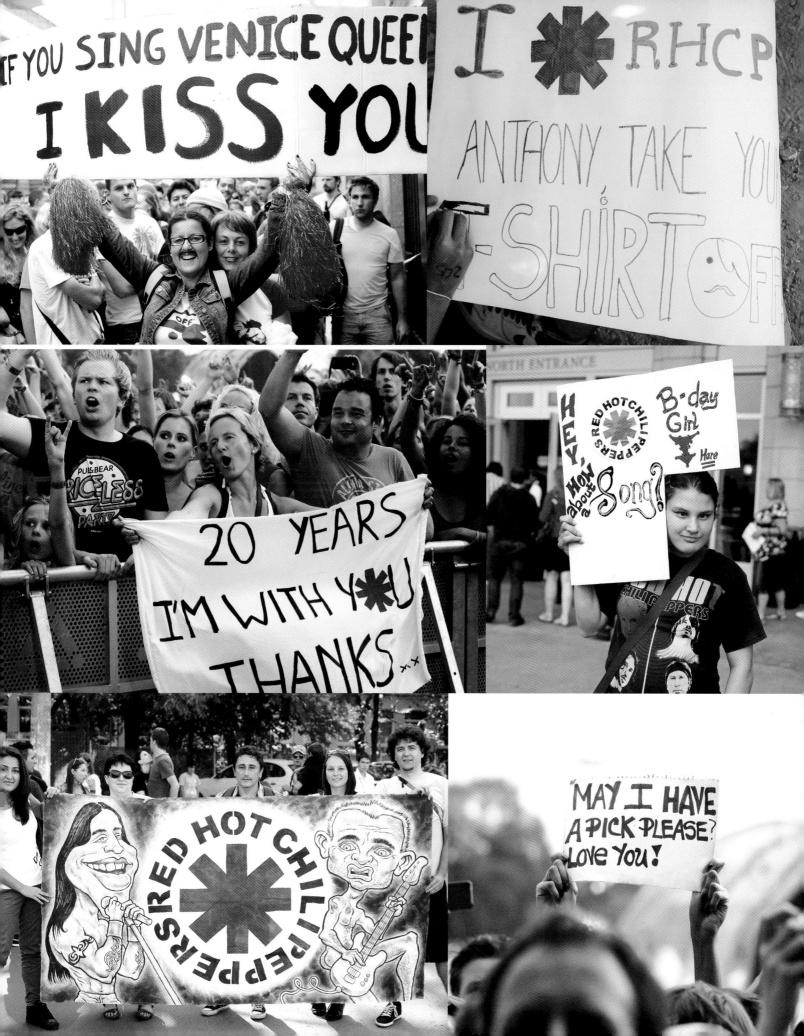

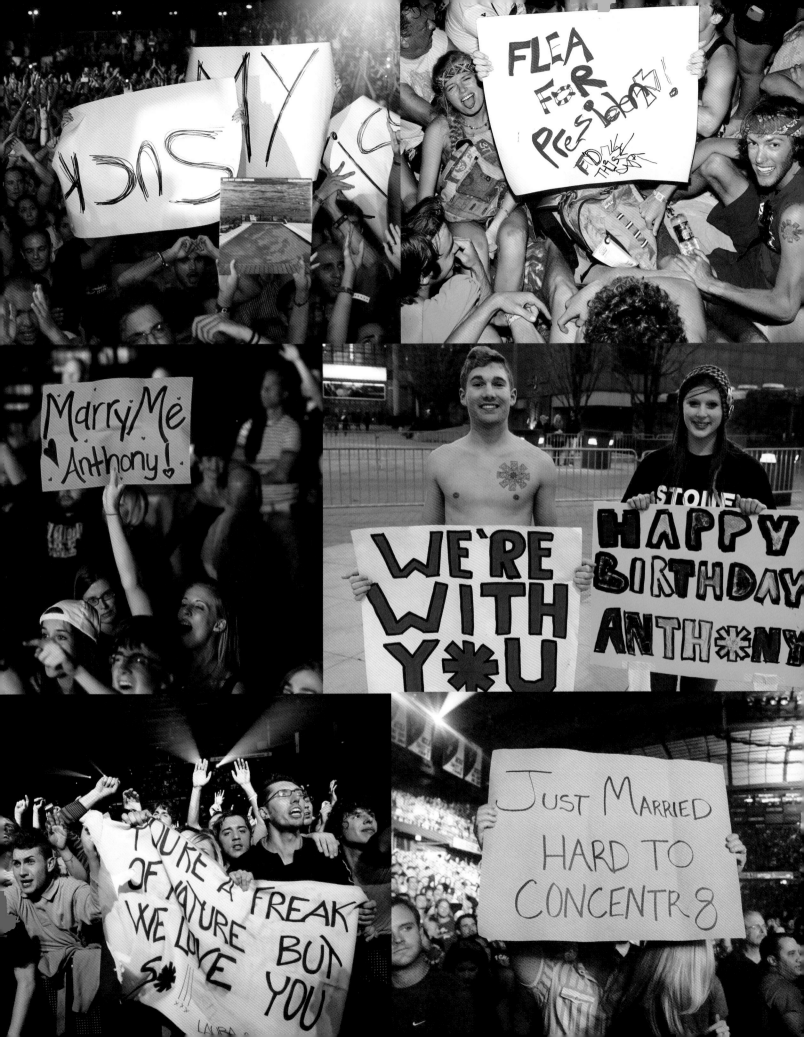

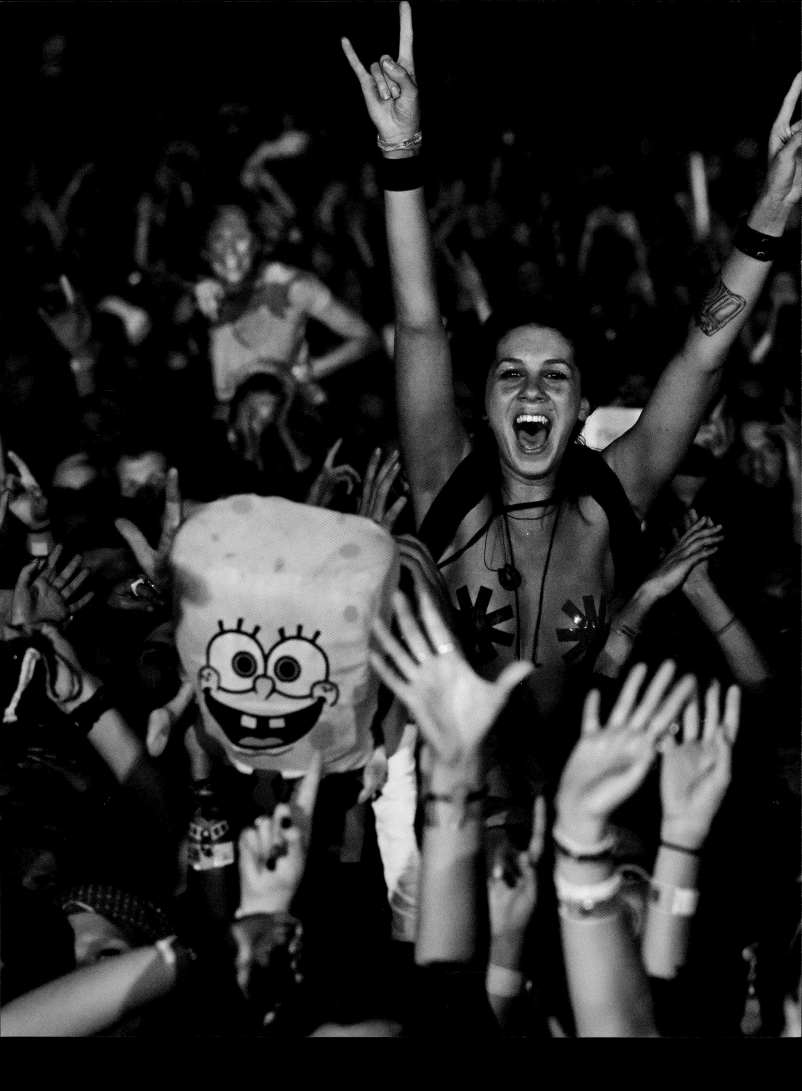

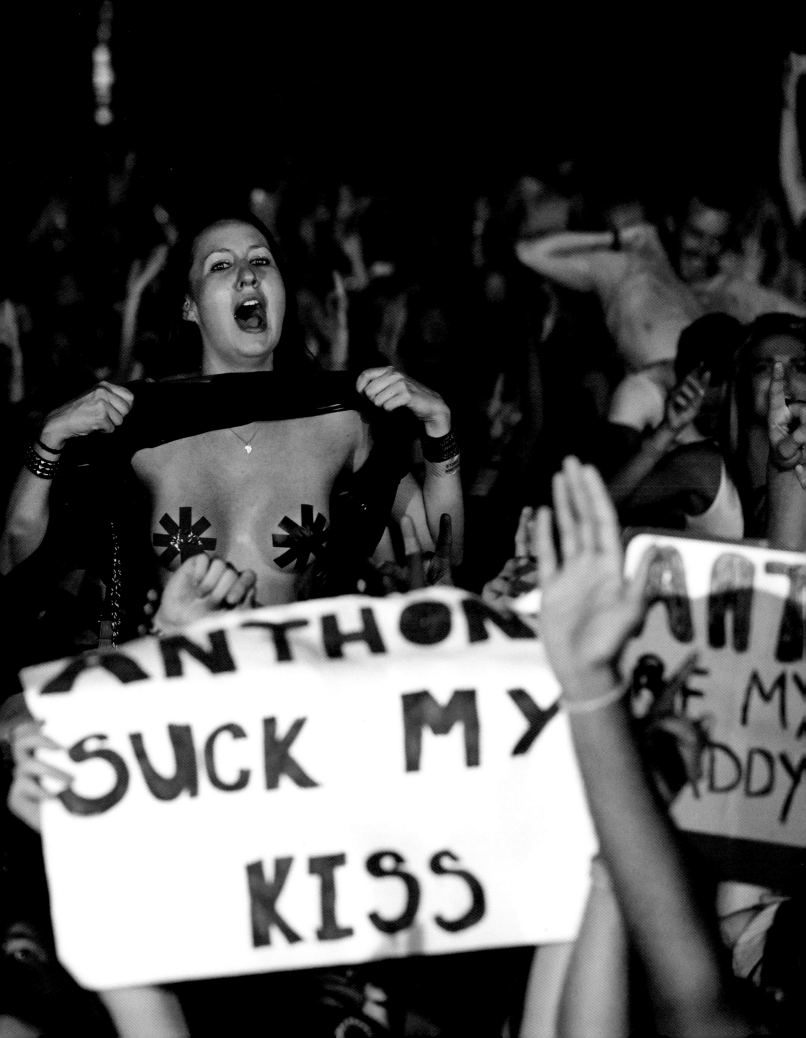

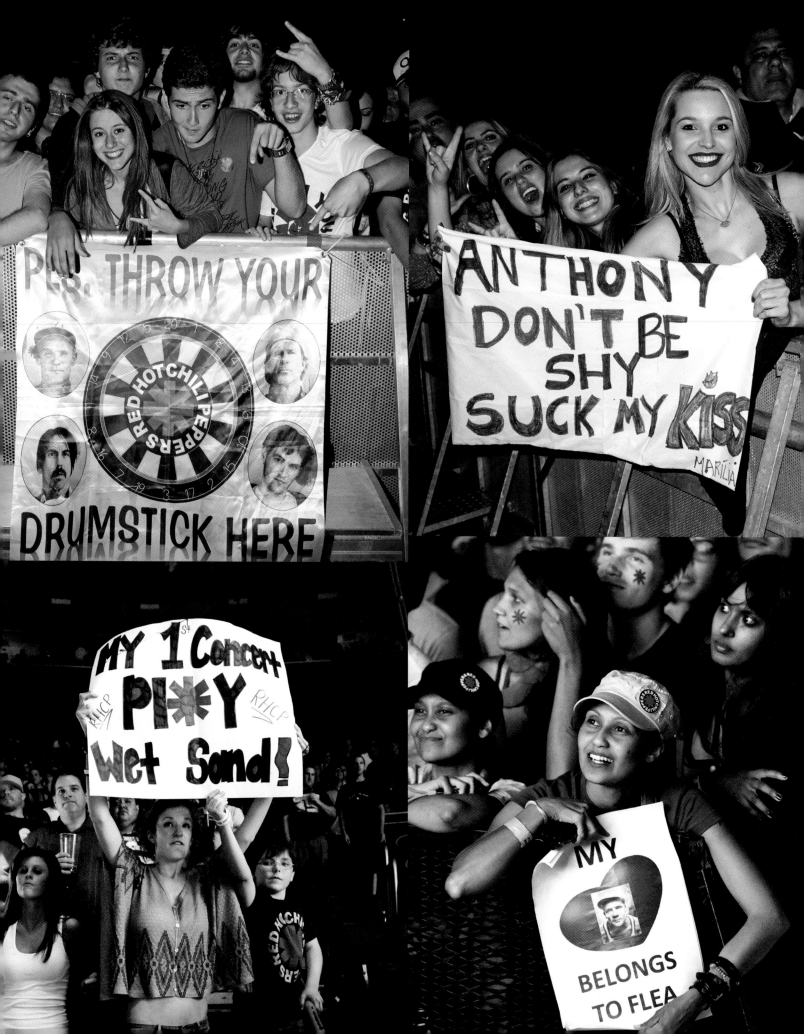

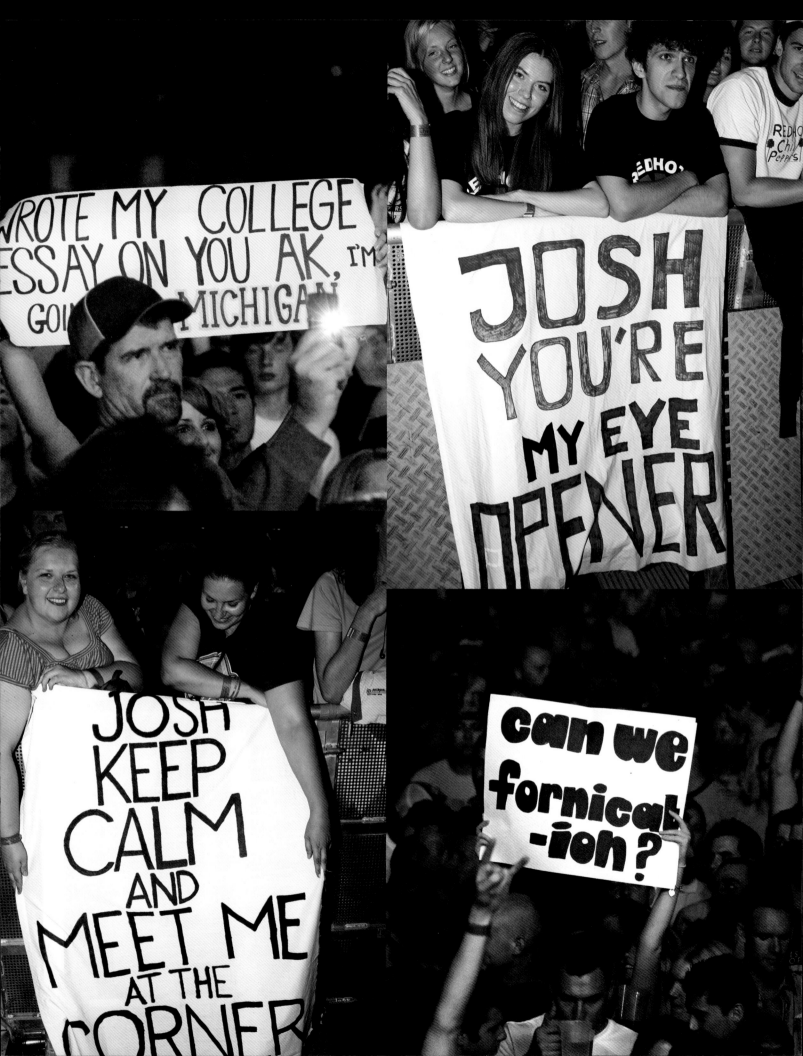

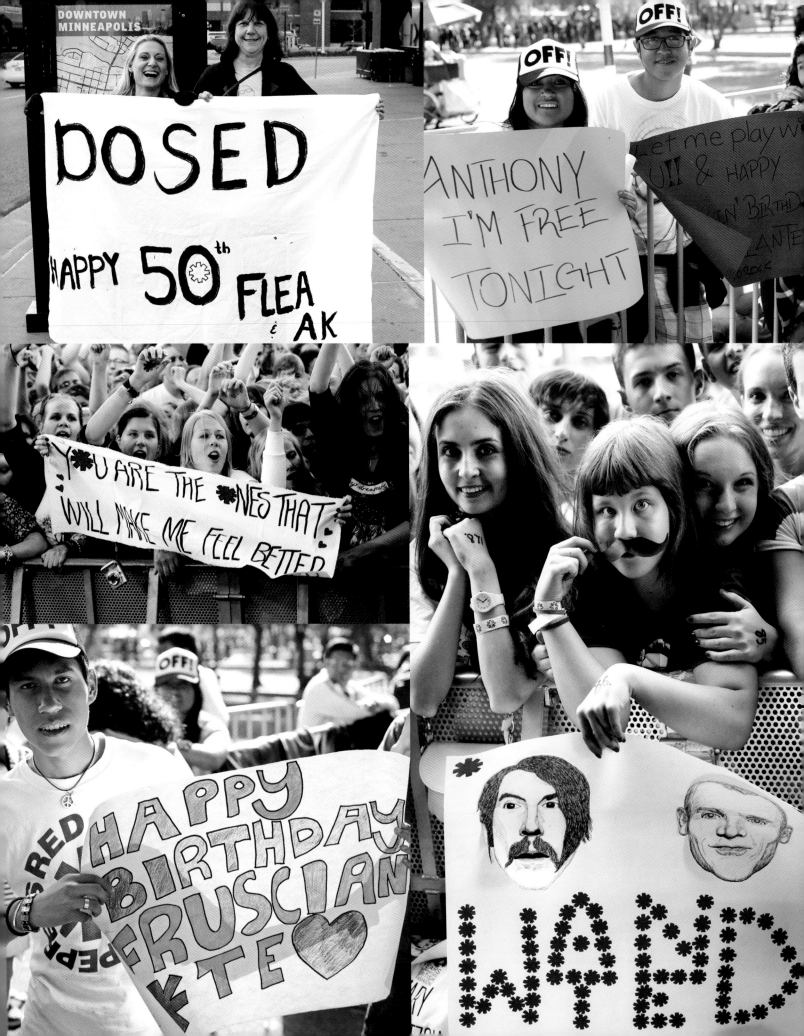

I COULD DIE 4U

RED HOT CHILI PEPPERS
10/12/11 TORINO
11/12/11 MILANO

SHOW ME UR SOUL

CHILI PEPPERS
TNX FOR MAKING
CROATIA FEEL BETTER

UKRAINE

RED HOT CHILI PEPPERS

Thank Y*U

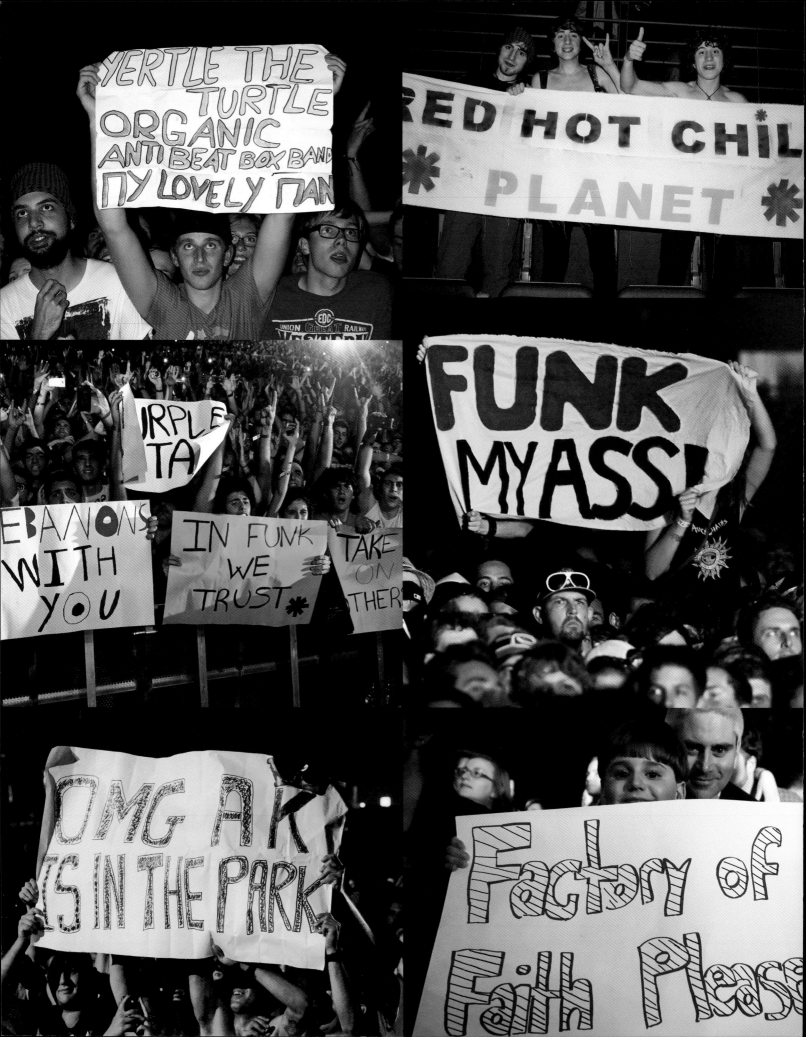

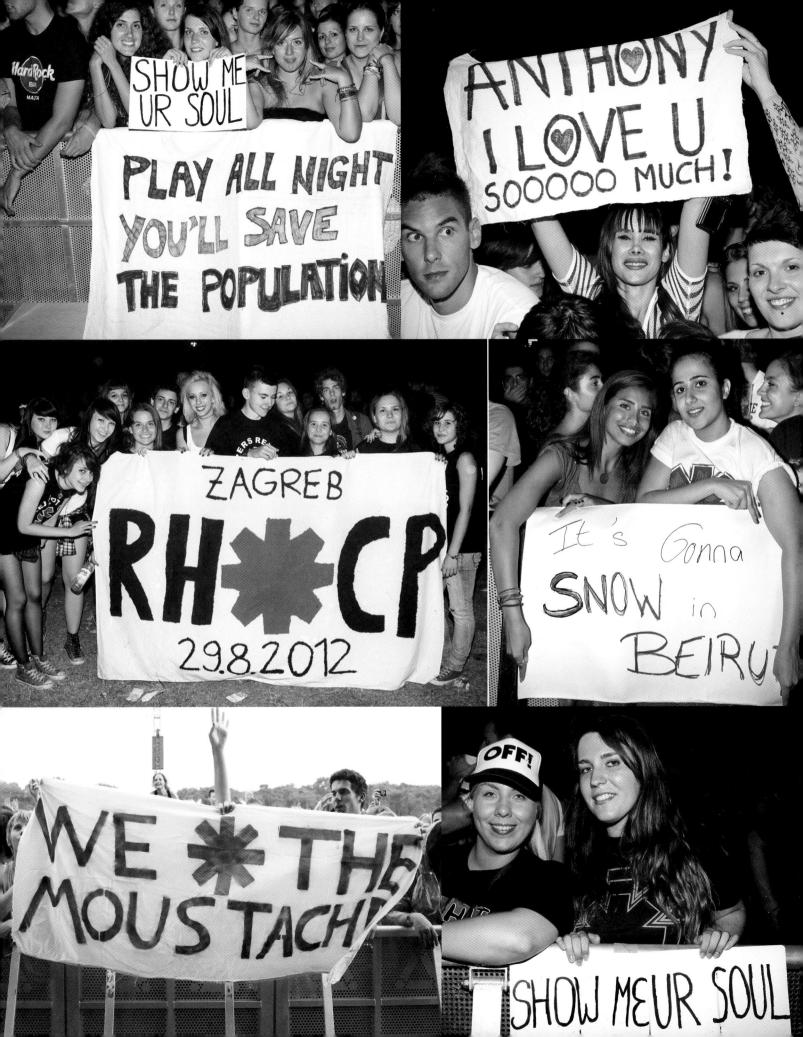

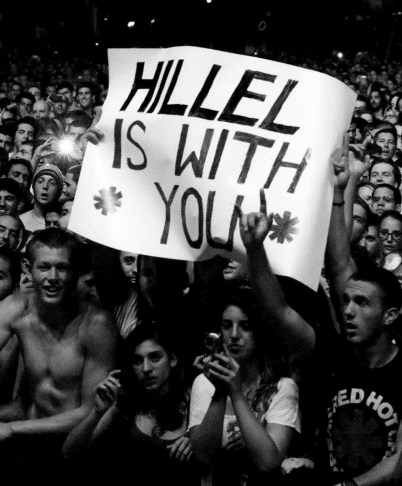

צאתכם לשלום

Go in Peace

رافقتكم السلامة

Ofek Gilboa, 25
Israel

When I listen to music I like to imagine it visually. I think I like the Chili Peppers so much because the music is so visual. I can't explain it. I listen to music and close my eyes and let my imagination go. It happens to me a lot with the Chili Peppers. It makes my creativity flow. In some way, I think that the music shows me the way. I think the Red Hot Chili Peppers is the soundtrack to my life—especially my teenage years. In Israel you must go into the army for three years at the age of eighteen. Just before I went I got my first and only tattoo. I have a RHCP sign on my back. Everybody asks me, "And what if you stop loving the band?" That's not going to happen, but if it did happen, it would remain a mark on me representing my youth. It's a scar I want to carry the rest of my life.

My RHCP collection is the biggest project of my life. I think I have the biggest collection in Israel and I am sure one of the greatest in the world.

When it started I just wanted to own all the albums but now it's like, "I must get that single because it has a different number on the back!" I know all the B-side albums and rare stuff—only me and a few crazy Chili Peppers people around the globe got them.

My favorite song is "Sir Psycho Sexy." For me, this song defines the Red Hot Chili Peppers. It's got the punk, the melody, the funkiest bass line ever, and the craziest guitar. It has the sweetest singing voice but then it goes up and down from nasty to sweet, leading up to an epic ending. The song is so full. If someone told me they wanted to know about the Red Hot Chili Peppers through one song, this would be it.

The RHCP opened my mind to music. Because of them I learned about Jimi Hendrix, the Ramones, Funkadelic, and Nirvana. I got to know new music and old music, all because of the Chili Peppers. Thank you for that, because I truly believe there is no happy life without music.

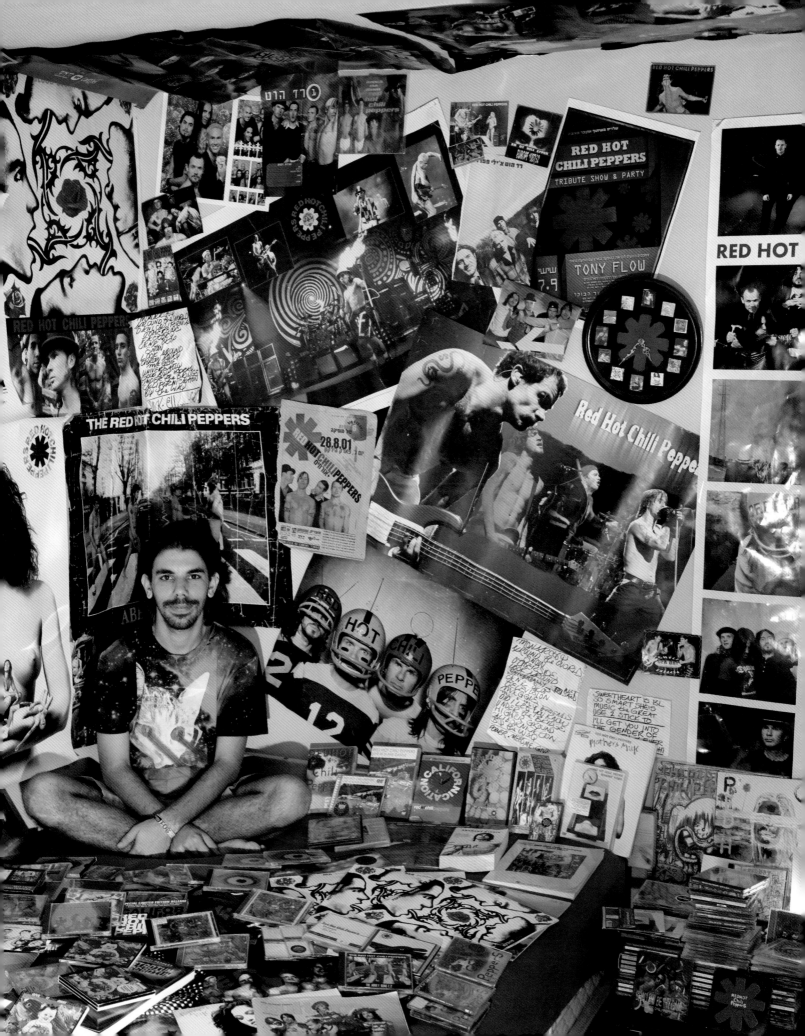

Simona Morisi, 44
Italy (Center Right)

SOME CALL IT THE PEPPERS FAMILY AND SO IT IS. FOR ME YOUR MUSIC HAS AN IMPORTANT ROLE, IT'S THE SOUNDTRACK OF MY LIFE, IT HAS MADE POSSIBLE MANY THINGS, INCLUDING THE RELATIONSHIP WITH MY HUSBAND, BUT ALSO I FOUND FRIENDS. I SHARED AND I SHARE A LOT WITH THEM, AND THROUGH THE MUSIC I HAVE LEARNED TO LOVE MYSELF AND THEREFORE LOVE OTHERS.

Heidi Tallulah Wilson, 22
United Kingdom (Right)

RHCP WERE THE FIRST OF ALL MY MUSIC EXPERIENCES: MY FIRST GIG, MY FIRST BAND T-SHIRT, MY FIRST TIME REALLY APPRECIATING MUSIC. I WAS VERY LITTLE THE FIRST TIME I SAW THEM AND COULDN'T THANK MY PARENTS ENOUGH FOR GIVING ME THE BEST START IN MY MUSICAL CHILDHOOD.

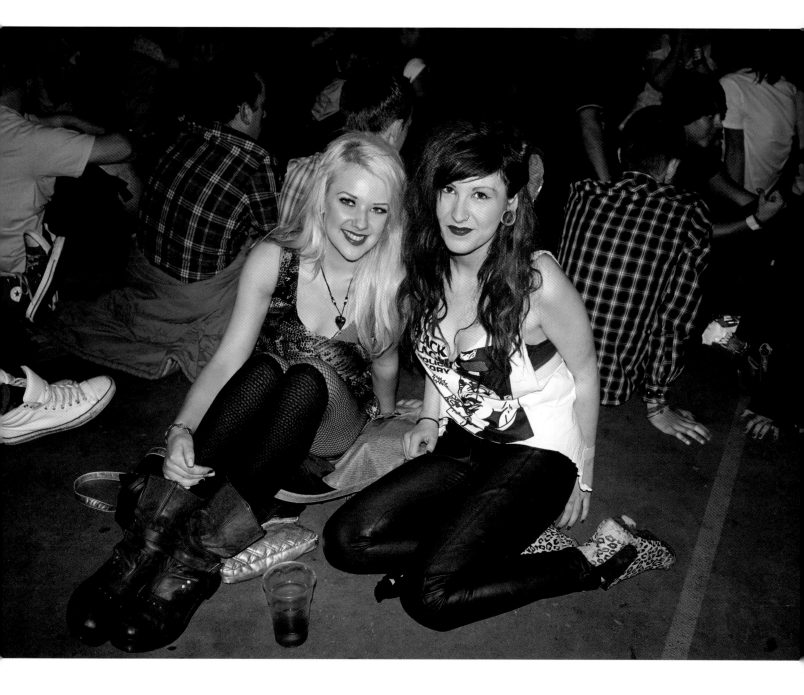

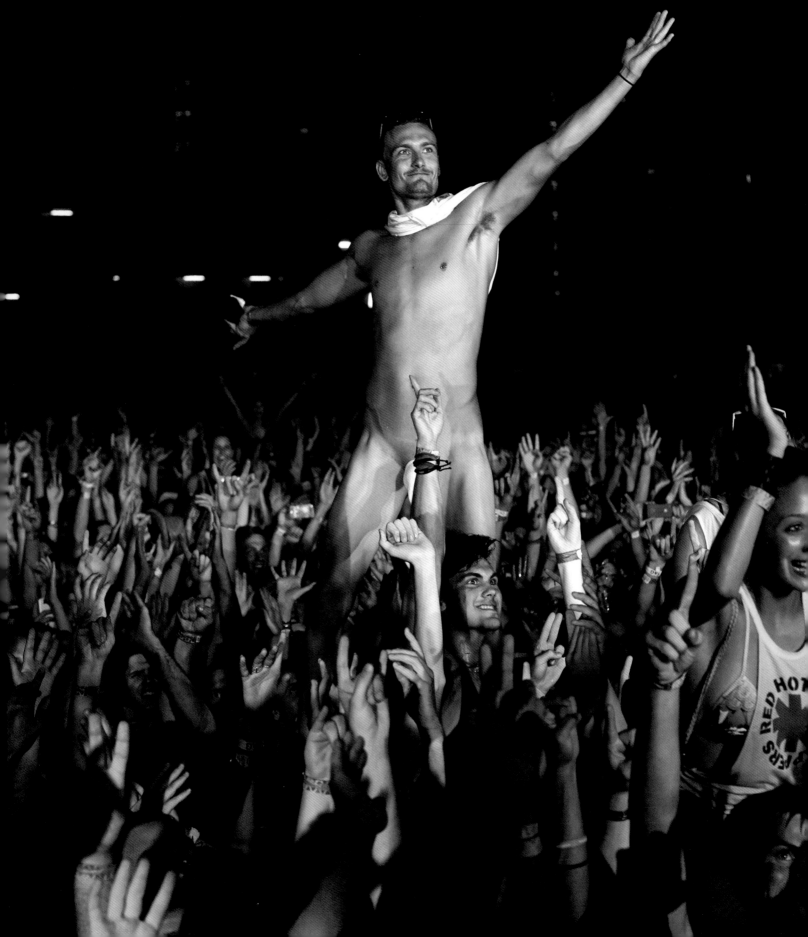

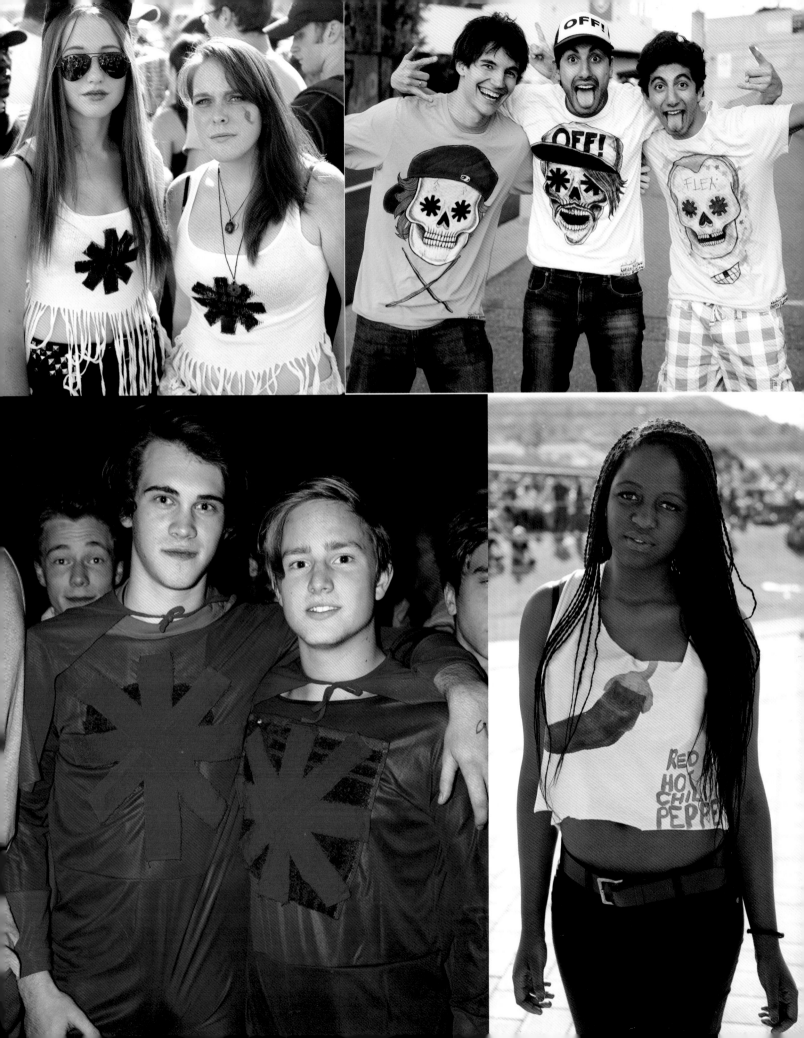

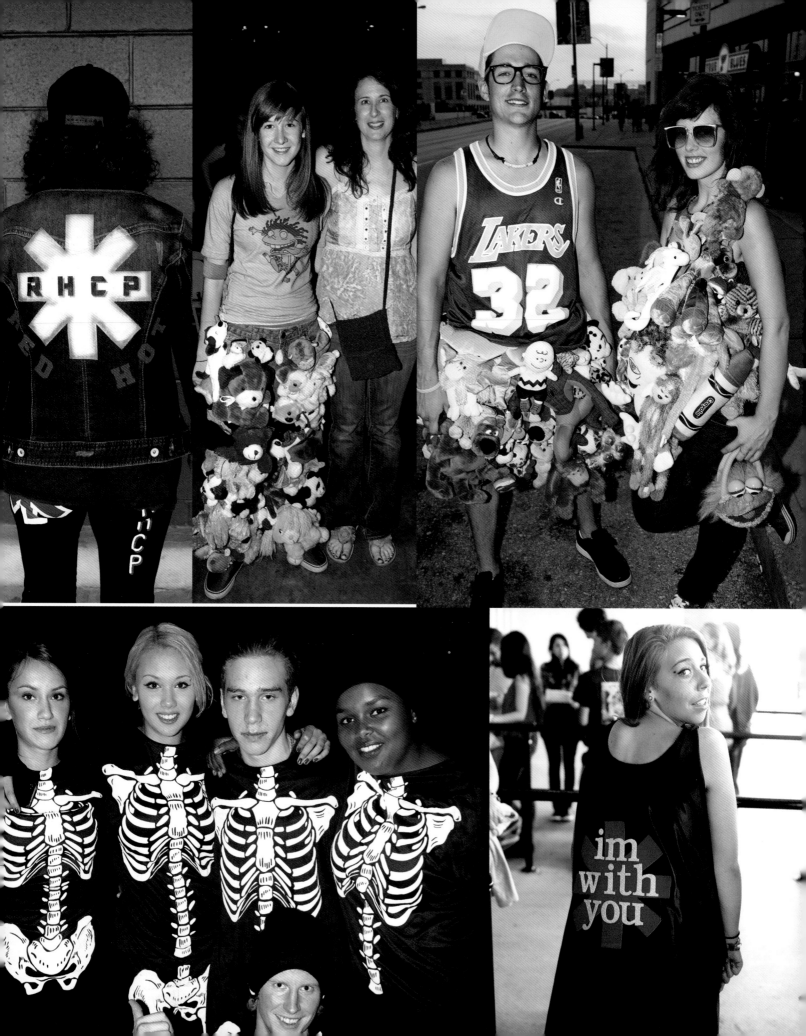

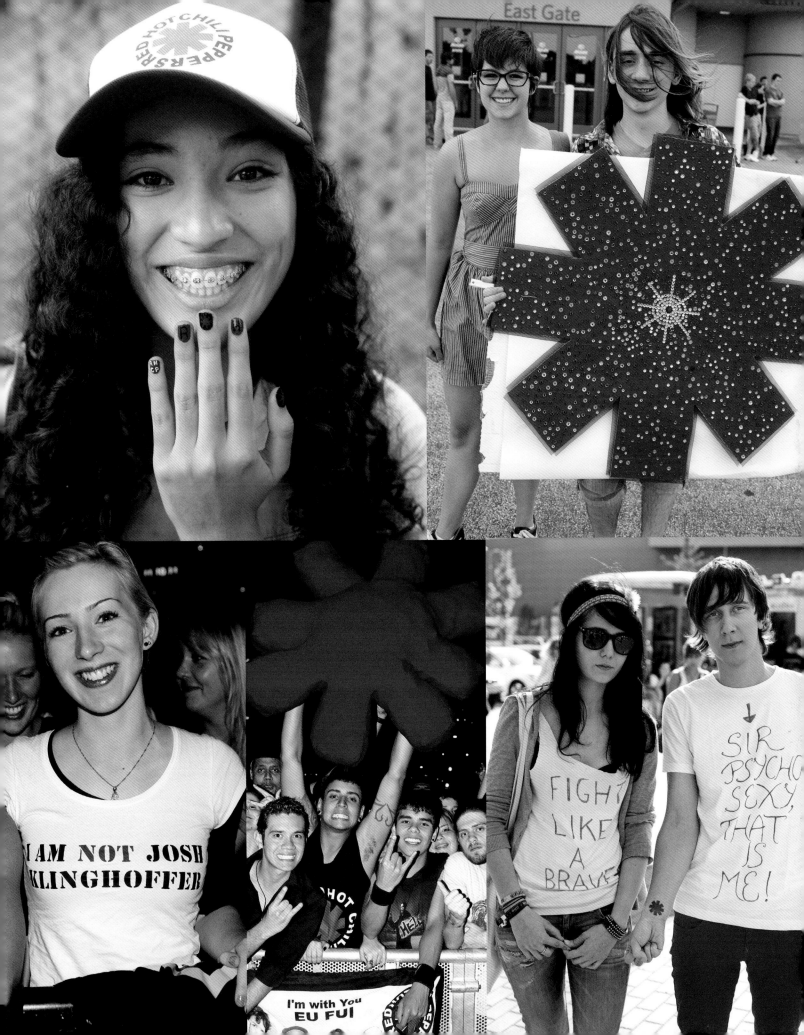

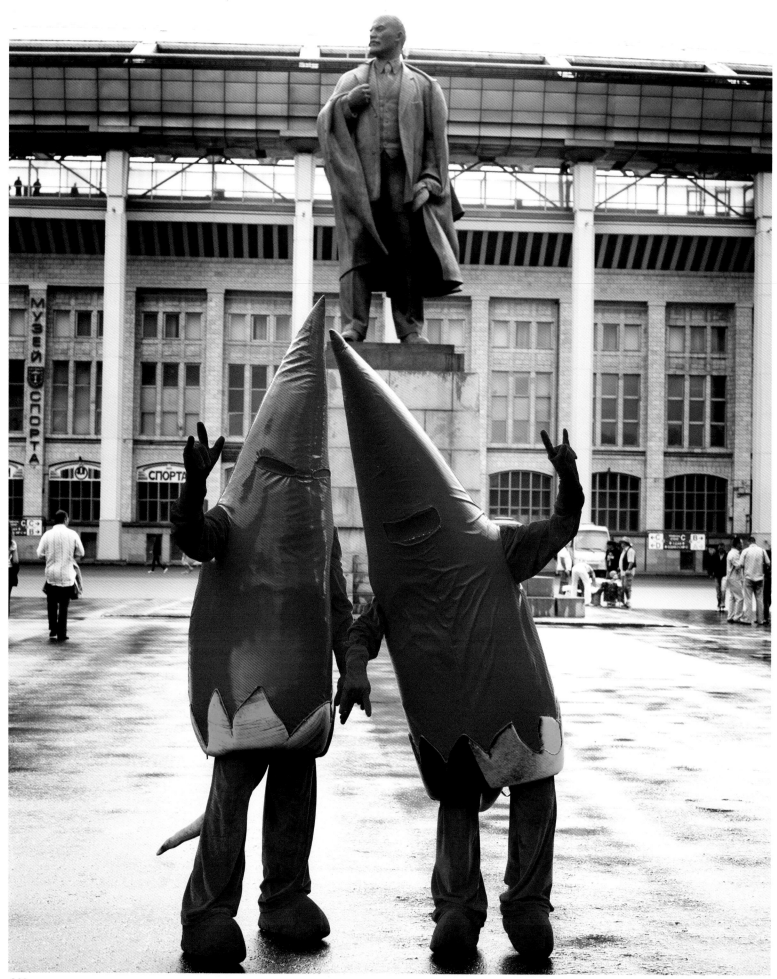

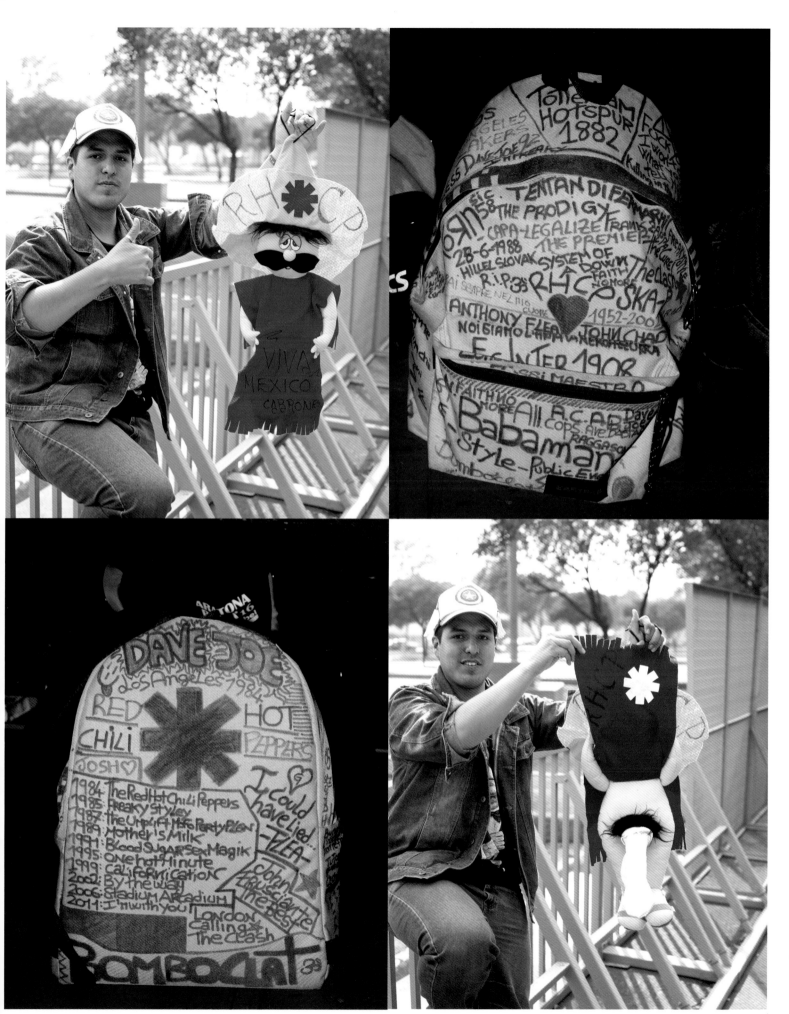

189

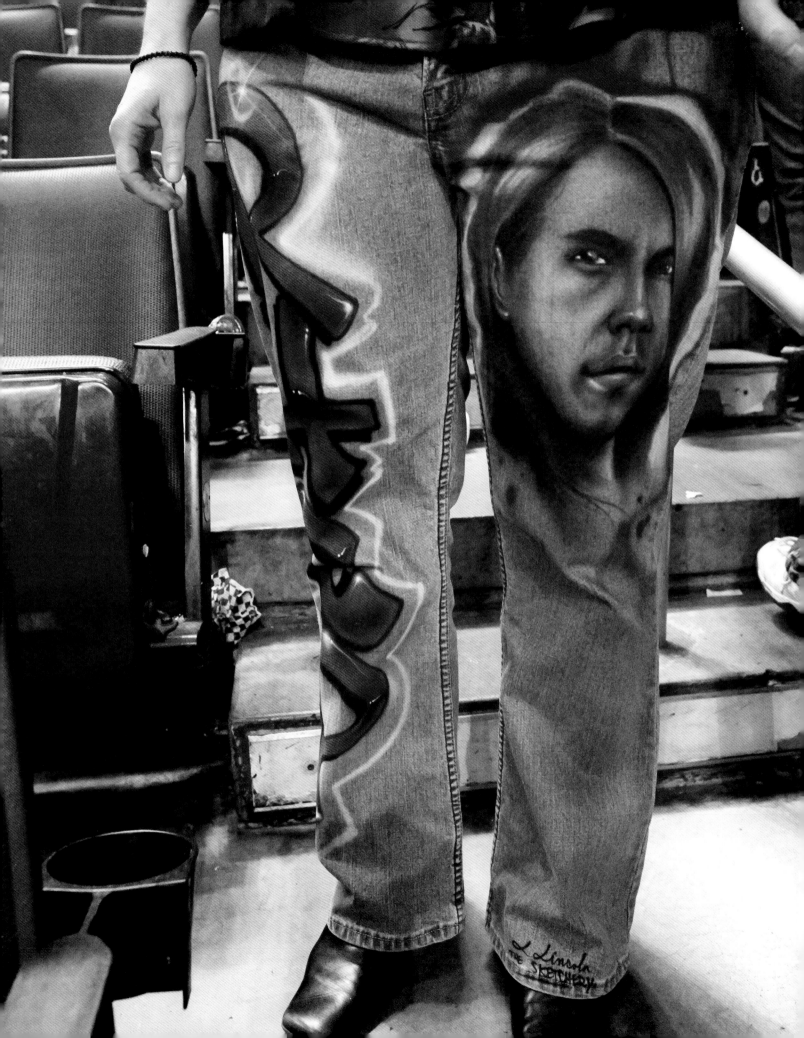

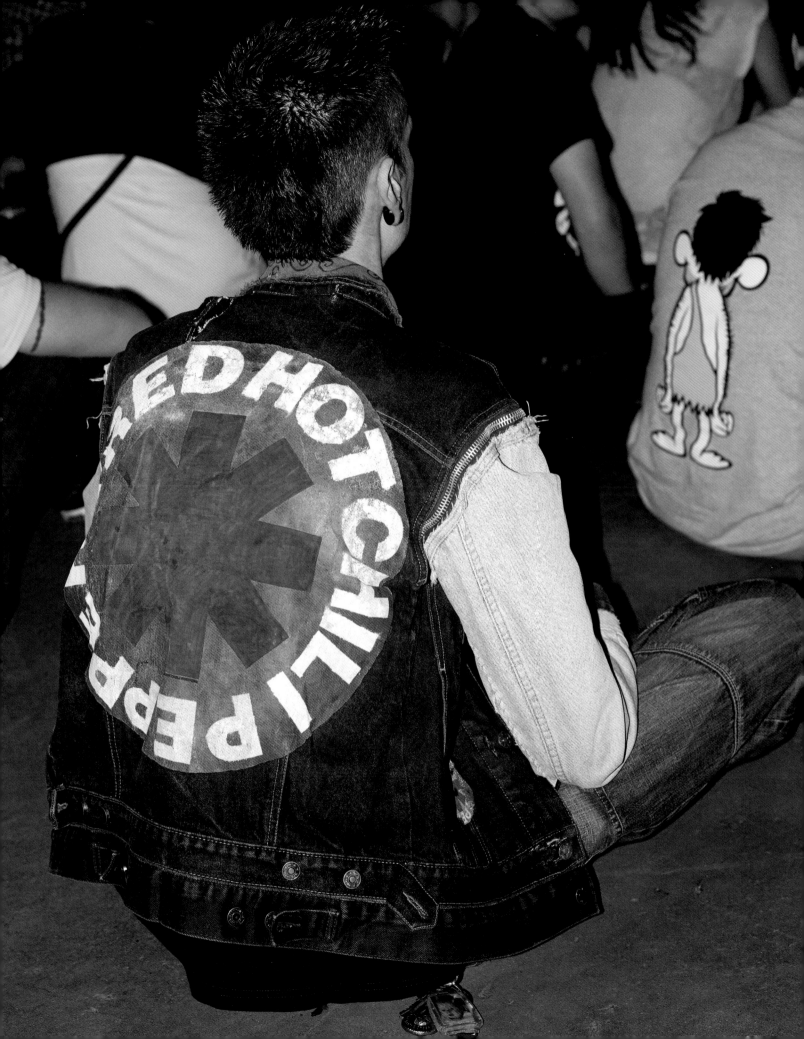

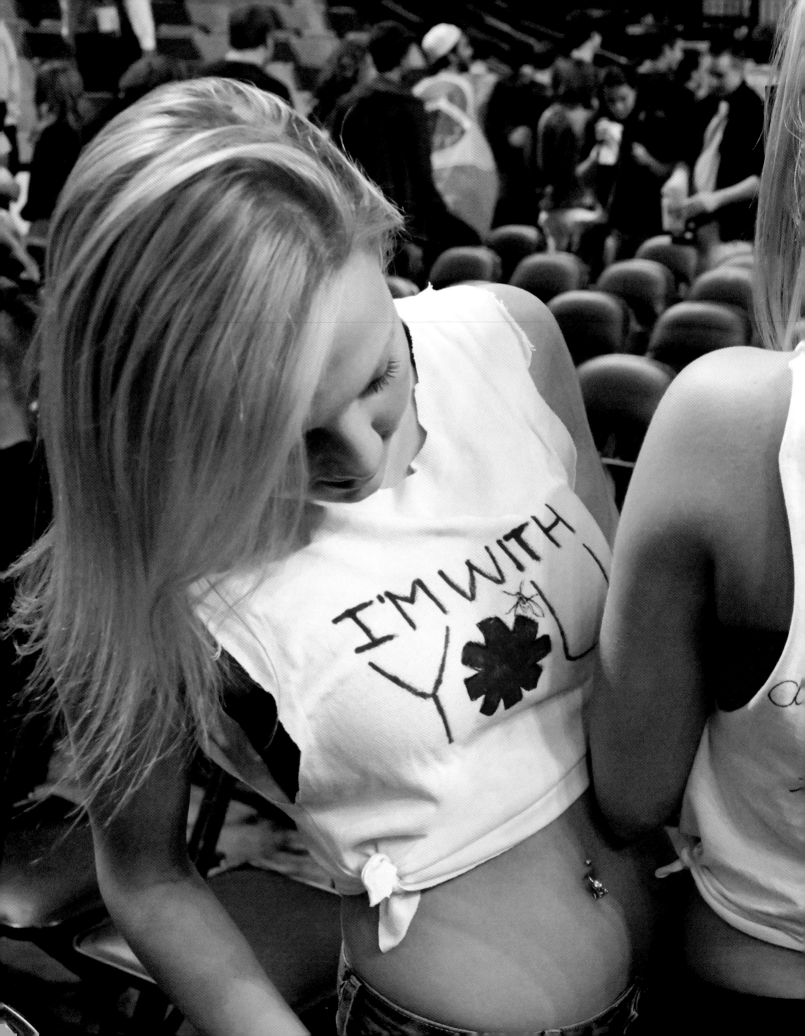

She's Only 18
...t like the Rolling Sto...
...k took a shortcut
...being fully grown

Danielle Colburn, 20
Massachusetts (Left)

It was unreal to go to my first concert ever, and have it be my favorite band! I got awesome seats and got my picture taken for the fan book in a shirt I'd made for the show. I'm a student, a philosopher, and most importantly, a nobody.

My favorite lyrics are "She's only eighteen, don't like the Rolling Stones. She took a shortcut, to being fully grown." My dream is to become a neuroscientist and to get my PhD in Philosophy.

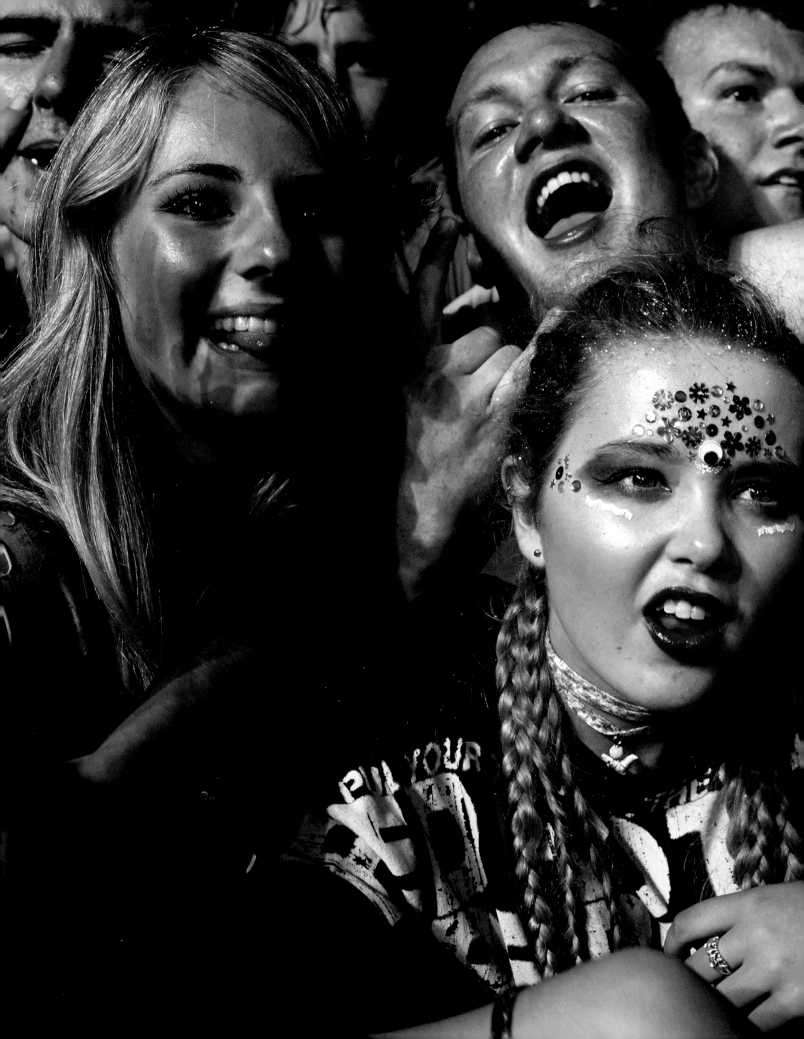

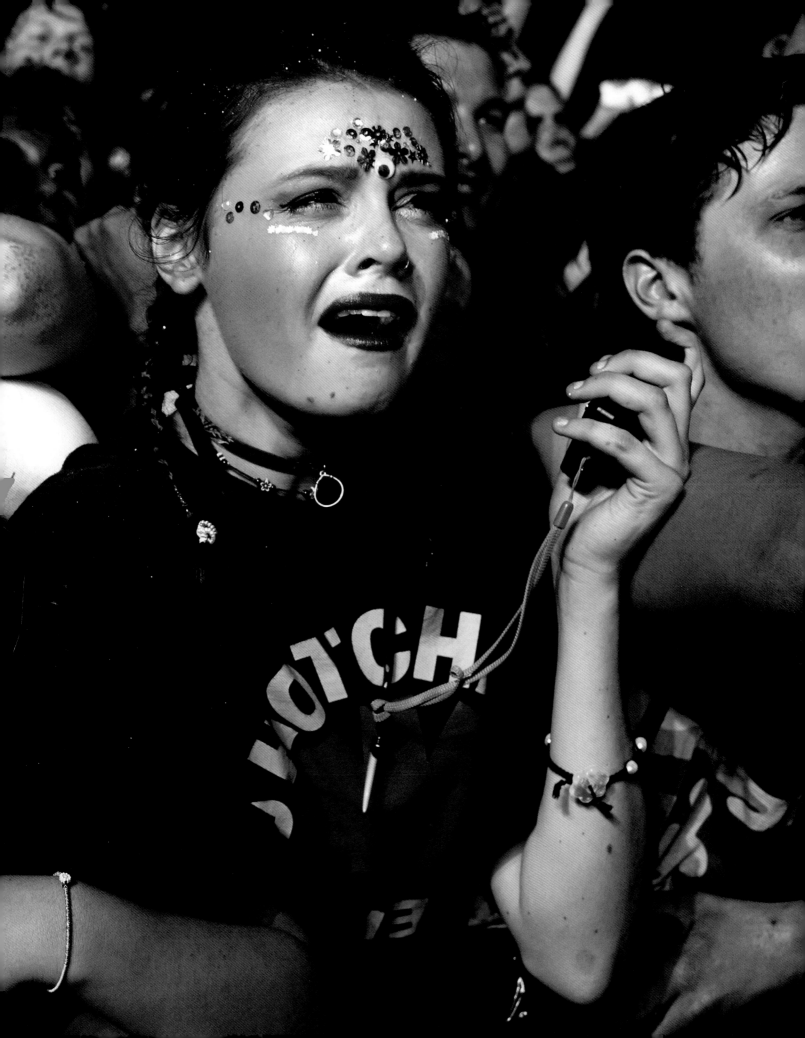

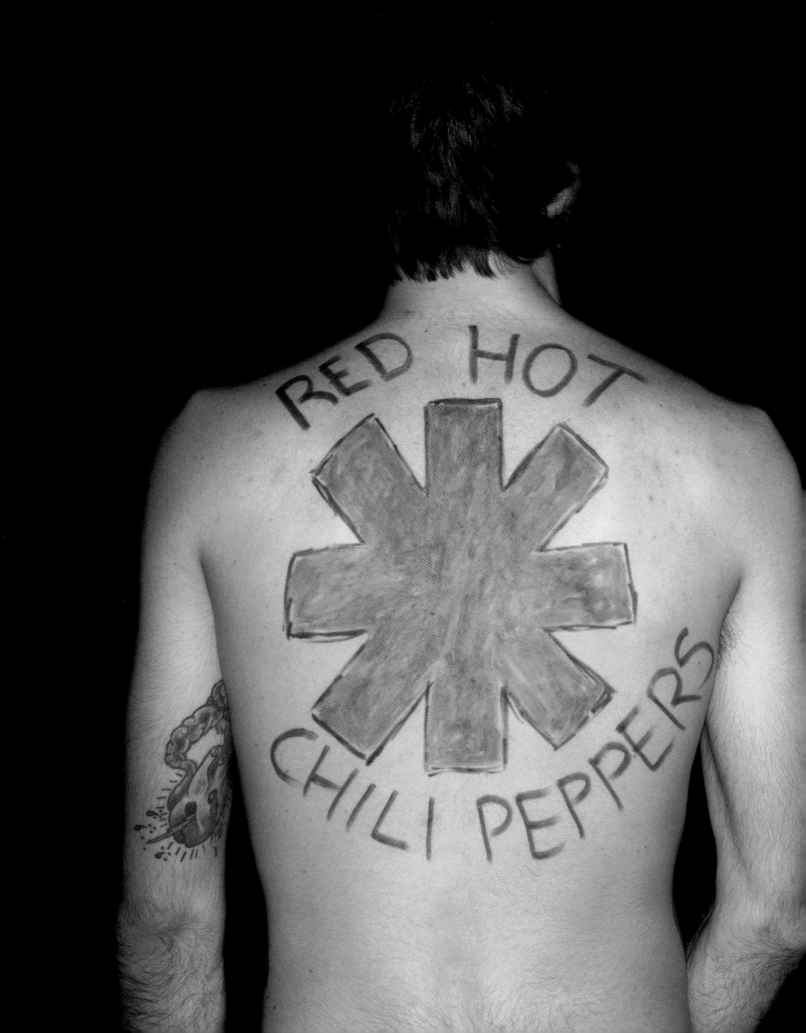

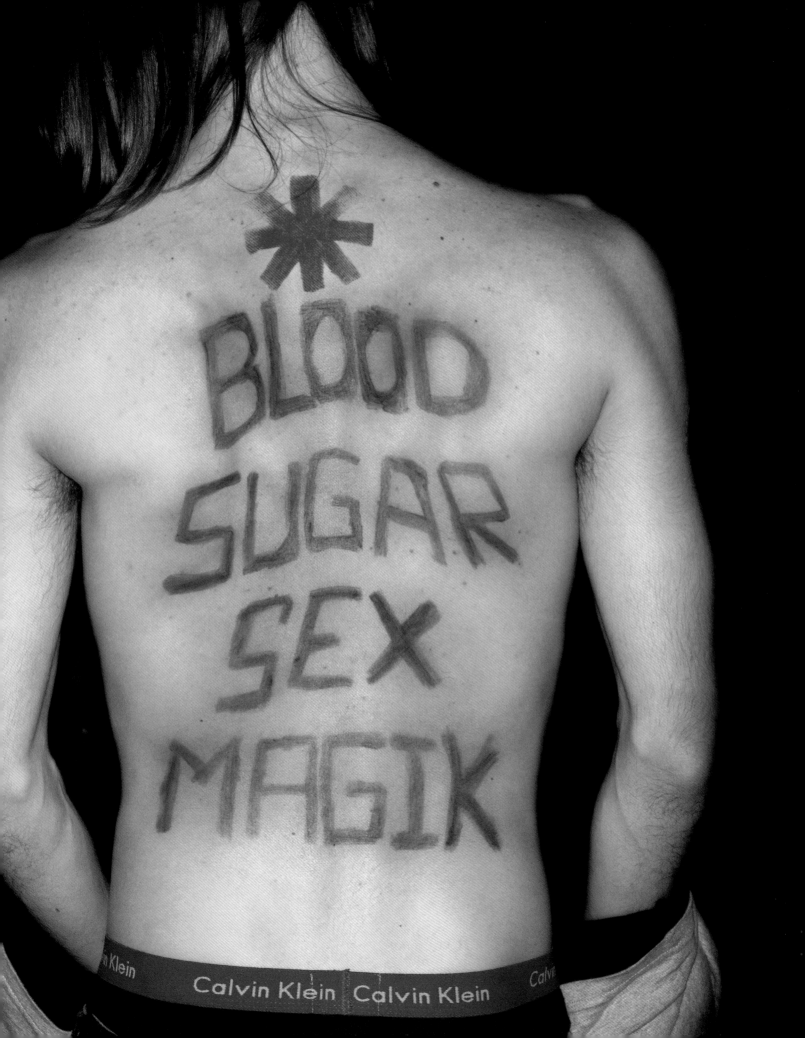

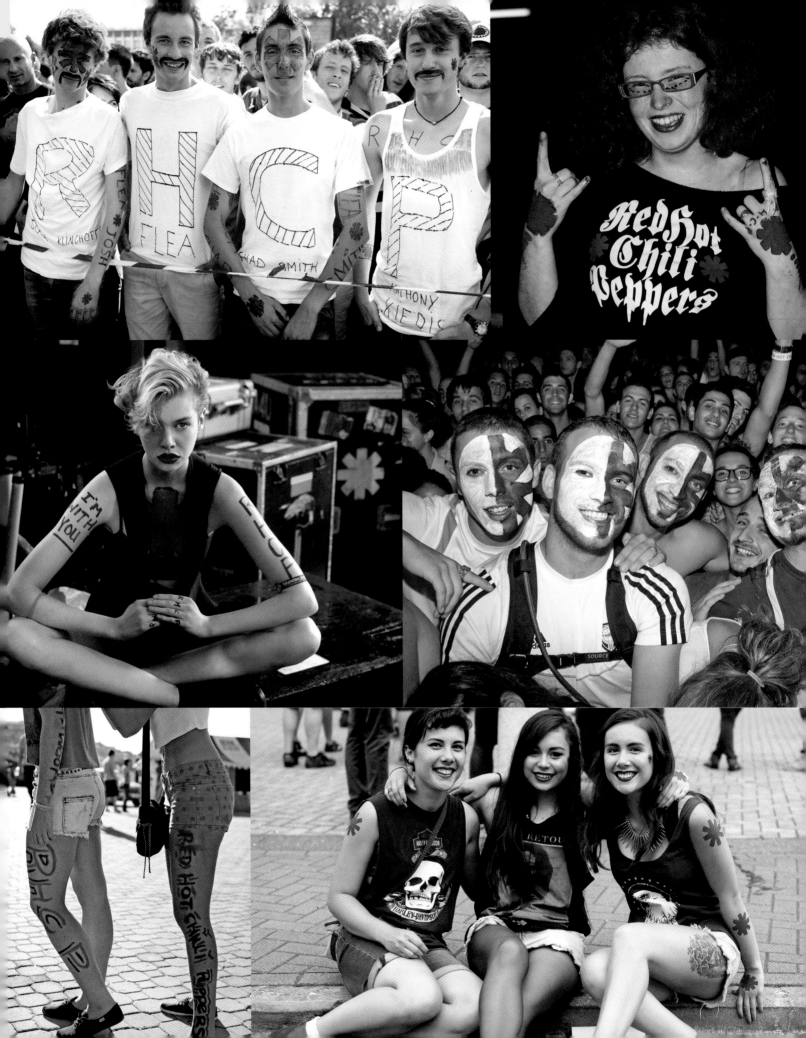

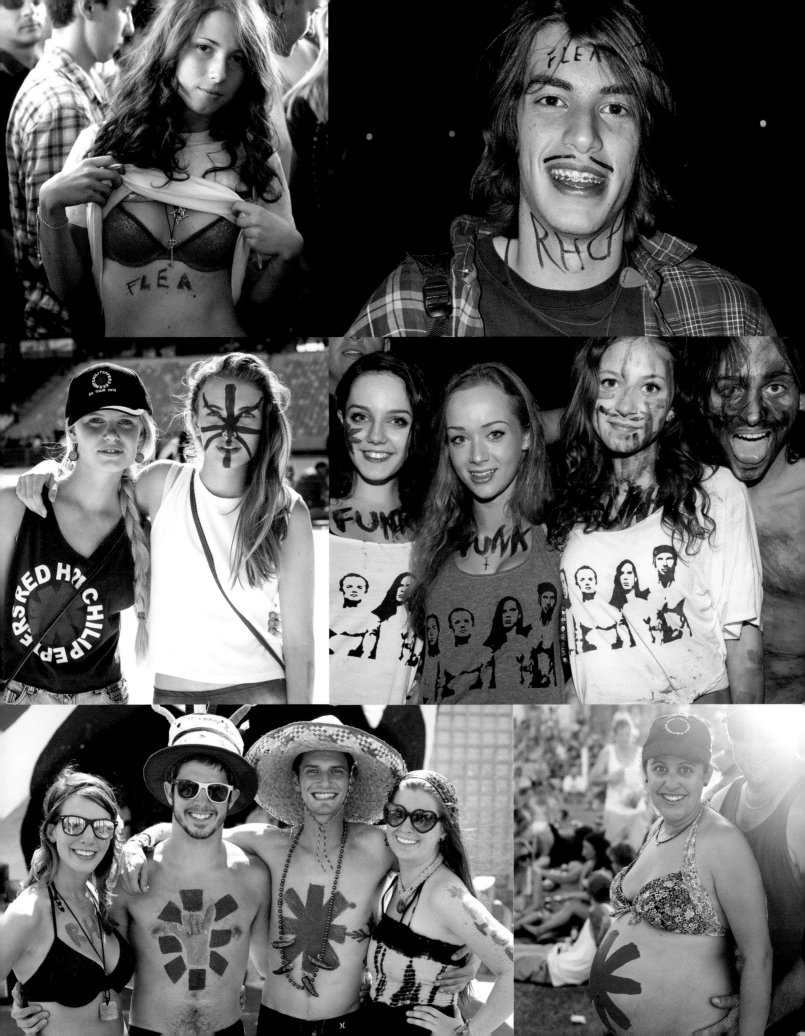

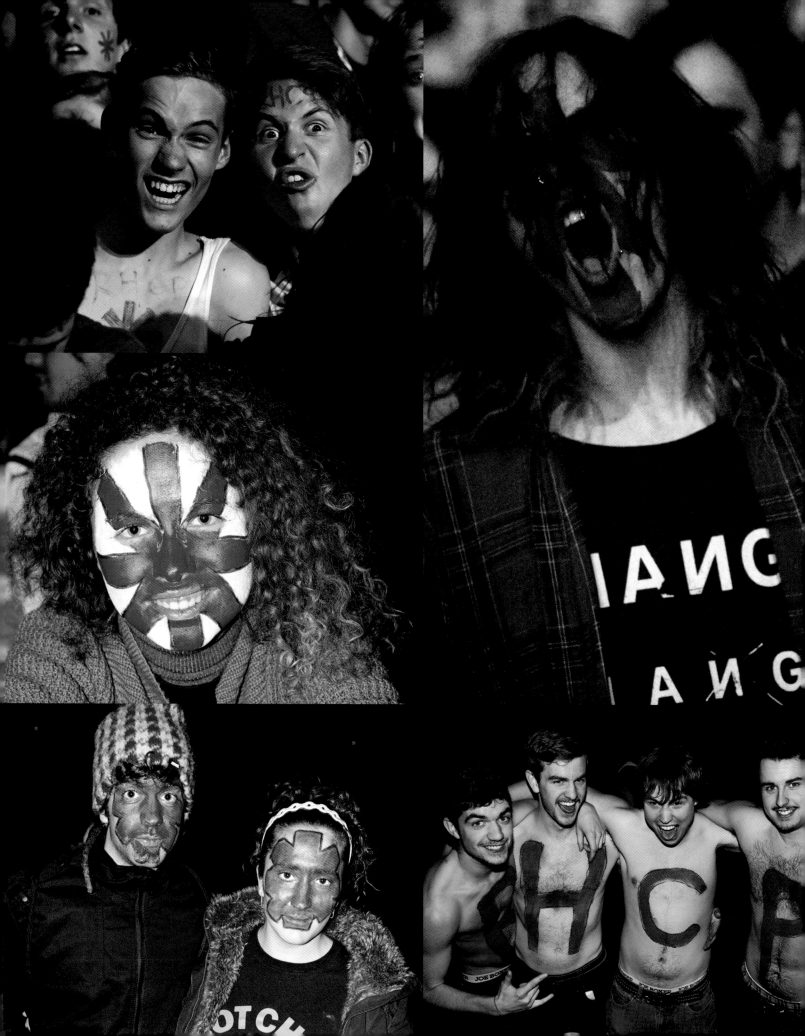

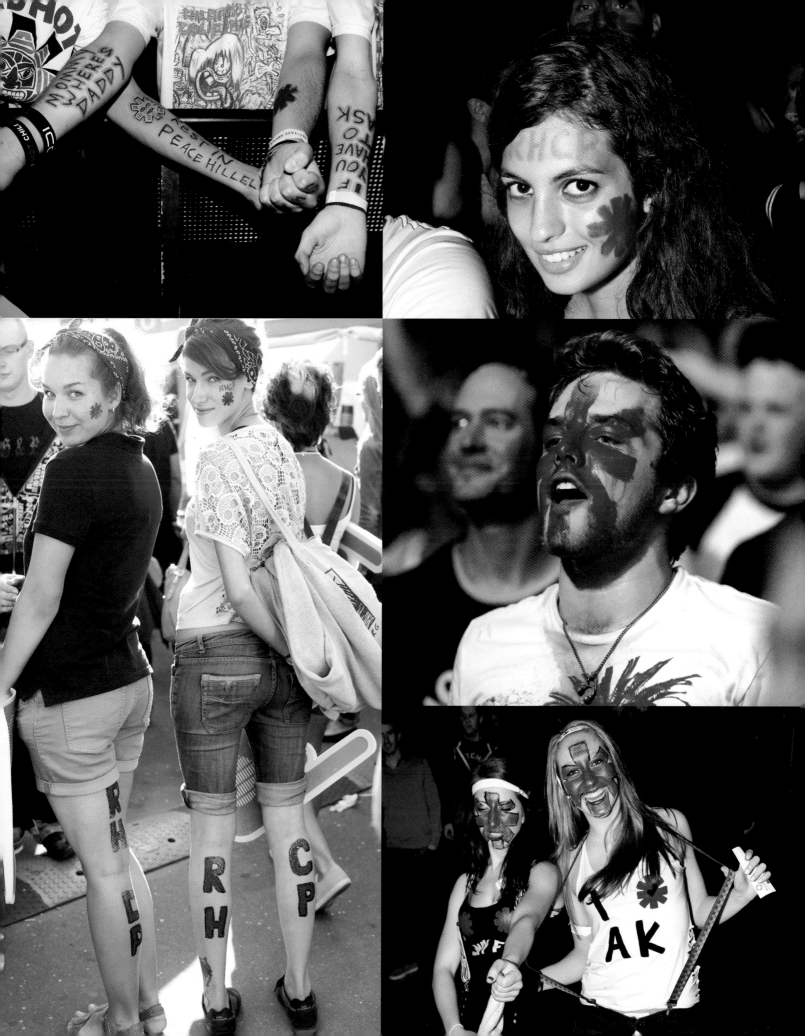

We are children going to school and try-
ing to learn to play the guitar, drums,
and bass. We learned about the Red Hot
Chili Peppers through our parents. It's
really good "car music." Freja made all
seven T-shirts. We all liked very much
Flea's entrance on stage, walking on his
hands! We hope to see RHCP in Denmark
again soon!

Sammy Jane, 16
Oregon (Center Right)

NOT ONLY DO THEY HAVE A UNIQUE SOUND WITH A FUNKY BASS AND HYPNOTIC GUITAR, THEIR LYRICS SPEAK SO MUCH TRUTH IN SUCH A METAPHORICAL, HONEST, AND DEEP WAY. THEIR SOUND IS SO EUPHORIC.

I AM AN ARTIST. I HAVE HIP DYSPLASIA AND SEVERE RETROVERSION, WHICH STOPS ME FROM DOING LOTS OF THINGS, SO I DEDICATE MY TIME TO ART. SOMEDAY I WANT TO GET NOTICED FOR MY ART. NOT BECAUSE I WANT FAME, BUT I WANT PEOPLE TO DISCOVER THE TRUTHS HIDDEN IN MY ART, JUST LIKE RHCP DOES WITH THEIR MUSIC.

I LOVE ALL THE BAND'S SONGS. EACH SONG IS A PIECE OF MAGIC. I WOULD HAVE TO SAY MY FAVORITE LYRICS COME FROM "STADIUM ARCADIUM": "TEDIOUS WEEDS THAT THE MEDIA BREEDS BUT THE ANIMAL GETS WHAT THE ANIMAL NEEDS AND I'M SORRY." TRUEST LYRIC OF TODAY'S WORLD I'VE EVER HEARD.

SOMEDAY I WANT TO BE ABLE TO RUN WITH NO PAIN. I WANT TO HELP PEOPLE IN SOME WAY. I ALSO WANT TO SHOW PEOPLE THE REAL BEAUTY OF ANIMALS THROUGH MY ART. OH, AND I WANT TO MEET FLEA!

WHAT I'VE LEARNED FROM RHCP, ART, AND MANY OTHER THINGS IS WHERE TRUE HAPPINESS COMES FROM. HAPPINESS COMES FROM LOVE, EXPERIENCES, AND ALL OTHER PURE AND TRUTHFUL THINGS.

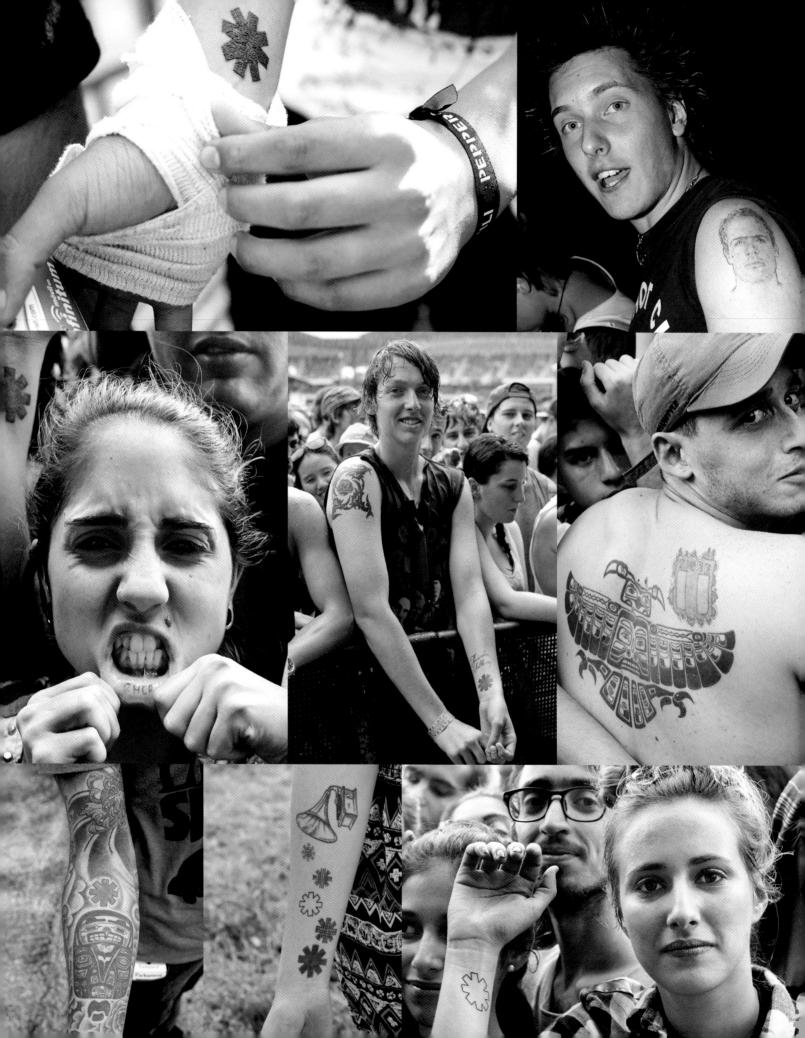

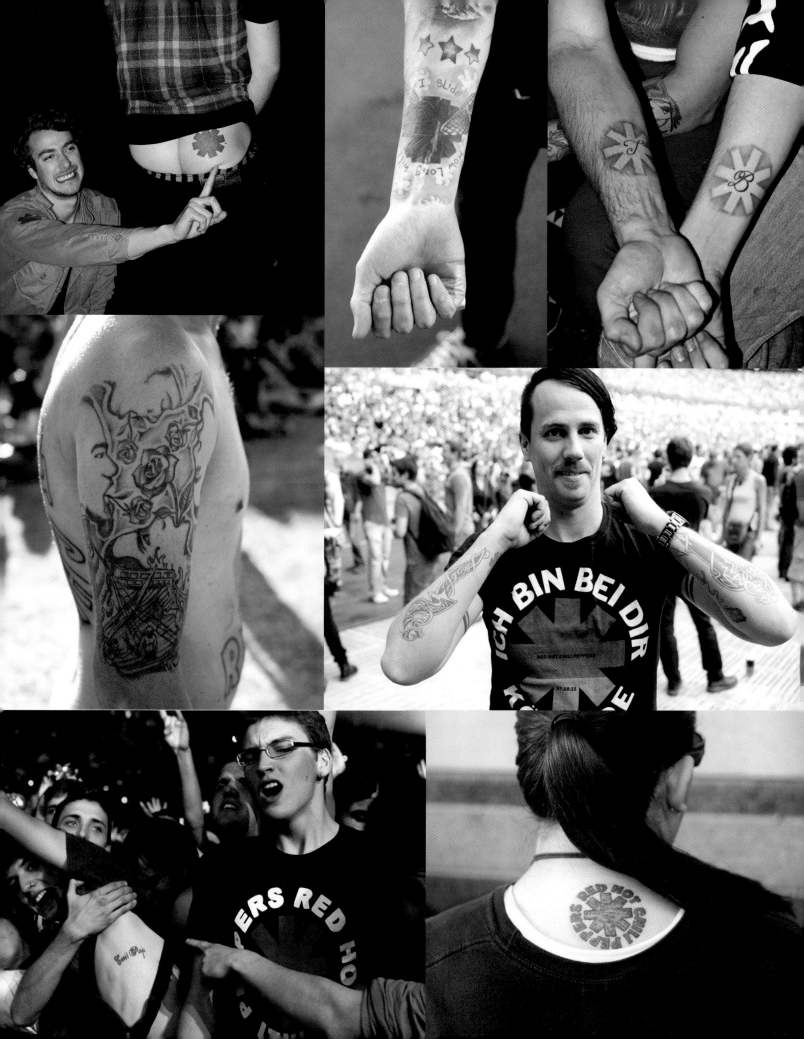

Claire Helen Popple, 40
United Kingdom

MY MOST MEMORABLE RHCP EXPERIENCE WAS WHEN I WENT TO PRIDE PARK DERBY IN 2006. LOOKING FOR THE TOILETS, MY FRIEND AND I WENT DOWN A LONG CORRIDOR AND FOUND OURSELVES LOOKING THROUGH THE WINDOW OF A DOOR AND SUDDENLY ANTHONY CAME RUNNING UP,,,, IT HAD BEEN MY DREAM TO ASK ANTHONY TO AUTOGRAPH MY ARM NEXT TO MY CHILI ASTERISK.

WE HID BEHIND A TOUR BUS AND WAITED FOR A WHILE. THEN WE GOT CHATTING TO SOME ROADIES AND SAID HOW MUCH WE WANTED TO MEET THE BAND. THEN ONE OF THEM POINTED OVER TO A BIG BLACK CAR AND THERE WAS ANTHONY. I TOOK A DEEP BREATH AND WENT OVER TO HIM. I INTRODUCED MYSELF AND SAID HOW MUCH I HAD ENJOYED THE SHOW AND EXPLAINED THAT I WANTED HIS AUTOGRAPH TATTOOED ON MY ARM. HE ASKED ME IF I WAS SURE ABOUT THIS AND I SAID IT WAS MY DREAM, SO HE DID! I WAS SHAKING, DISBELIEVING THIS WAS REALLY HAPPENING. HE WAS SO LOVELY AND HE REALLY SPENT TIME DOING IT CAREFULLY. HE COULD HAVE JUST SCRIBBLED IT, BUT IT WAS SO BEAUTIFULLY WRITTEN. THEN I ASKED HIM FOR A HUG, WHICH HE OBLIGED. I SKIPPED OFF SO MERRILY, LIKE A CHILD, THE NEXT DAY I DROVE STRAIGHT TO THE TATTOO PARLOR TO COMPLETE THE MISSION. TO THIS DAY, I CANNOT BELIEVE IT HAPPENED. I AM SO THRILLED TO HAVE THIS MEMORY ON ME FOREVER. NOW MY DREAM IS TO HAVE THE REST OF THE BAND'S AUTOGRAPHS TATTOOED AROUND MY ASTERISK!

I LOVE THE EXCITEMENT OF ORGANIZING A TRIP TO SEE THE CHILI PEPPERS. THE FUN WE HAVE, THE PLACES WE VISIT, THE LAUGHTER AND THE NEW EXPERIENCES WE SHARE TOGETHER. THE MUSIC HAS HELPED ME SO MUCH AND COMFORTED ME THROUGH SOME BAD TIMES. I HONESTLY CAN'T IMAGINE MY LIFE WITHOUT THE RED HOT CHILI PEPPERS.

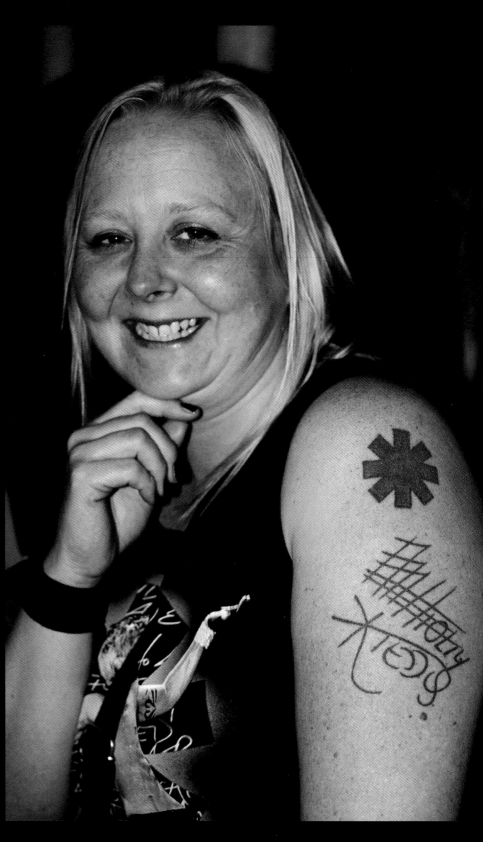

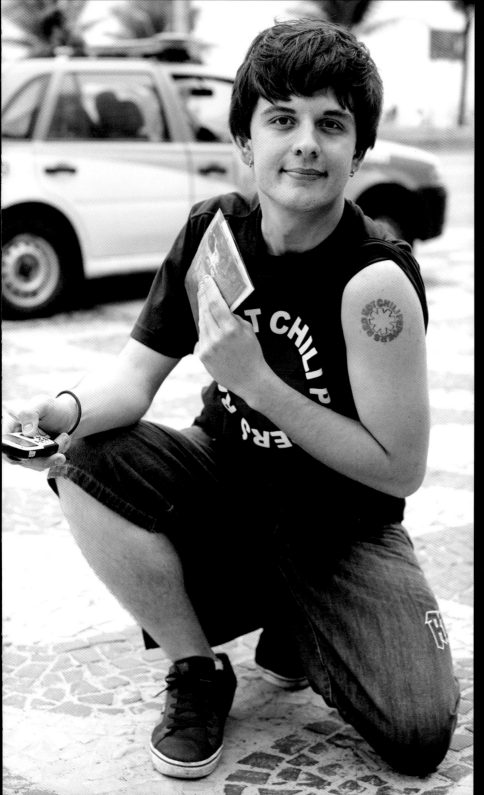

Daniel David, 22
Brazil

I traveled to São Paulo to see them perform. I immediately got on a bus and went to the hotel where the band was staying, hoping see Anthony, Flea, Chad, and Josh. At the very moment I arrived I saw Anthony walking on the other side of the street. I remember when I saw him, I felt as if I'd lost my vision completely and tears took a hold of me. I asked myself, "So is it real? These guys really exist and Anthony is right there?" I just let the tears flow. It was a wonderful sensation.

Flea came out of the hotel and met the fans. For me, everything was just a beautiful dream and I could wake up at anytime. Suddenly I extended my left arm towards Flea and I ask him to autograph my biceps. It was like an injection of happiness applied directly into my veins. Immediately after he autographed my arm, I got into a taxi and went looking for a tattoo parlor. I didn't think twice. Later that night I went to the show with my two autographed CDs and my new tattoo.

If I could say in one sentence what the Red Hot Chili Peppers mean in my life, I'd say it's something that makes me feel good. It simply makes me feel good. It's pure, true, and sincere love.

To the band: I would like to say that the music you do reaches people's hearts. Never stop doing what you do.

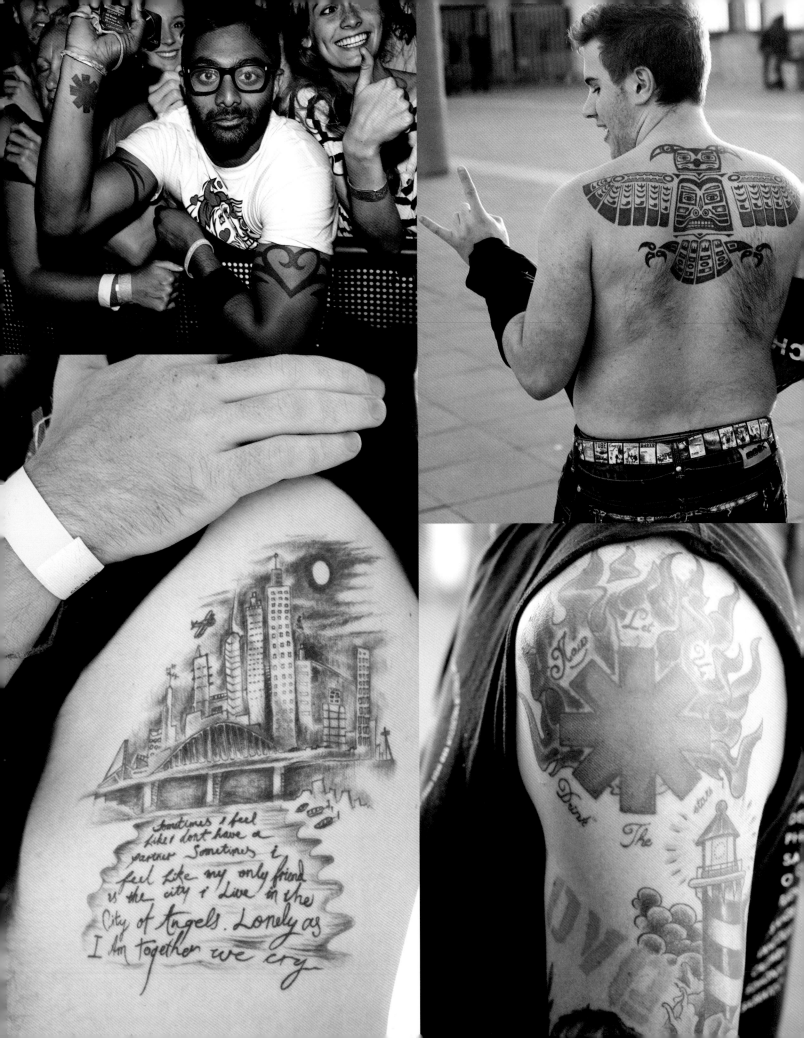

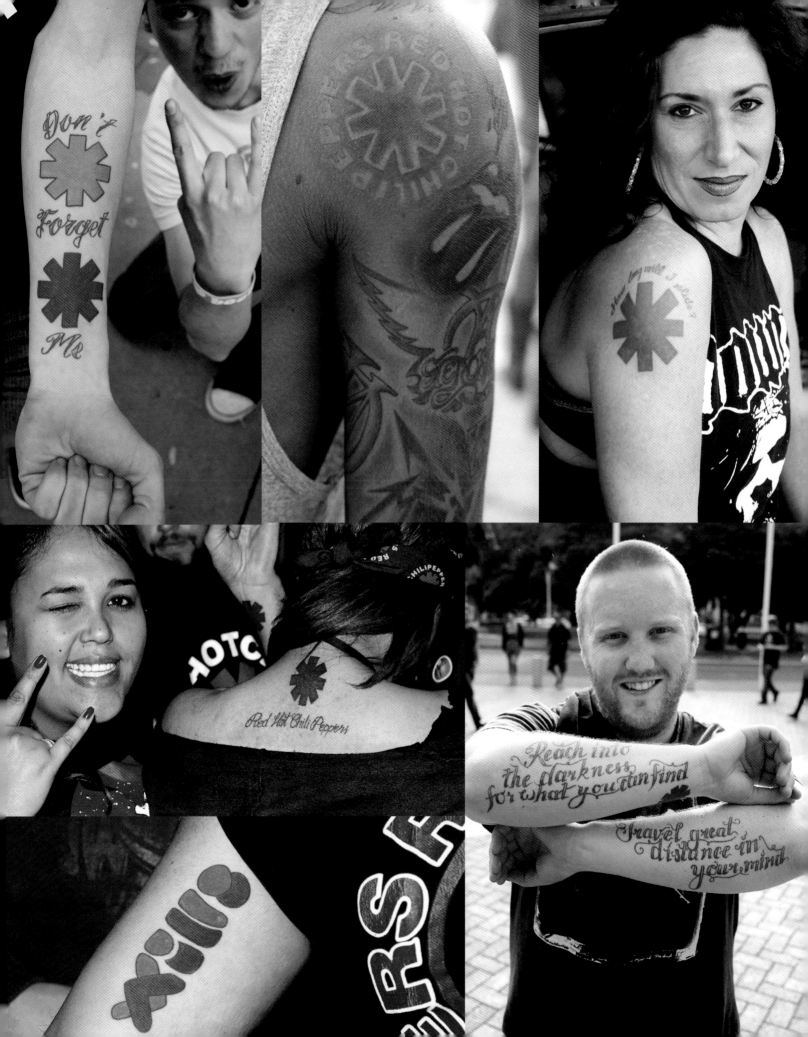

Allesandro Cunia, 31
Italy

I HAVE SEEN THE RED HOT CHILI PEPPERS LIVE FIFTEEN TIMES SO I HAVE MANY MEMORIES: AT THE HEINEKEN *JAMMIN' FESTIVAL* I GOT A DRUMSTICK FROM CHAD SMITH. I GOT JOHN FRUSCIANTE'S GUITAR PIC IN BOLOGNA. IN MILAN IN 2006 I TOOK HOME A SET LIST FROM THE CONCERT AND GOT TO MEET JOHN FRUSCIANTE. HE SIGNED MY T-SHIRT AND TOOK A PICTURE WITH ME. I SHOWED HIM MY RHCP TATTOOS AND WHEN I SHOWED HIM THE ONE ON MY BACK LIKE ANTHONY'S HE SCREAMED "OH MY GOD!" AND WE LAUGHED TOGETHER! IT WAS FANTASTIC. IF I COULD STOP TIME I WOULD HAVE FOREVER REMAINED WITH JOHN IN THAT MOMENT.

THEN IN 2007, WHEN THE RHCP PLAYED AT UDINE, ITALY, I WON A CONTEST FROM THE BAND'S OFFICIAL WEBSITE AND GOT TO GO ON STAGE! THAT NIGHT I MET TRACY ROBAR, THE BASS TECHNICIAN. I SHOWED HIM MY TATTOOS AND SHARED SOME OF MY RHCP EXPERIENCES, AND AT THE END OF THE CONCERT TRACY GAVE ME THE MOST AMAZING GIFT: THE BASS STRINGS USED BY FLEA DURING THE CONCERT! EVERY TIME I SEE THE BASS STRINGS, IT STILL SEEMS UNBELIEVABLE.

I WOULDN'T SELL THEM FOR ALL THE GOLD IN THE WORLD! IN NOVEMBER 2011, WHEN THE RHCP CAME TO LONDON, I MET CHAD SMITH AND LATER ANTHONY KIEDIS! I NOW HAVE A PICTURE WITH ALL OF THE BAND MEMBERS. MY LAST EXPERIENCE SEEING THE RHCP LIVE WAS IN BERN, SWITZERLAND IN 2012. I WAS JUST WALKING DOWN THE STREET AND RAN INTO CHAD. I GOT HIM TO GIVE ME HIS CIGARETTE AND I MADE A VIDEO OF IT! IT WAS AMAZING! I CAN'T WAIT TO HAVE MORE EXPERIENCES AND GOOD TIMES WITH THE RHCP!

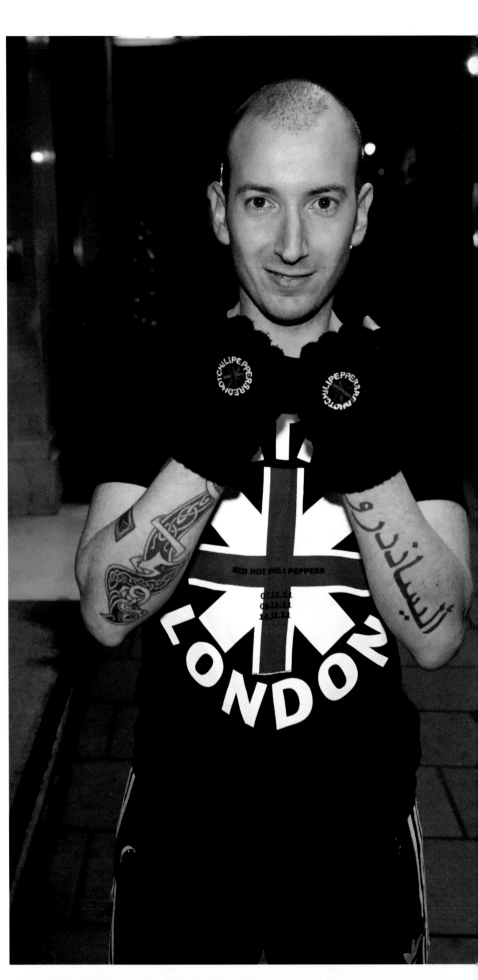

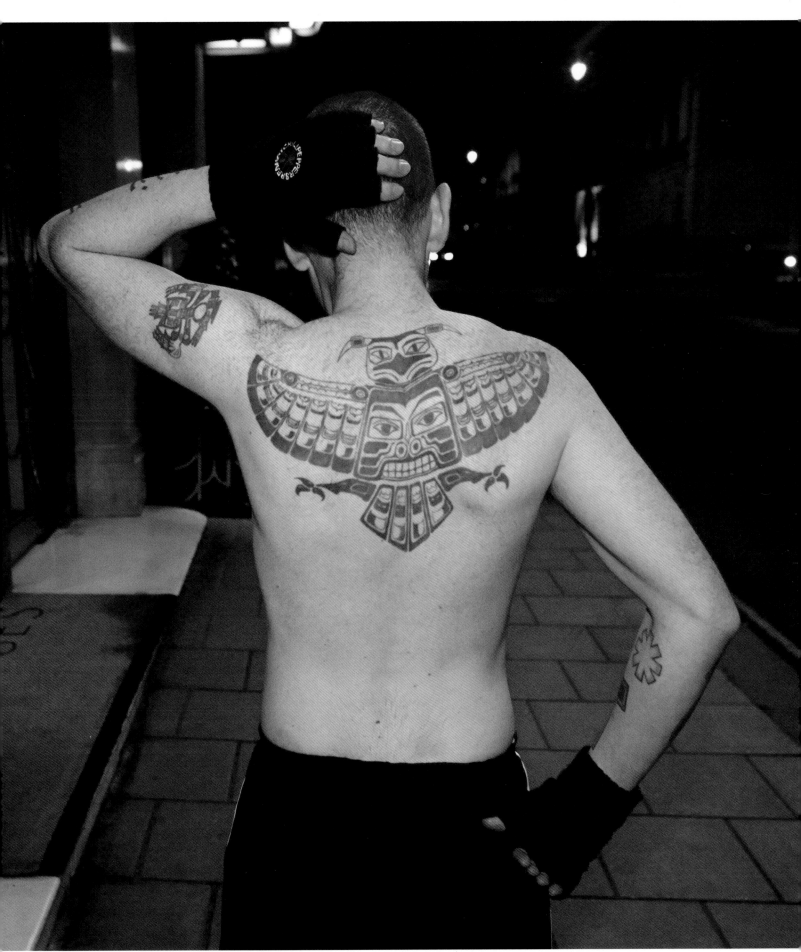

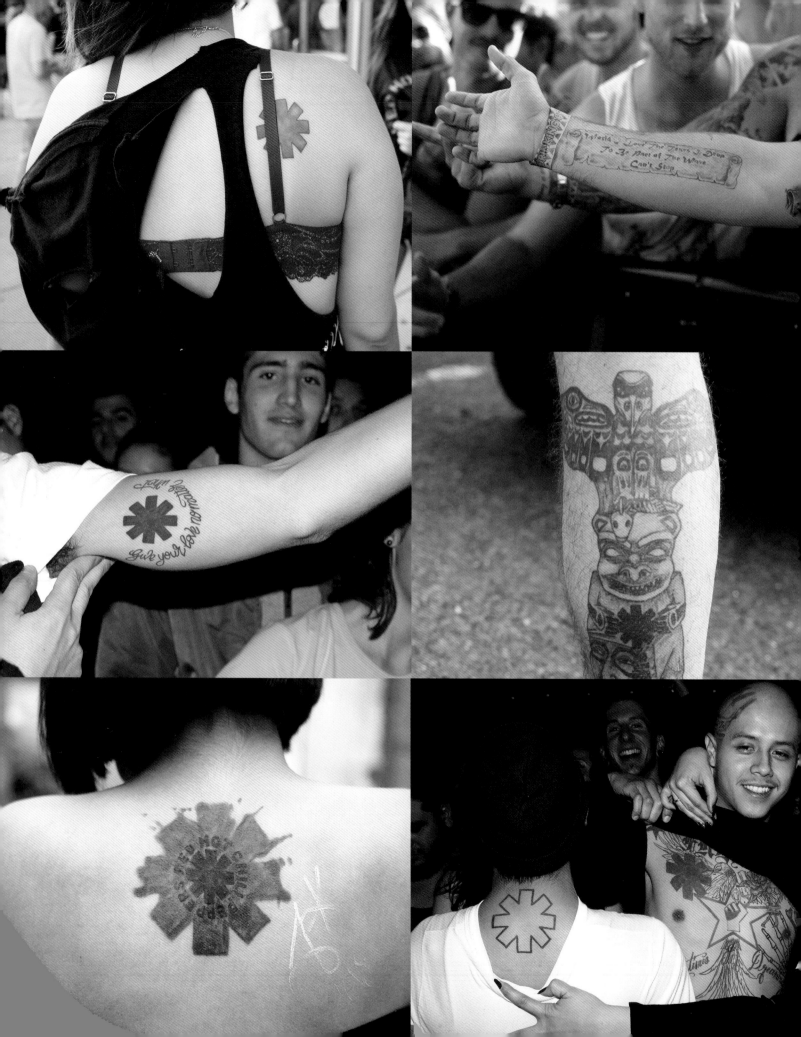

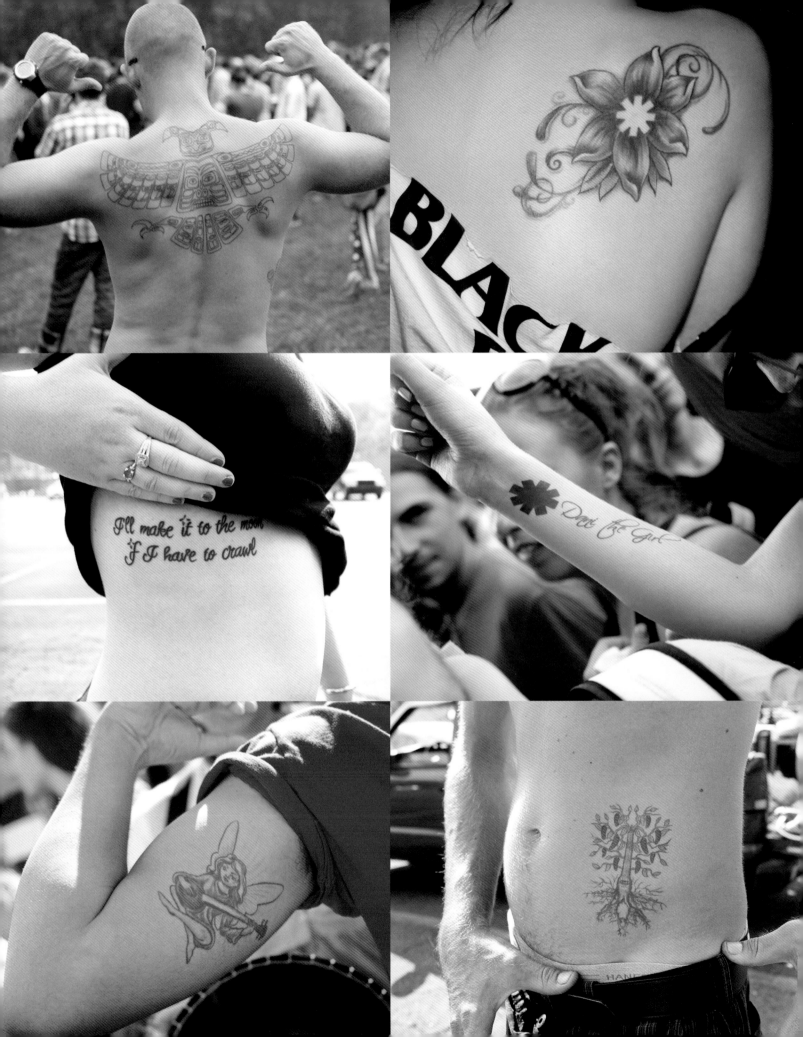

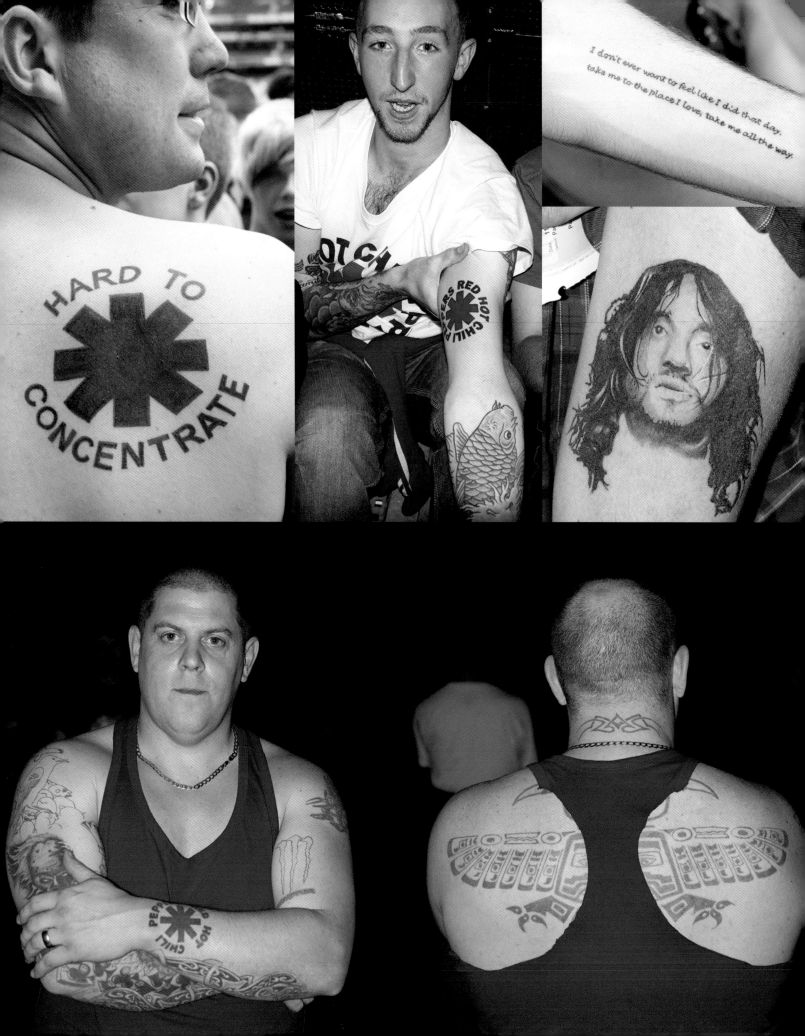

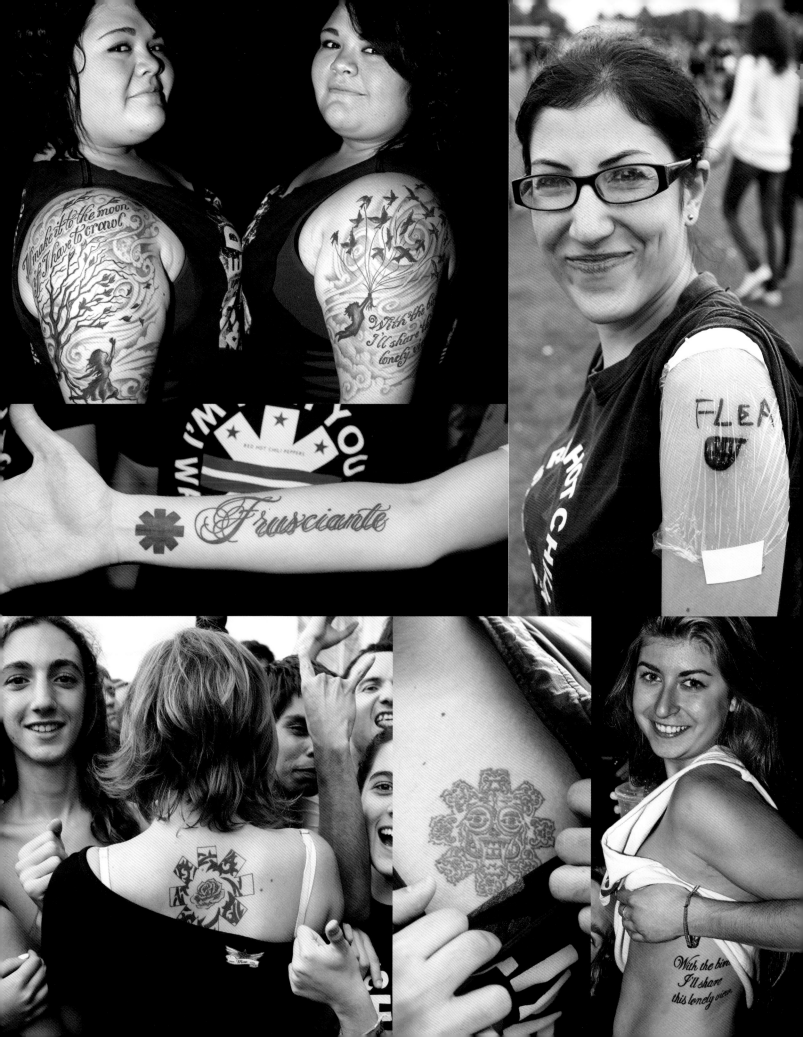

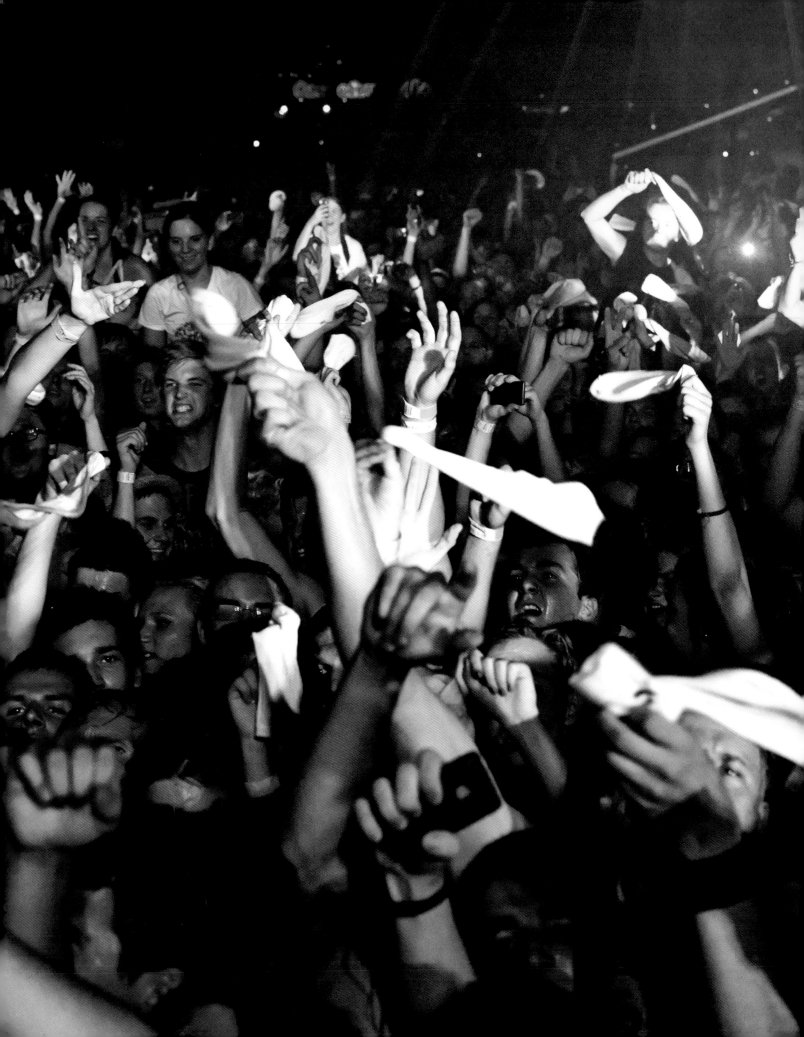

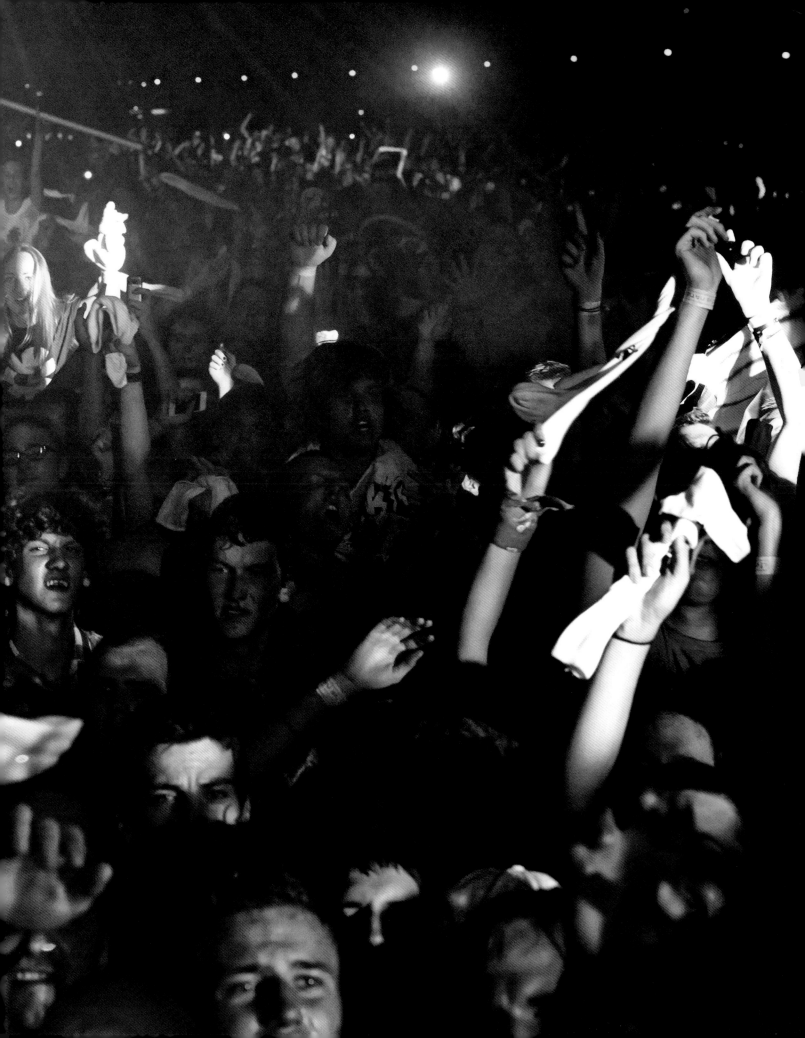

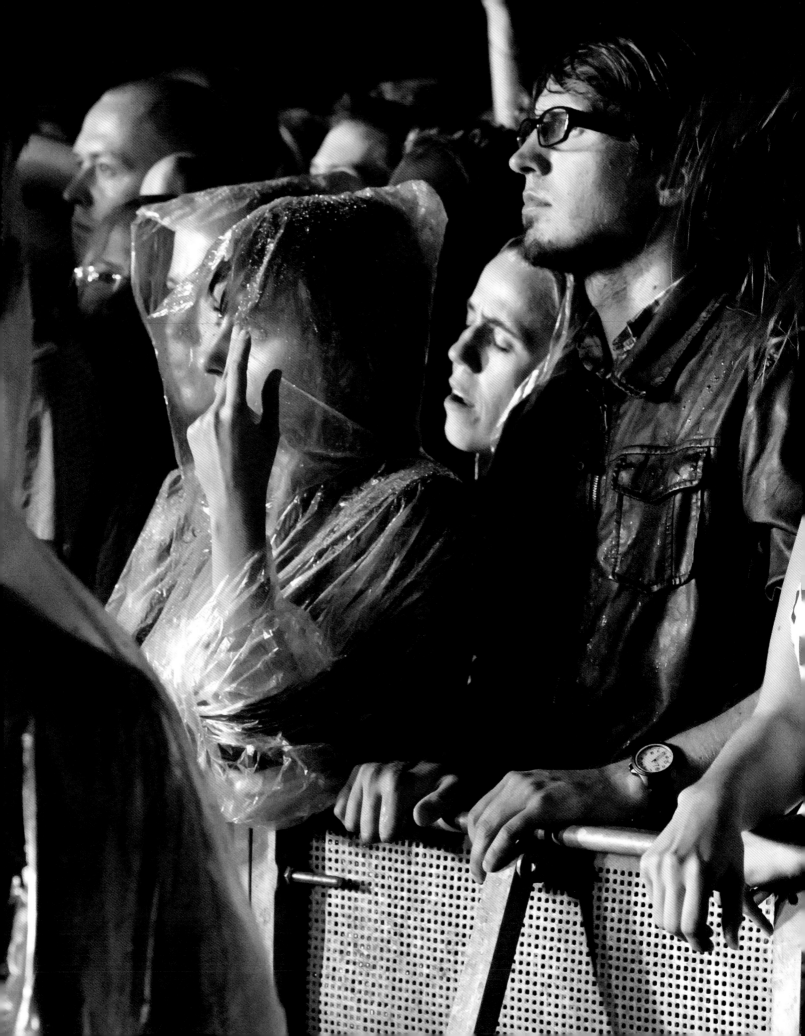

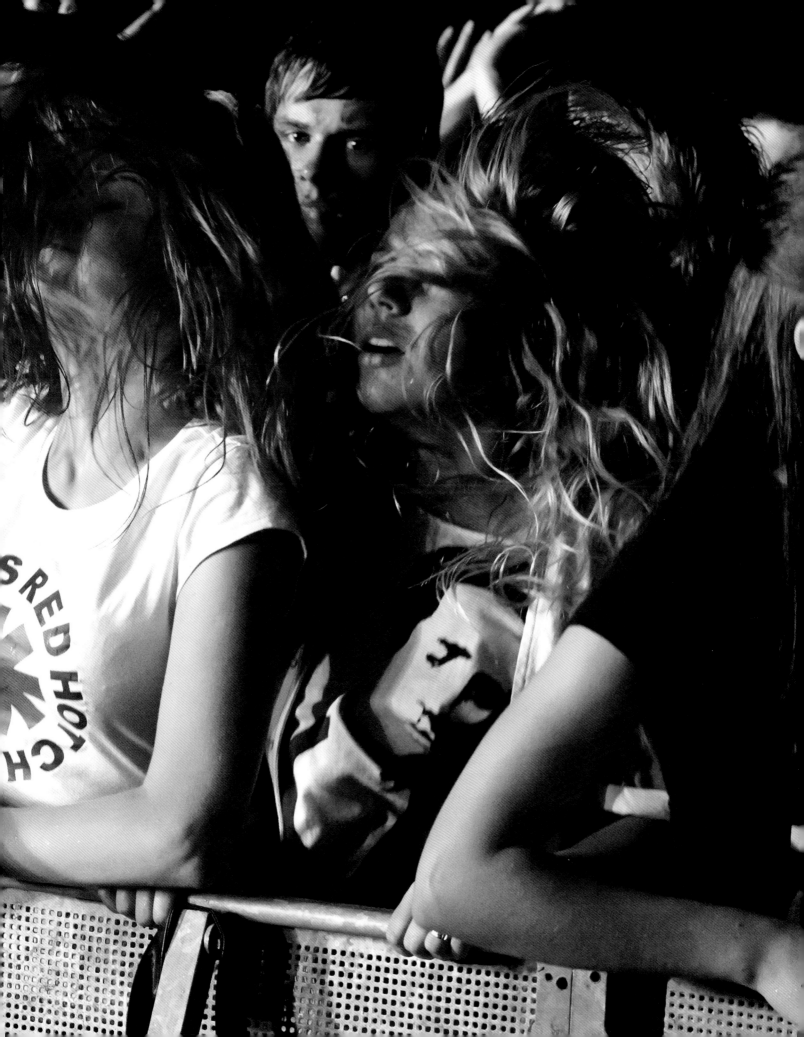

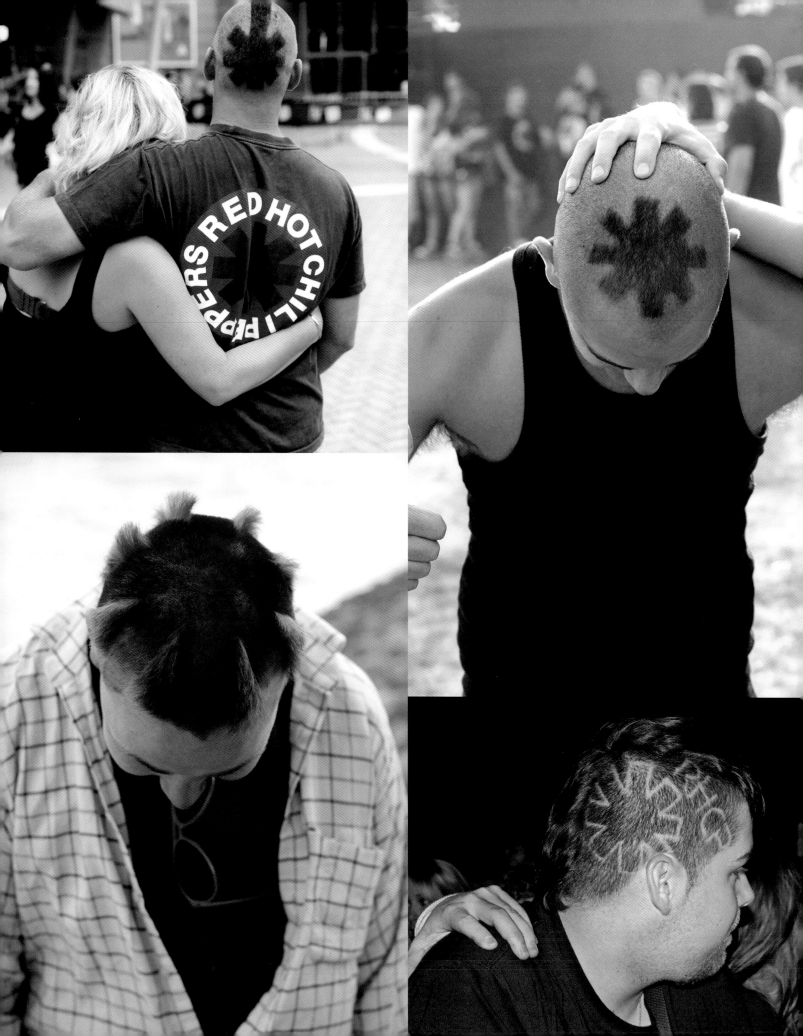

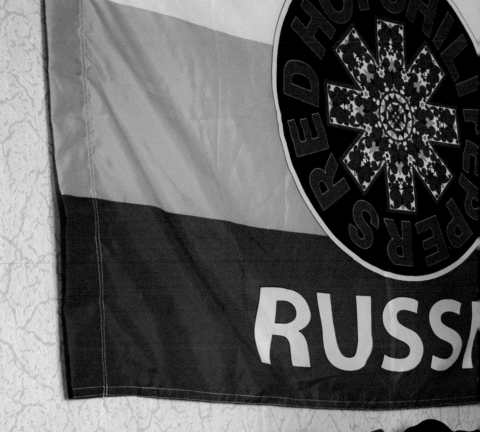

Yury Grumov, 40
Russia

When the RHCP came to Moscow in 1999 I couldn't go because I was fighting against my bad drug addiction. I was on the bottom. I didn't see any escape. After three years of isolation, now everything is fine. I love my wife. I will be forty soon. I don't regret anything. This is my life. Many things have changed since that 1999 show.

I attended a RHCP show in Berlin in December 2011 with a special gift. I painted Matryoshka dolls of the band. So there we were: me, my wife, our dog, and my dolls. We spoke only Russian but in this foreign country I met wonderful people, including one person who took us and the dolls backstage. Flea, Josh, Chad, and Anthony all walked in, shook our hands, and talked with us for about thirty minutes.

I just want to say that we have a great community of RHCP fans in the former U.S.S.R. states and there are a lot of people who deserve to be in the pages of this book.

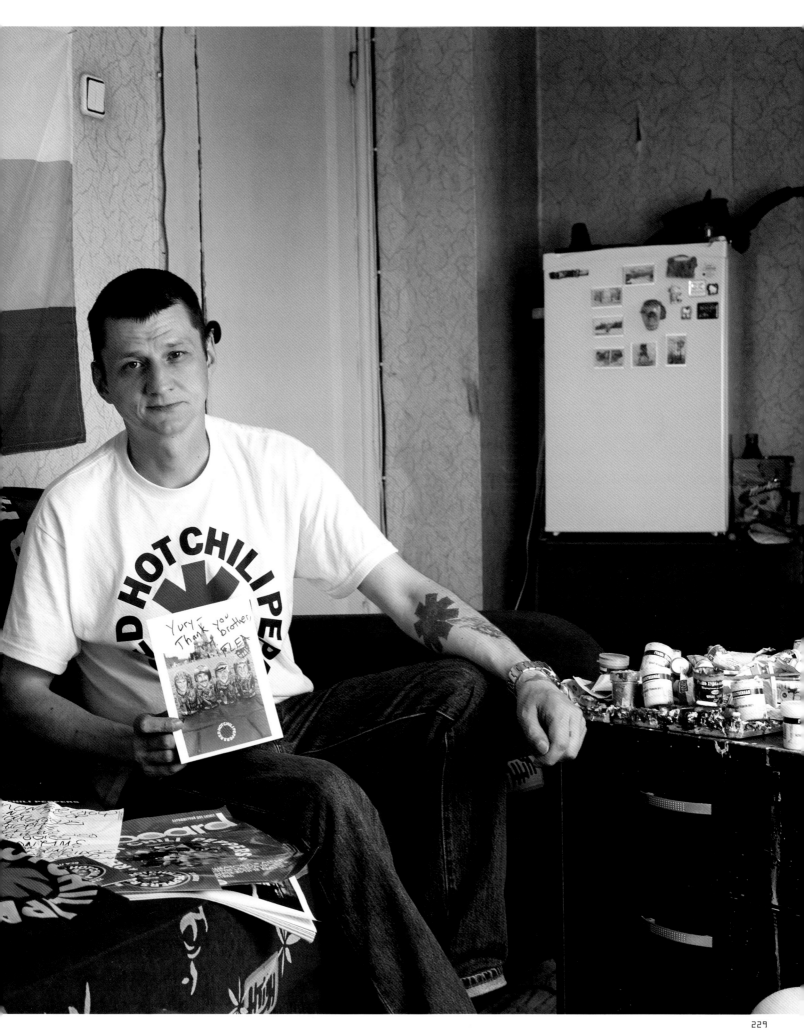

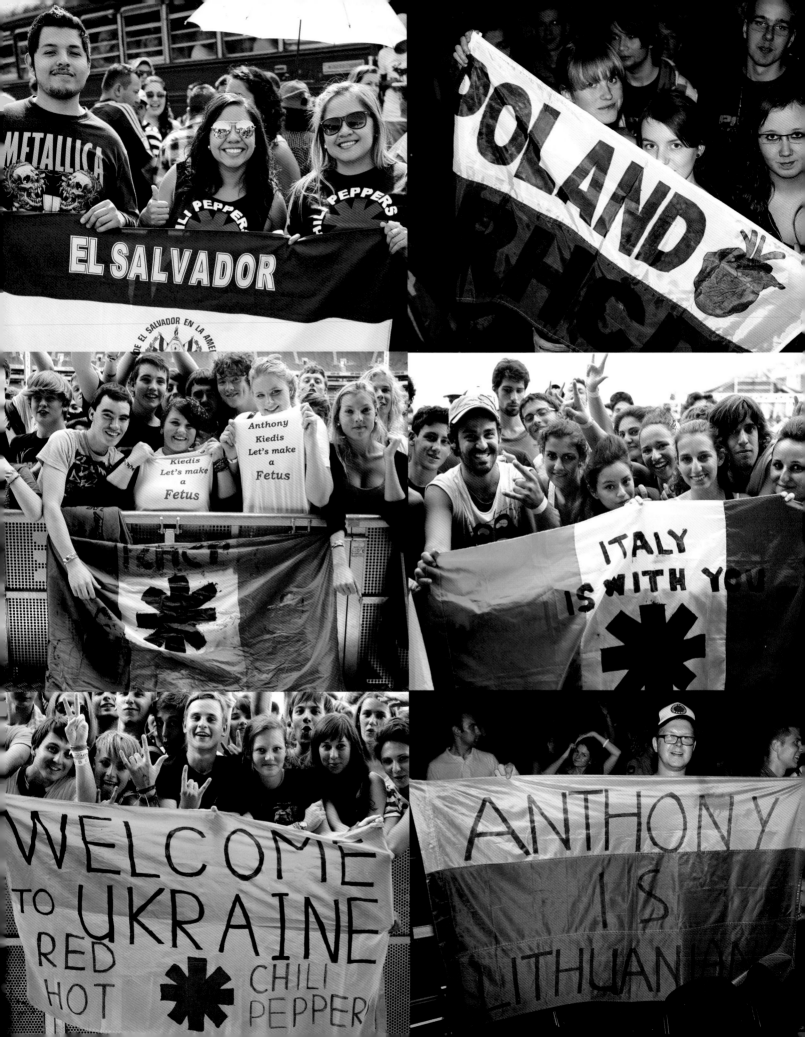

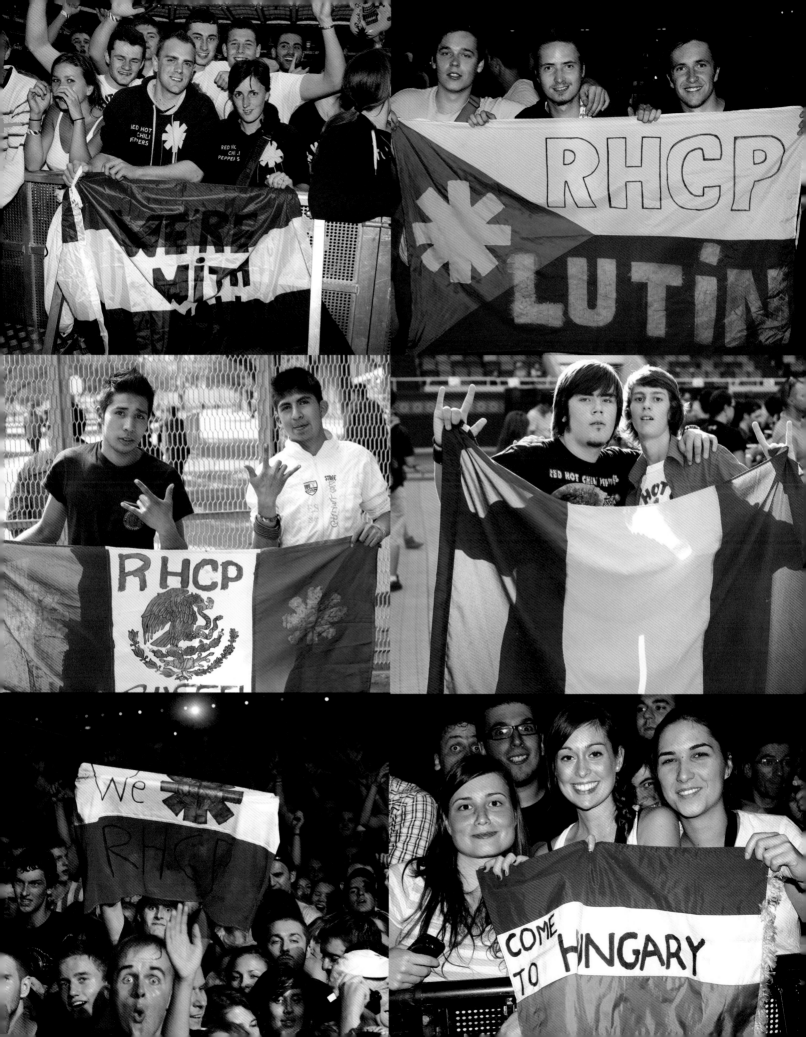

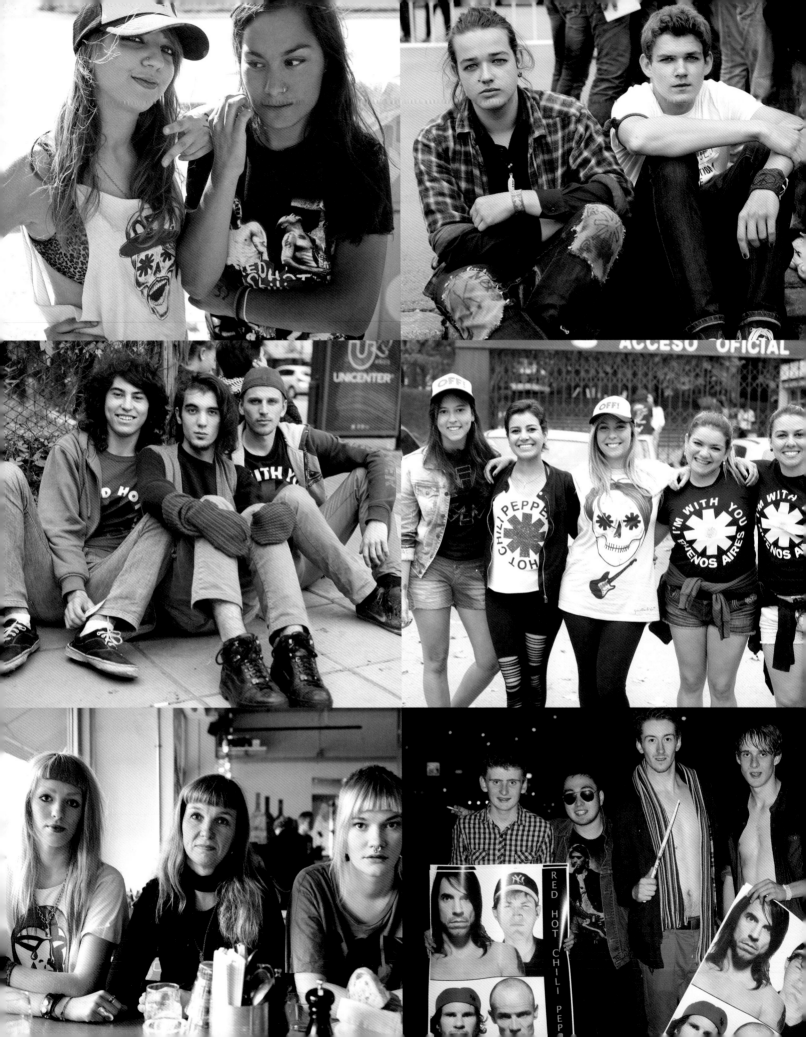

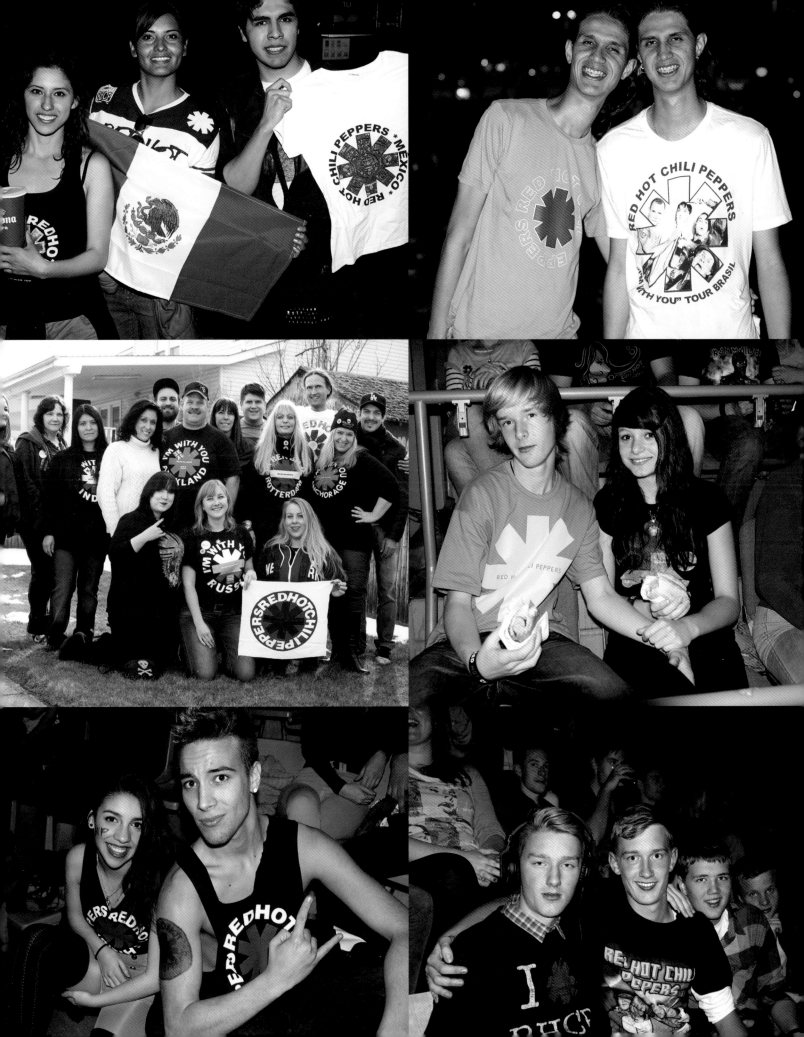

Elif, 21; Seyma, 46; and Eren Kurklu, 16
Turkey

ELIF— We went to the concert in Istanbul on September 8, 2012. I had no idea what was waiting for us: one of the best days in my life. It was wonderful listening to the concert right in front of the band. We were asked if we wanted to meet the band and then taken backstage. We met them all and talked to them. It was just like a dream. Anthony gave me his badge and now it is one of the most special things in my life and I will keep it forever.

SEYMA— The concert in Istanbul was the best experience I have ever lived with my daughters. It was a total dream come true. Taking us backstage and getting the chance to meet the band was incredible.

When you think of a world-famous rock band you would assume things are different in their lives and you just don't imagine them talking to you or even seeing them. But they were so incredible and so modest and so kind and humble, especially towards my daughter, Elif. Nothing else will compare to the smiles on my daughter's faces during the conversation with Anthony. They are very special people who created a very special moment in our lives. Thank you.

EREN— Our tickets were in the very back and I thought, "Damn, I will really be let down if I don't get to see anything." But still it's the Red Hot Chili Peppers, so it was 1,000 percent worth it. When we arrived we asked security if there was any way to get into the disabled area. My sister suffers from the disease Epidermolosys Bullosa, so we just wanted to find a way to get in as safely as possible. The workers surprised us—when we got in we saw the stage right in front of us! We were left completely speechless and didn't know what to do. We were the first ones there so we just rushed to the front row and stayed there during the whole concert. It was unbelievable. But that wasn't all. At the end of the concert, David came and asked if we wanted to meet the band. So that was basically a dream come true. There we were, backstage with Anthony, Chad, Flea, and Josh. It was unbelievable. Words can't describe the experience.

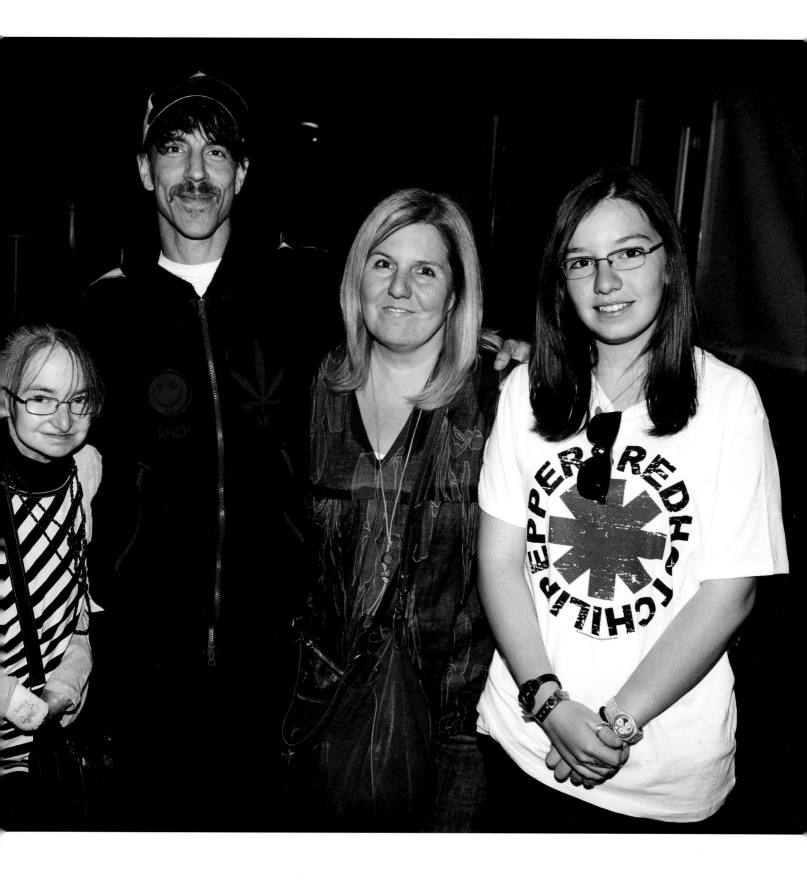

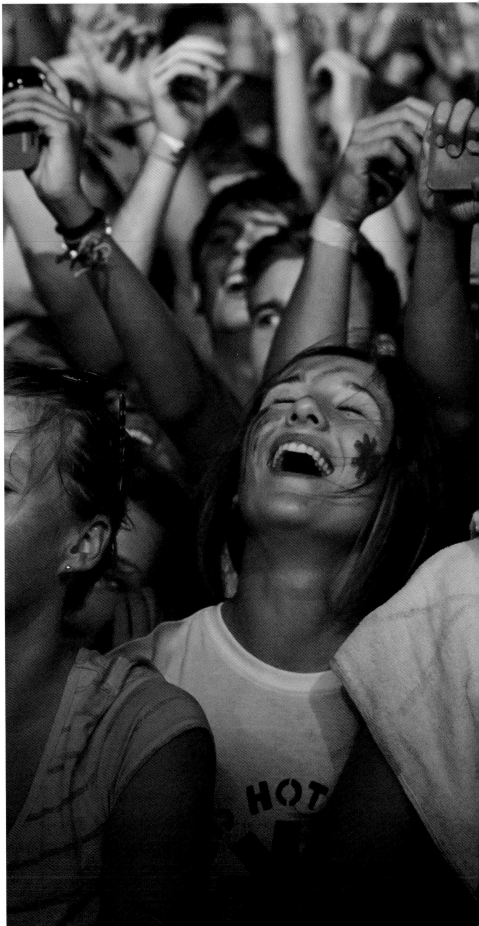

Liam Cowie (Center) Lasse Herdien (Right) South Africa

LASSE— BACK IN FOURTH GRADE WE'D HAVE A THIRTY-MINUTE MUSIC ENRICHMENT PERIOD ONCE A WEEK. THAT MEANT OUR TEACHER WOULD STICK US IN FRONT OF *MTV*. ONE TIME SHE DECIDED TO "EXPAND OUR MINDS" BY SHOWING US THE "GIVE IT AWAY" VIDEO. MY BEST FRIEND AND I WERE MESMERIZED. I JUST SAW SILVER GODS IN A DESERT. JOHN ROCKING HIS SILVER STRATOCASTER. FLEA JUST BEING FLEA. ANTHONY DANCING FRENZIEDLY. AFTER THEY RAN OFF INTO THE SUN, MY FRIEND AND I WENT CHILI PEPPERS CRAZY. THIS HASN'T CHANGED SINCE.

THE HEAVY GUITAR RIFFS, LUST AND SEXUAL INNUENDOS, DEATH, AND DRUG REFERENCES AND ENERGY MAKE *BLOOD SUGAR SEX MAGIK* MY FAVORITE ALBUM OF ALL TIME. ITS RHYTHMICALLY RAW, IT'S LYRICALLY HONEST, IT'S THE PERFECT EMBODIMENT OF WHO THE CHILI PEPPERS ARE. IT'S THEIR MAGNUM OPUS (KUDOS TO RICK RUBEN) AND THE BEST THING TO LISTEN TO AND WATCH PERFORMED IN CONCERT. IT'S ALSO HOME TO THEIR BEST—AND MY PERSONAL FAVORITE—SONG, "SIR PSYCHO SEXY."

IN HIGH SCHOOL I DYED MY HAIR RED, HAD THE CHILI PEPPERS ASTERISK SHAVED INTO THE RIGHT SIDE OF MY HEAD, AND THE LETTERS RHCP SHAVED INTO THE LEFT SIDE. I WAS SENT TO THE PRINCIPAL'S OFFICE AND MY MOM WAS CALLED IN. (SHE LIKED THE HAIRCUT RIGHT UP UNTIL THAT PHONE CALL.) AS A CONSEQUENCE, I HAD TO GO BALD AND SIT OUTSIDE THE PRINCIPAL'S OFFICE EVERY LUNCH BREAK UNTIL MY HAIR GREW BACK.

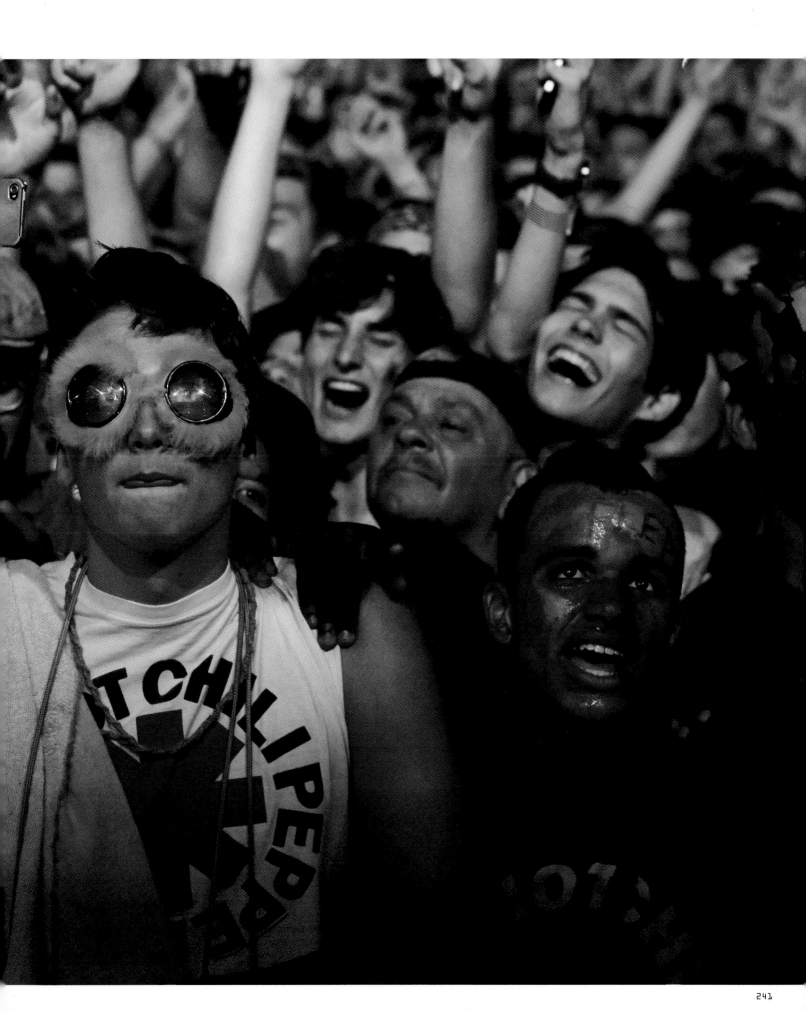

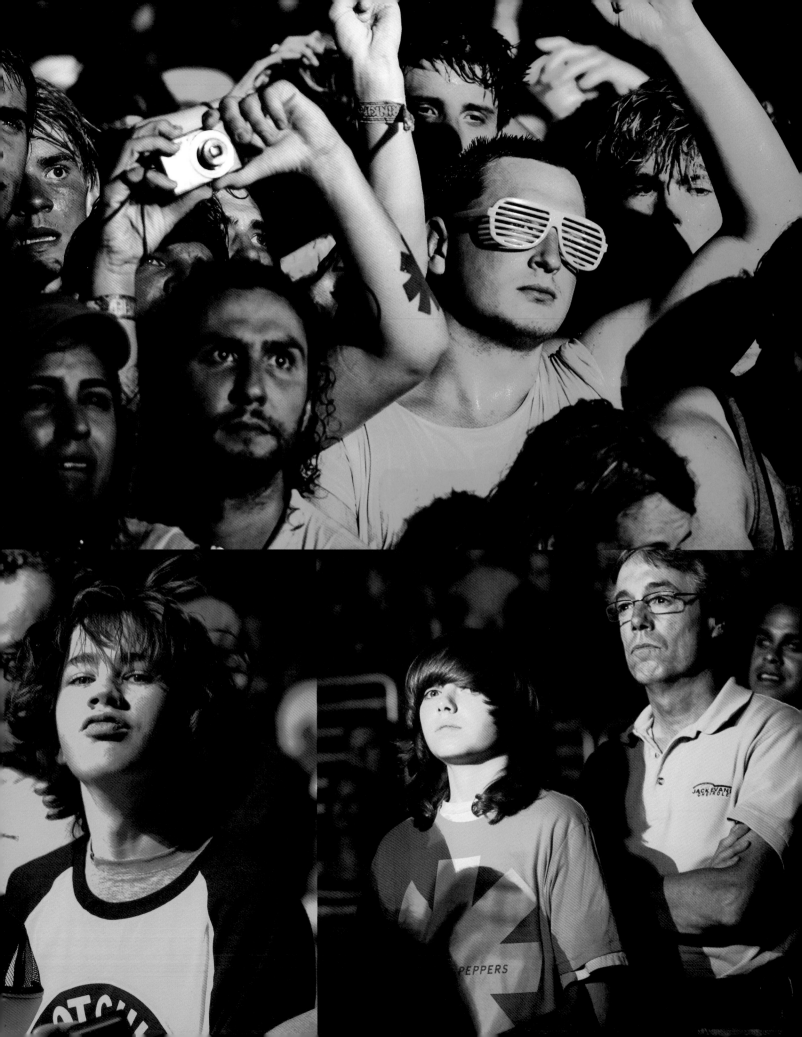

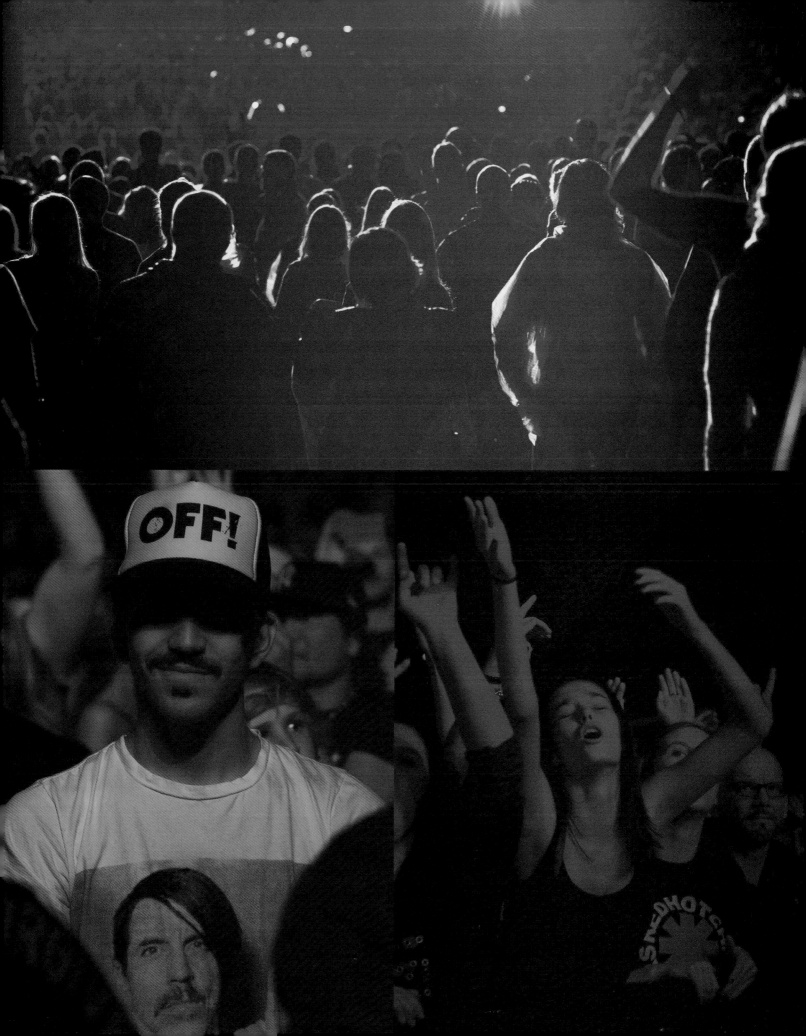

My experience with being a fan of bands has changed over the course of my relatively short life. At one time, I had to know everything about the people who created the music that made the life I led worth it. They were responsible for the magic that I was using as a sort of oxygen. As I've become closer to and a part of the world of music as a profession, and maybe a bit with age, I've lost some of the passion for the people who do it, but the music, the magic, the thing that we can all share in, I guess that would still propel me to be rammed up against a steel barricade for hours waiting to witness it happen before my eyes. I appreciate everything in a person that drives them to be connected to that communal feeling, in any way. I love being a part of it. I love being a part of this. Life is hard, sometimes it takes magic to make someone smile... sorry, I mean...magik.

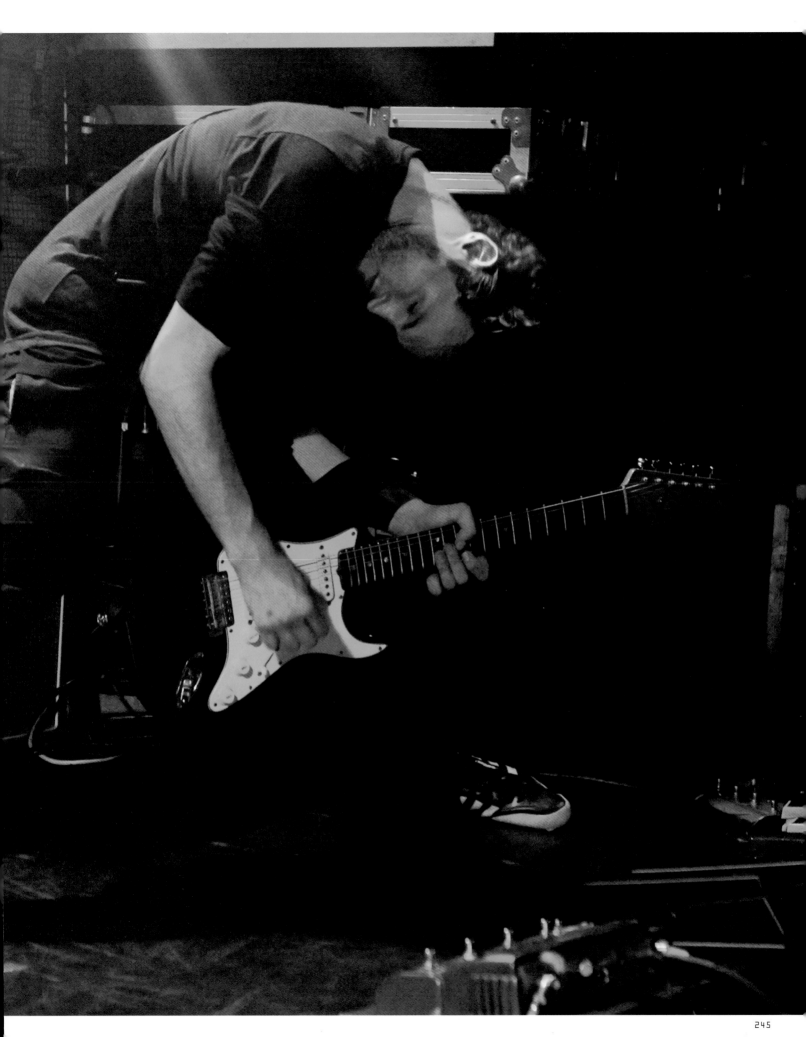

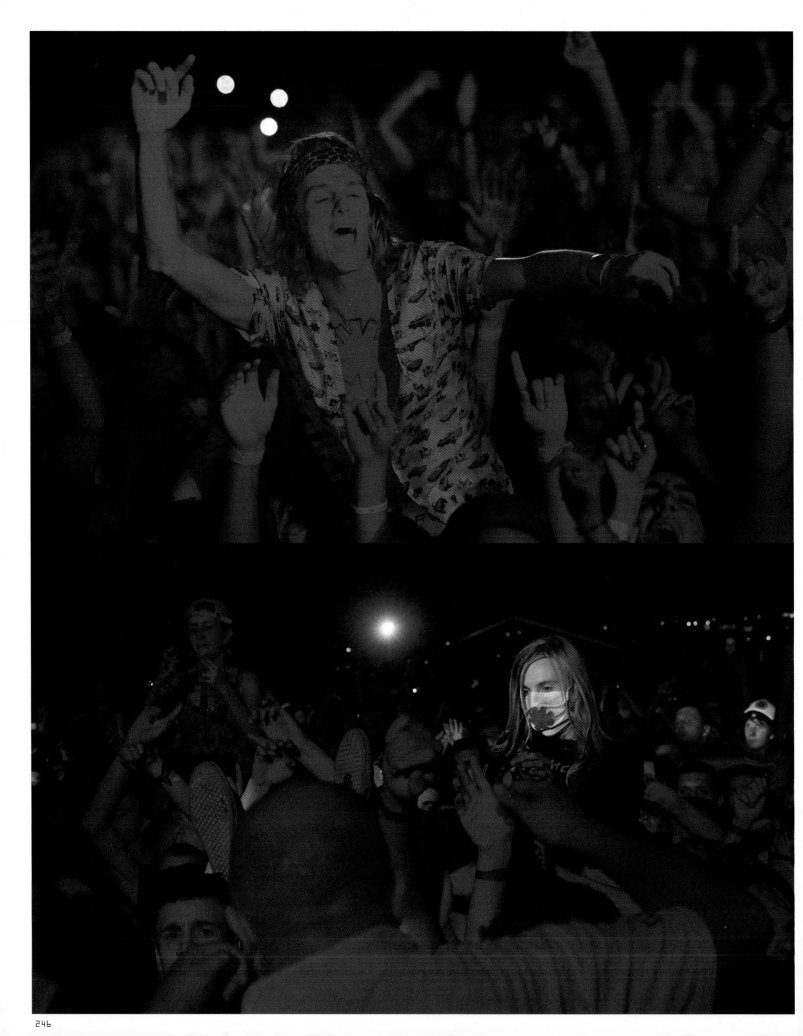

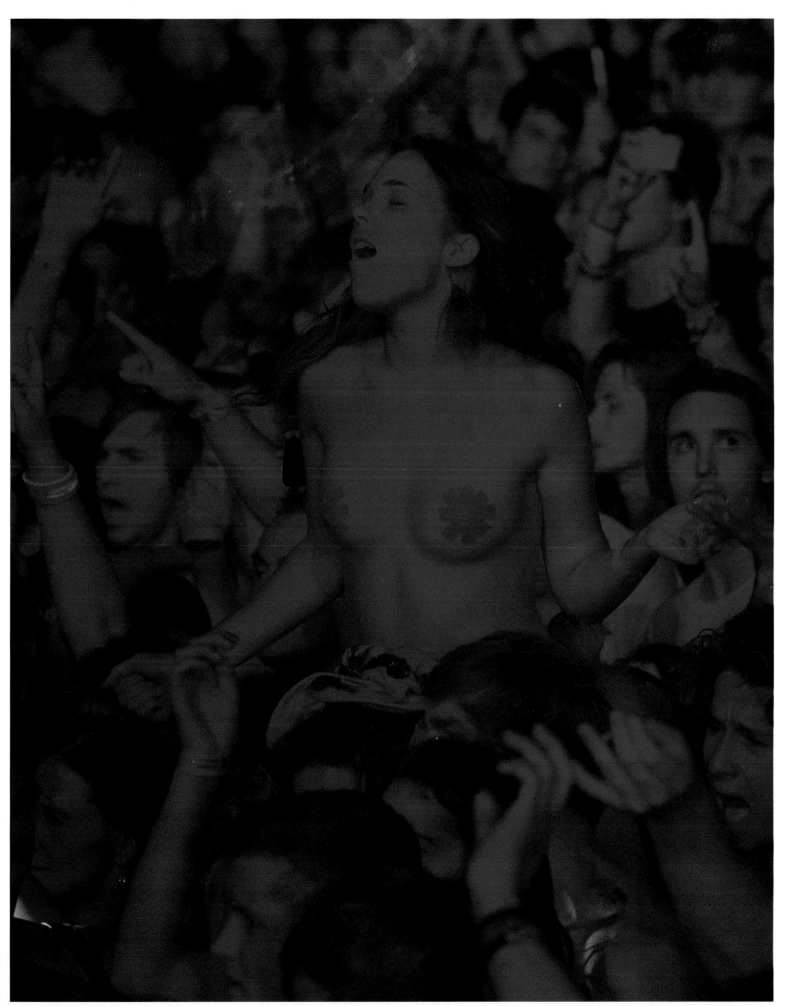

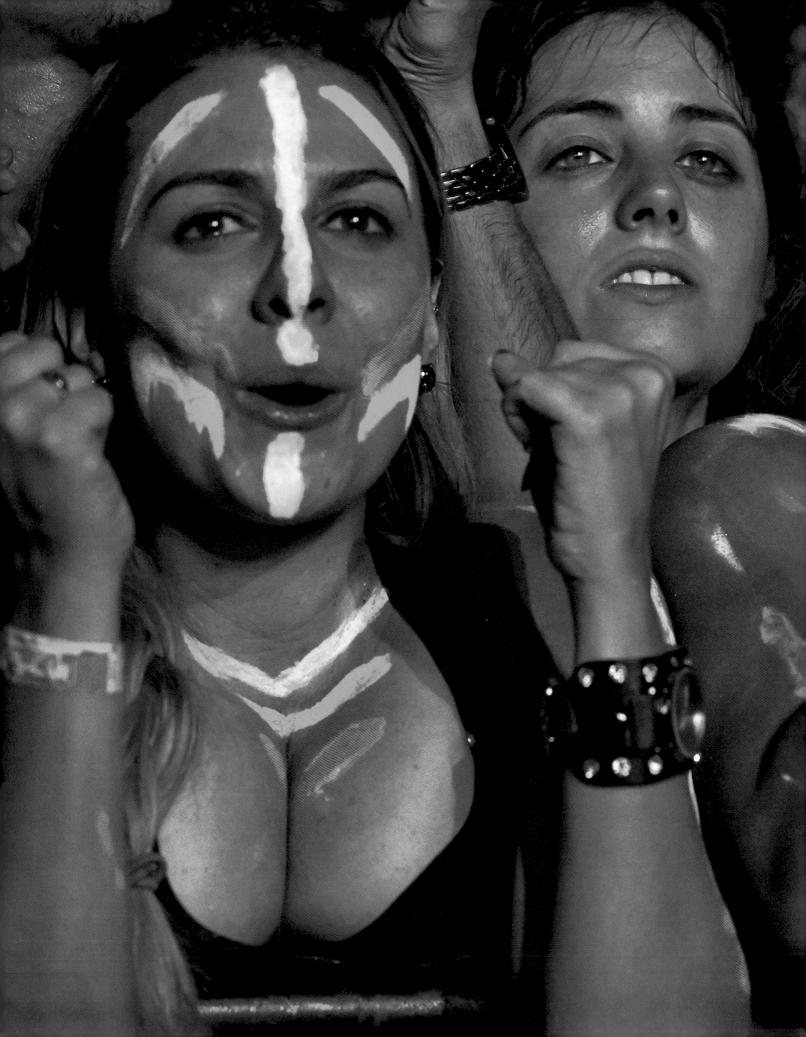

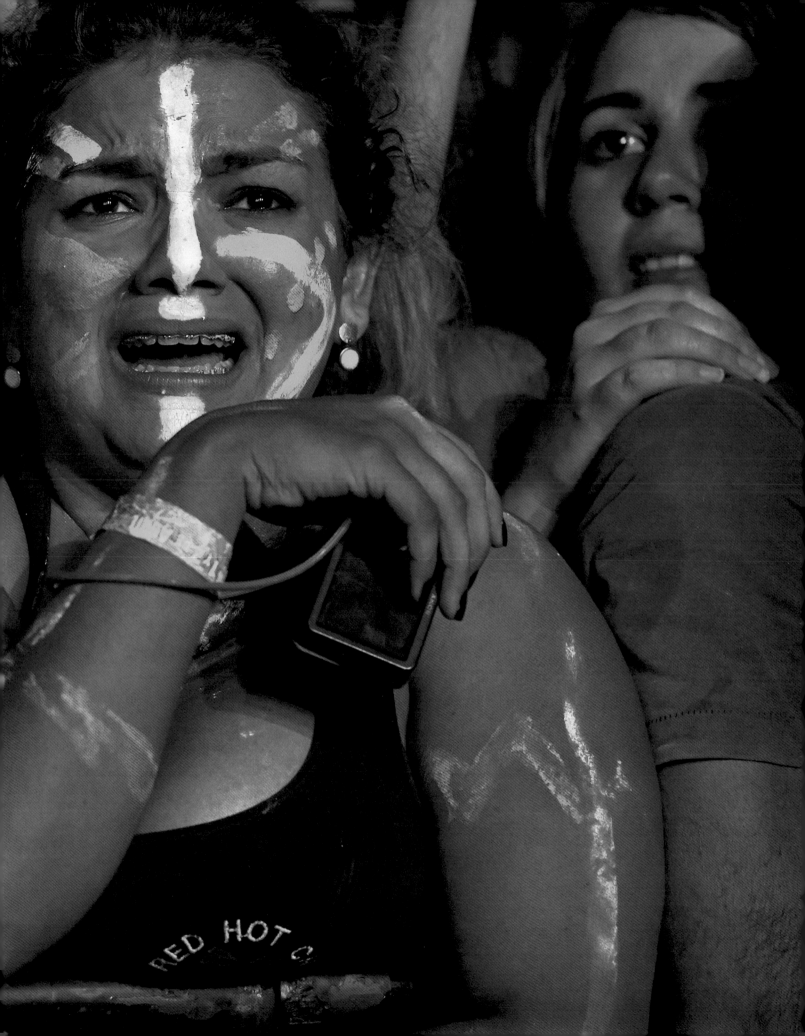

Luiz Fernando Oliviera, 34
Brazil

One of the most special experiences for me was meeting Anthony in São Paulo in 2011. I arrived at the hotel and in less than ten minutes of being there Anthony crossed the street and took some pics with fans. I wasn't expecting that. My cell phone and camera was brand new and I didn't have enough time to learn how to make it work. I asked for a girl to take a picture. Anthony smiled to me and said "Aha!" after seeing me—trying my best to look like him and with the same tattoos. I thought he might be pissed off but I'm sure he got it was because I have huge admiration for him. Another great experience was my first contact with Chad in 2011. He was so nice to meet and made me so happy. I didn't sleep all that night, crying tears of joy. Anthony is a genius songwriter. He is simply the best in my opinion. I just want to thank Anthony, Flea, and Chad for their respect for the people who love their art. And for all the love and good energy they send back to us fans. Because of the love I have for the band I have learned so much. Your love for music changed my life forever.

Jenna MacFie, 22 (Left)
Claire Shaug, 22 (Right)
Calgary

JENNA— CLAIRE INTRODUCED ME TO RHCP. UP UNTIL A YEAR AGO I HAD KNOWN OF THEIR MUSIC BUT NOT BEEN COMPLETELY INTRIGUED BY IT. FOR HER, ANTHONY KIEDIS, WAS AN IDOL. WE GOT AHOLD OF SOME TICKETS FOR THEIR CONCERT, SO TO NOT STICK OUT LIKE A SORE THUMB I BEGAN RELIGIOUSLY LISTENING TO THEIR MUSIC.

THAT CONCERT I HAD BEEN PREPARING FOR, WELL THANK GOODNESS I DID, BECAUSE CLAIRE AND I GOT TO MEET THE BAND. I THOUGHT THAT STUFF ONLY HAPPENED IN MOVIES! ANTHONY WAS EXTREMELY NICE AND MADE CONSTANT EYE CONTACT. EVERYONE ELSE MADE ME FEEL COMFORTABLE AND THE CONVERSATION JUST FLOWED. THEY MADE THIS CONCERT A LIFELONG MEMORY AND ME A LIFELONG FAN.

I AM A DENTAL ASSISTANT BUT THAT'S NOT ALL I AM ABOUT. I AM ABOUT SIMPLE THINGS IN LIFE, STOLEN MOMENTS. I'M ABOUT TRYING TO BETTER MYSELF AS A PERSON AND TRYING TO KEEP AN OPEN MIND TO THE WORLD, CONSTANTLY TRYING NEW THINGS AND MEETING NEW, POSITIVE PEOPLE. I STRIVE TO LIVE THROUGH LOVE. MY STORY HAS YET TO UNFOLD.

MY FAVORITE ALBUM IS *BLOOD SUGAR SEX MAGIK*. THERE ISN'T A SINGLE SONG ON THAT ALBUM I COULDN'T JAM OUT TO.

CLAIRE— I'D HAVE TO SAY WHAT CONNECTED ME TO THE RHCP WAS THEIR INCREDIBLE ENERGY. YOU CAN'T HELP BUT FEEL A LITTLE MORE ALIVE WHEN LISTENING TO THEIR MUSIC.

Naoko Shimizu, Japan

Dear Mr. Anthony Kiedis,

I'd like to say thank you so much for providing a song for the benefit record *Songs for Japan*, and for playing at the Summer Sonic 2011 even though it was only a few months after the tsunami disaster. I was deeply touched by your words, "we're always with you," at the show. It meant a lot to us. Your music makes us so happy and keeps us alive whenever we are having a difficult time. We really love your music. We talk about you every day and hope you come back to Japan again!

IT WAS THE YEAR 1991 OR 1992. WE WERE IN SOME PLACE AND WE WERE SMOKING MARY JANE. AS USUAL WE WERE TALKING ABOUT MUSIC AND ONE GUY ASKED MY FRIEND WHETHER SHE HAD HEARD "GIVE IT AWAY" BY THE RED HOT CHILI PEPPERS AND SHE SAID "YES, SURE!" THEY STARTED TO SING "GIVRWAY GIVRRRRWAY GIVVVRWAY NOW." I WAS IN LOVE WITH THAT GUY AND BECAME ANGRY WITH MYSELF BECAUSE SHE KNEW THAT BAND AND I DID NOT. NEXT DAY I WENT TO SOME MUSIC SHOP WITH PIRATED RECORDS, WE DIDN'T HAVE SHOPS WITH LEGAL RECORDS AND FILMS UNTIL AFTER THE DISSOLUTION OF THE USSR. I ASKED THEM TO GIVE ME ALL THE AUDIO TAPES THEY HAD OF THE CHILI PEPPERS. I GAVE THEM MY LAST MONEY. THE MUSIC MADE ME CRAZY..,

WE WERE IN MOSCOW ON THE RED SQUARE WHEN THE RED HOT CHILI PEPPERS HAD A SHOW THERE FOR FREE. IN THAT TIME I WAS ALREADY A BIG FAN AND SUFFERED BECAUSE OF MY ADDICTION TO DRUGS. IT WAS 1999 AND BY THAT TIME I HAD NINE YEARS OF INTRAVENOUS DRUG USE. THAT DAY I FELT LIKE I COULDN'T GO BECAUSE I DIDN'T HAVE ANY DOSE AND I HAD TO GO TO MEET MY DEALER AND BEG HIM TO GIVE ME SOME DRUGS. BUT HE DIDN'T PICK UP THE PHONE AND I COULDN'T MISS THE CONCERT. ANYWAY I WENT TO RED SQUARE. WHEN I GOT THERE I FORGOT ABOUT THE ACHE IN MY BODY, ABOUT A BIG EMPTY HOLE IN MY SOUL AND CONSTANT OBSESSION. THERE WAS AN OCEAN OF PEOPLE, BUT ANYWAY I GOT TO THE FIRST ROW. I SIMPLY SLIPPED THROUGH THE CROWD OF PEOPLE. I'M TINY, AND THAT OCEAN SWALLOWED ME UP. THE SECURITY HAD TO TAKE ME OUT BECAUSE I COULDN'T BREATHE. IN 1999 I WAS ALMOST DEAD, AND IT WAS THE BEGINNING OF THE END OF MY USAGE OF ANY DRUGS.

ONE DAY I RAN OUT OF ALL MY DRUGS AND I DIDN'T HAVE A CHANCE TO MEET MY DEALER AND I JUST SPENT MY TIME IN BED. I HAD ONE RECORD, *CALIFORNICATION*. OTHER RECORDS I DIDN'T WANT TO TOUCH. I DON'T KNOW HOW TO EXPLAIN IT. I STAYED IN BED FOR MANY DAYS. NO DRUGS. NO FRIENDS. NO CONVERSATIONS. NO HAPPINESS. JUST LIKE AN ALIVE BODY. JUST PAIN AND DESPAIR AND HOPELESSNESS. I KEPT LISTENING AGAIN AND AGAIN AND AGAIN AND AGAIN TO *CALIFORNICATION*. WHEN THE OTHERSIDE WAS PLAYING I KNEW, I JUST KNEW IT WOULD BE OKAY, THAT SOON IT WOULD BE OVER. I JUST CONTINUED LISTENING TO "OTHERSIDE" THE SONG MADE ME CALM. I STOPPED THINKING ABOUT DRUGS, I BECAME PATIENT AND BRAVE. I JUST WAITED TILL MY PERSONAL HELL WAS OVER. AND I OVERCAME IT. ON THE 7TH OF MARCH 2000 I HAD MY FIRST CLEAN DAY. I WILL NEVER FORGET THAT BED AND "OTHERSIDE."

I WAS AT THE SHOW IN UKRAINE IN 2011. WHEN ANTHONY STARTED "HOW LONG HOW LOOONG WILL I SLIDE," MY HANDS WERE SHAKING AND I BEGAN TO SOB LIKE A LITTLE GIRL.

Chandelle Carter, 22
New York (Right)

No matter how much I annoyingly screamed everyone's name and tried to climb the barricade, the guys always answered back or waved. Anthony's copy of the set list got handed to me by one of the guards who was enjoying my insanity, and when I yelled thank you Anthony blew me a kiss. It was so amazing to see how nice and appreciative they were of their fans. All of this made me more of a die-hard.

I'm a Brooklyn-raised artist who loves her family and her crazy friends. I paint, draw, sculpt, sew, and do web-design. I want to make my mother proud. I want to do all the things she wanted for me and make sure that the little brother that I'm raising grows up to be brave, loyal, and true to what he wants, above all else. I also want to save up enough money to follow the band from show to show on their next U.S. tour and meet the men who inspire and motivate me so much.

Oh, and STADIUM ARCADIUM was the biggest slice of genius I've ever been handed.

258

Gabbi Katz, 25
South Africa

I'M A BLUE-HAIRED BETTY WHOSE MISSION IN LIFE IS TO CHANGE PEOPLE'S ATTITUDE IN TERMS OF STEREOTYPING PEOPLE BECAUSE OF THE WAY THEY DRESS, THE COLOR OF THEIR HAIR, OR HAVING TATTOOS.

I HAVE BEEN A CHILIS' FAN SINCE MY EARLY TEENS, DESPITE GROWING UP IN A SMALL, CONSERVATIVE FARMING TOWN IN SOUTH AFRICA. I GUESS YOU CAN CALL ME AN *MTV* GENERATION KID, AND THE CHILIS' MUSIC VIDEOS ALWAYS KICKED ASS.

IN MY HIGH SCHOOL YEARS MY GROUP OF FRIENDS WOULD OFTEN HAVE CHILL HOUSE-PARTIES AND "BRAAIS," AS WE CALL BARBEQUES HERE IN SOUTH AFRICA. SOMEONE WOULD ALWAYS HAVE AN ACOUSTIC GUITAR ON HAND AND THE NIGHT WOULD END IN US GOING THROUGH A REPERTOIRE OF SONGS, OF WHICH "UNDER THE BRIDGE" WAS ALWAYS ONE.

Cassy Reilly, 24 (Left)
Paige Feltham, 24 (Right)
Canada

PAIGE— ON MY BIRTHDAY ON MAY 2, 2012, I WENT TO THE MONTREAL SHOW WITH CASSY. DURING THE ENCORE ANTHONY AND FLEA STARTED ROCKING OUT RIGHT IN FRONT OF US TO "GIVE IT AWAY." THEY CONTINUED TO BLOW MY MIND BY ADDING IN AN EXTRA LINE TO THE SONG, "HAPPY BIRTHDAY PAIGE!" BEST BIRTHDAY EVER, HANDS DOWN!

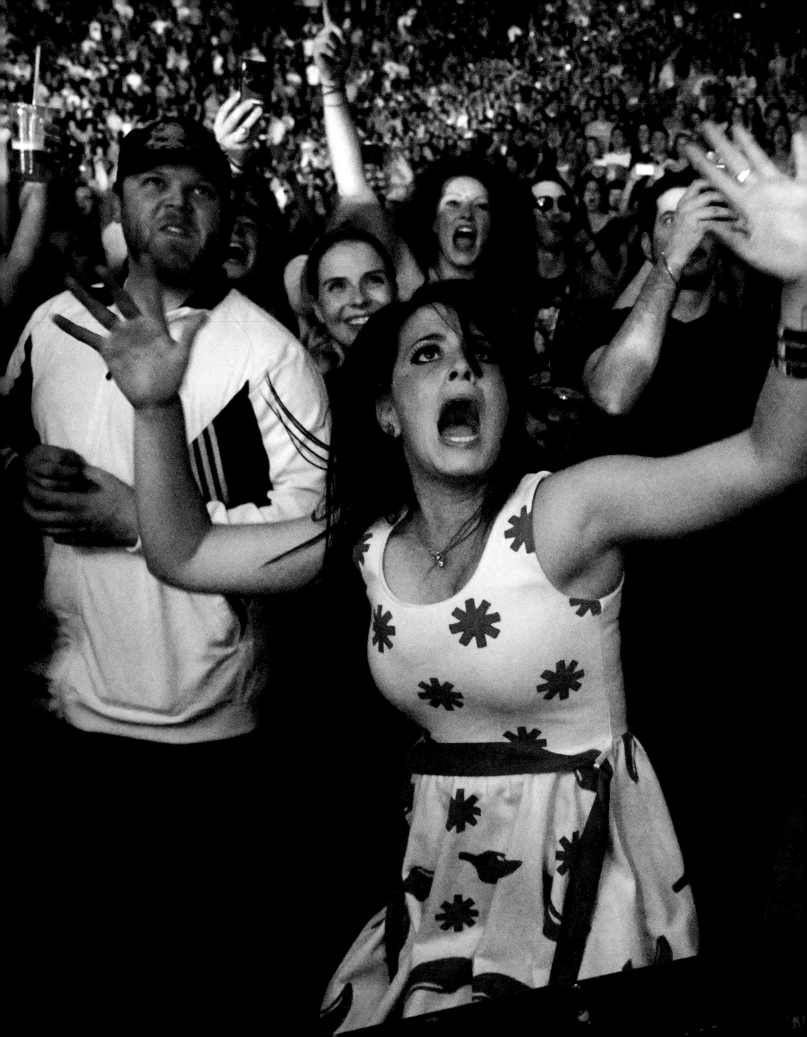

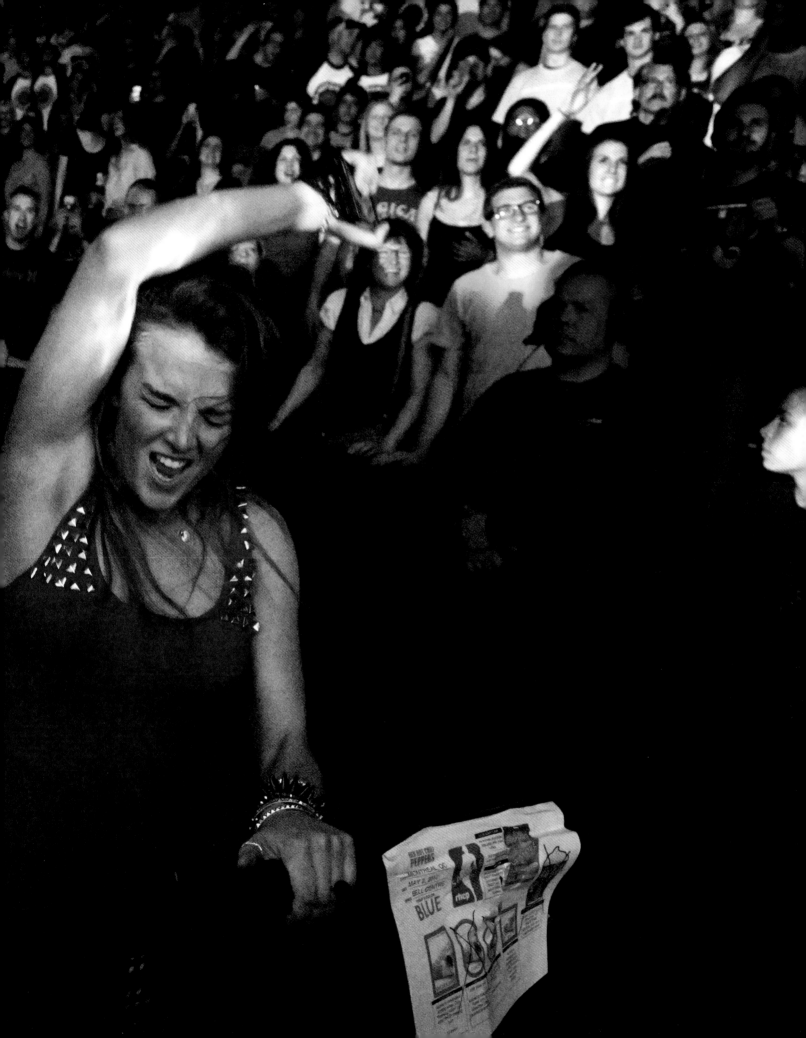

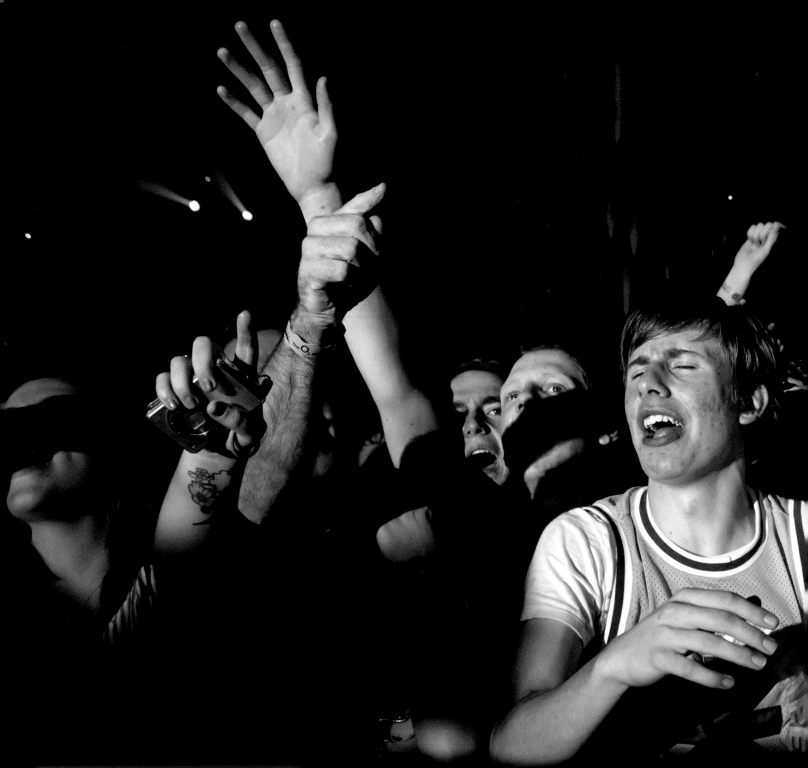

Marcus and James Ware, 18
United Kingdom

I WENT TO THE CONCERT IN LONDON WITH MY BROTHER. ANTHONY SPOKE TO US FROM STAGE BETWEEN SONGS. "DO I KNOW YOU GUYS?" HE ASKED. "HAVE I SEEN YOU BEFORE? I FEEL LIKE I HAVE SEEN YOU BEFORE." THEN HE TURNED TO FLEA AND SAID "THOSE ARE MY FRIENDS FROM IPSWICH." I ABSOLUTELY LOVE LISTENING TO THE LIVE ALBUMS. "LIVE IN HYDE PARK" IS MY FAVORITE AND I WAS LUCKY ENOUGH TO BE AT THAT SHOW. I WAS TEN YEARS OLD.

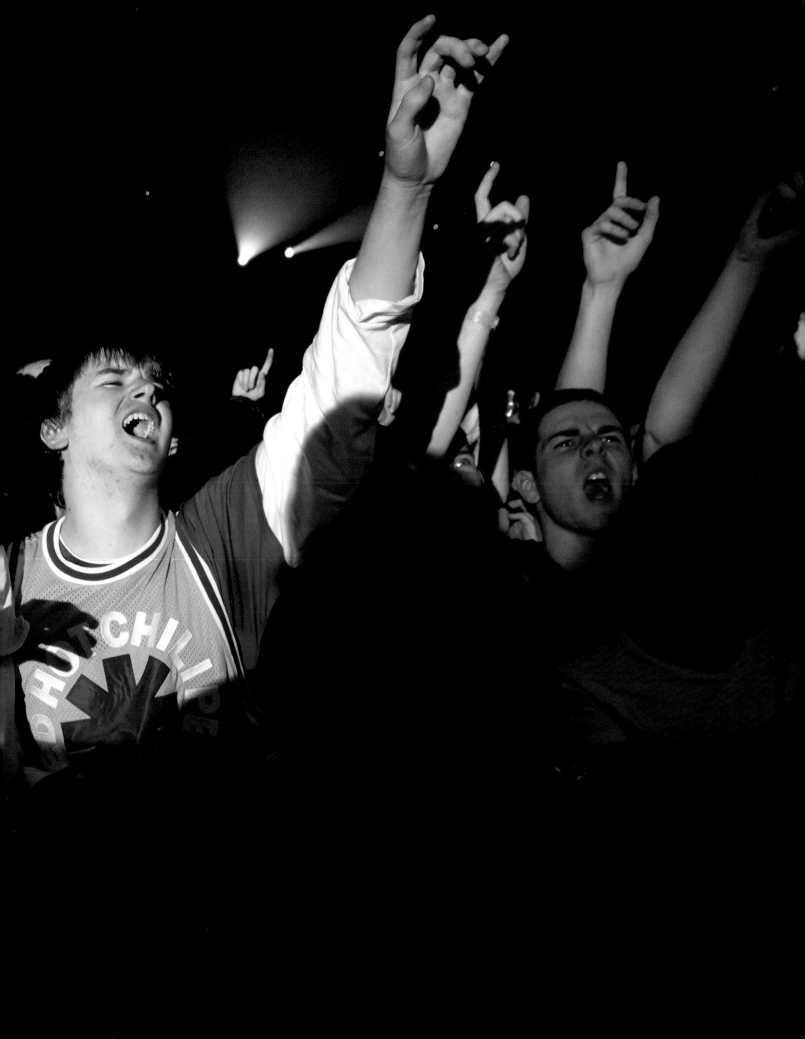

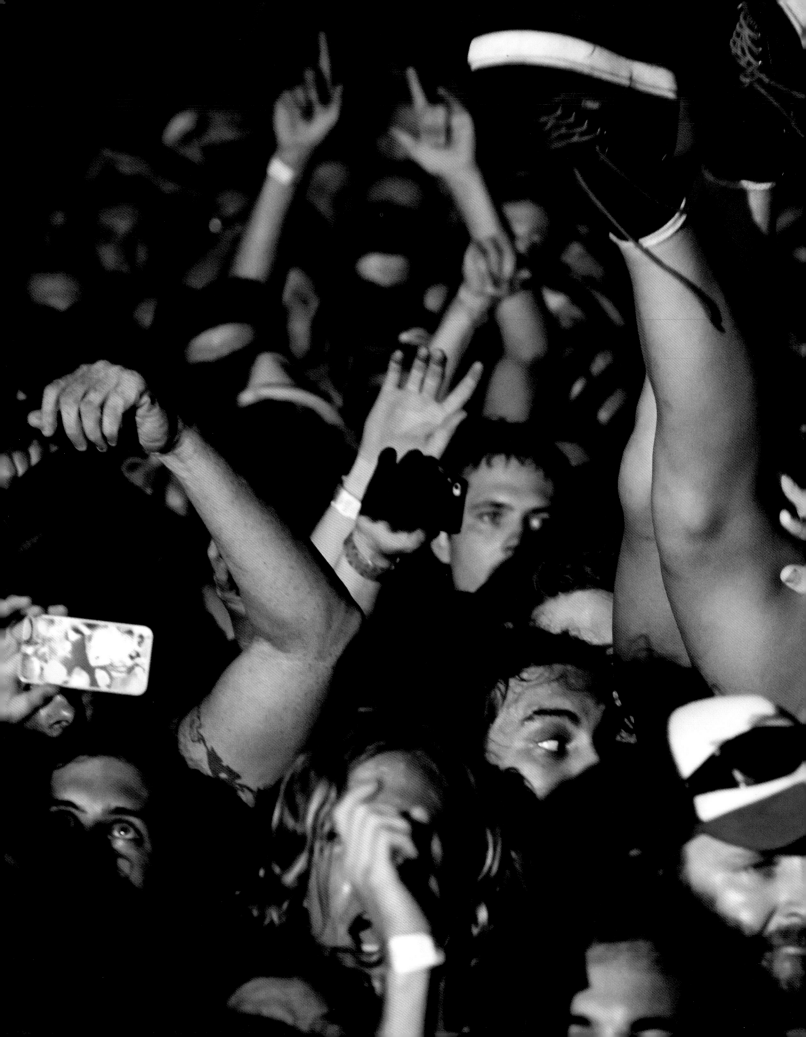

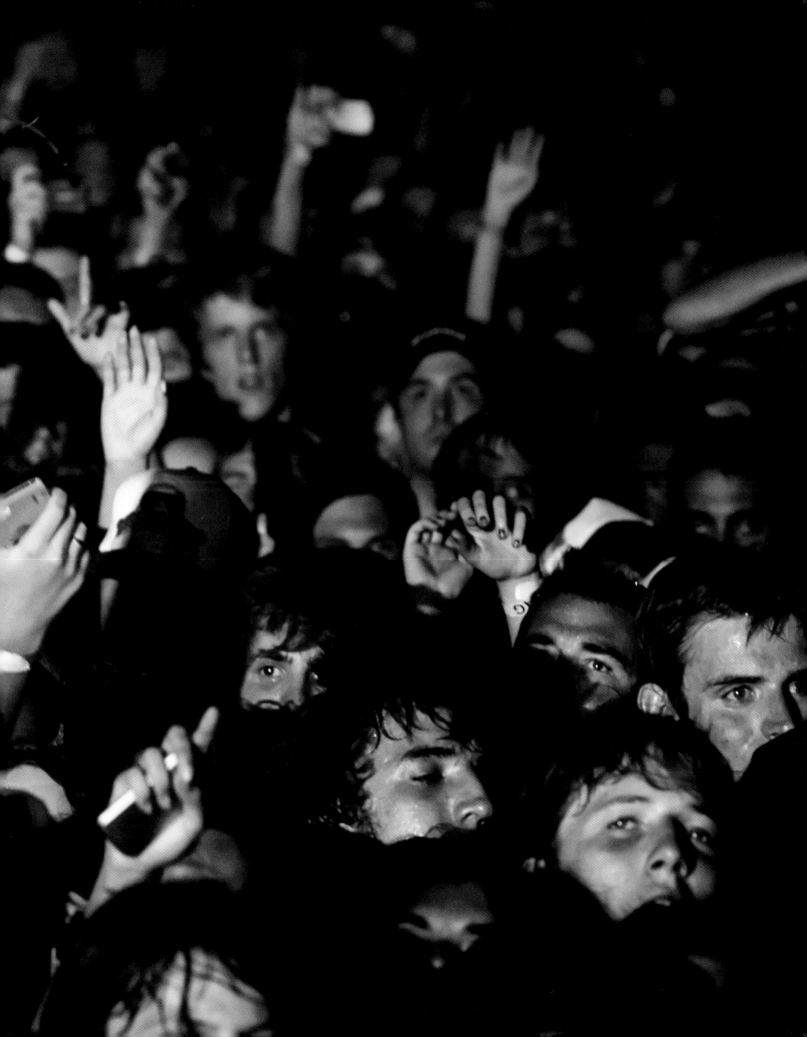

Robyn Renee Hart, 20
Massachusetts

My father, Dana Hart, gave me my first Chili Peppers album when I was seven. It was *Blood Sugar Sex Magik*. I fell in love with their music. When I was twelve, *By the Way* came out. I was elated when I received it for Christmas. I laid in bed that entire morning listening to the album on my Walkman, and reading along to the lyrics. I feel I connect so much to this album. It's definitely one of my favorites!

Simone Berg, 42
Hanover, Germany

THE RHCP WERE WITH ME DURING THE BIRTH OF MY TWO DAUGHTERS. MY MIDWIFE TOLD ME THAT IT WOULD HELP TO BRING MY FAVORITE MUSIC WITH ME TO RELAX. SO MY HUSBAND CHOSE A SELECTION OF SLOWER RHCP SONGS AND I HEARD THEM THE WHOLE TIME I WAS IN THE DELIVERY ROOM.

SOME OF MY FRIENDS CAN'T BELIEVE THAT I TRAVEL ALL AROUND TO SEE MY FAVORITE ROCK BAND AND THEY REALLY CAN'T BELIEVE THAT EVERY TIME I GET A PLACE STANDING IN THE FRONT ROW.

Gimme more than one hot minute! FAN #8952

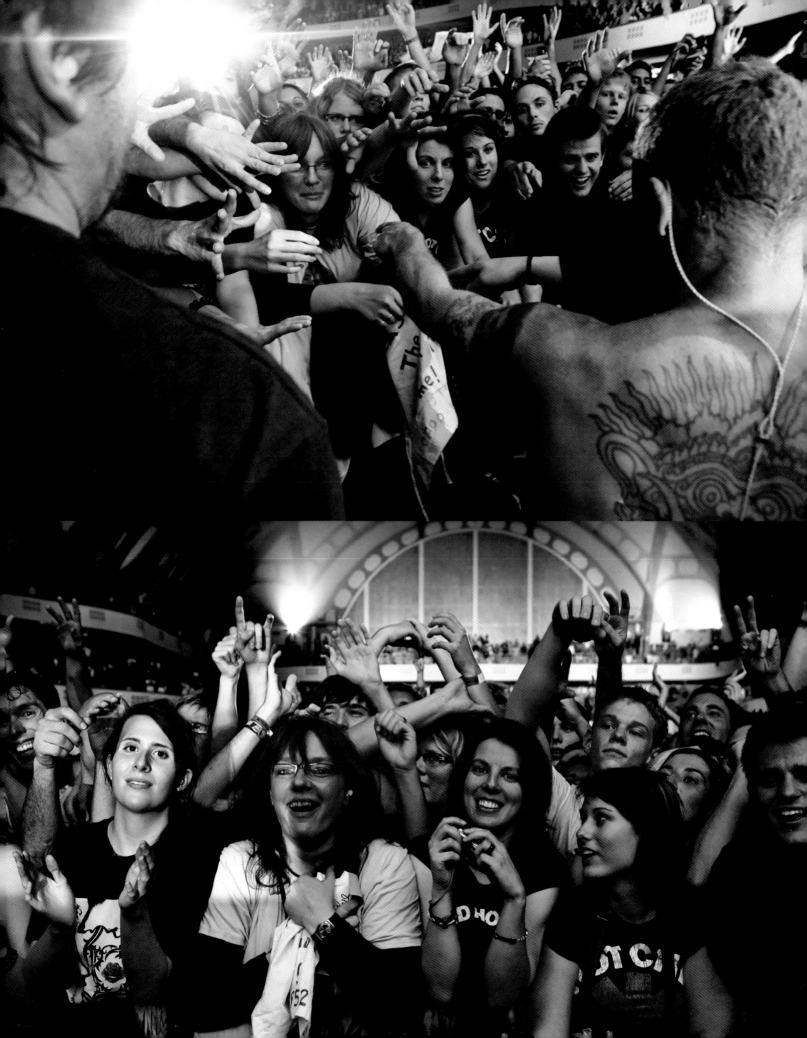

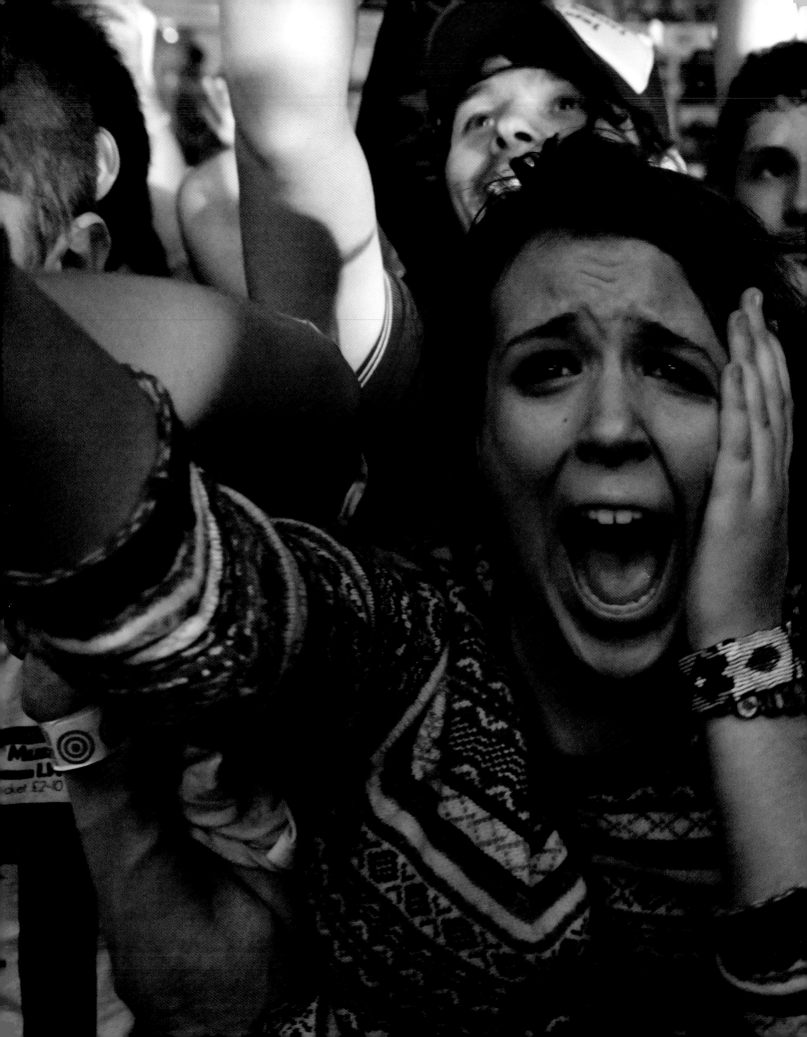

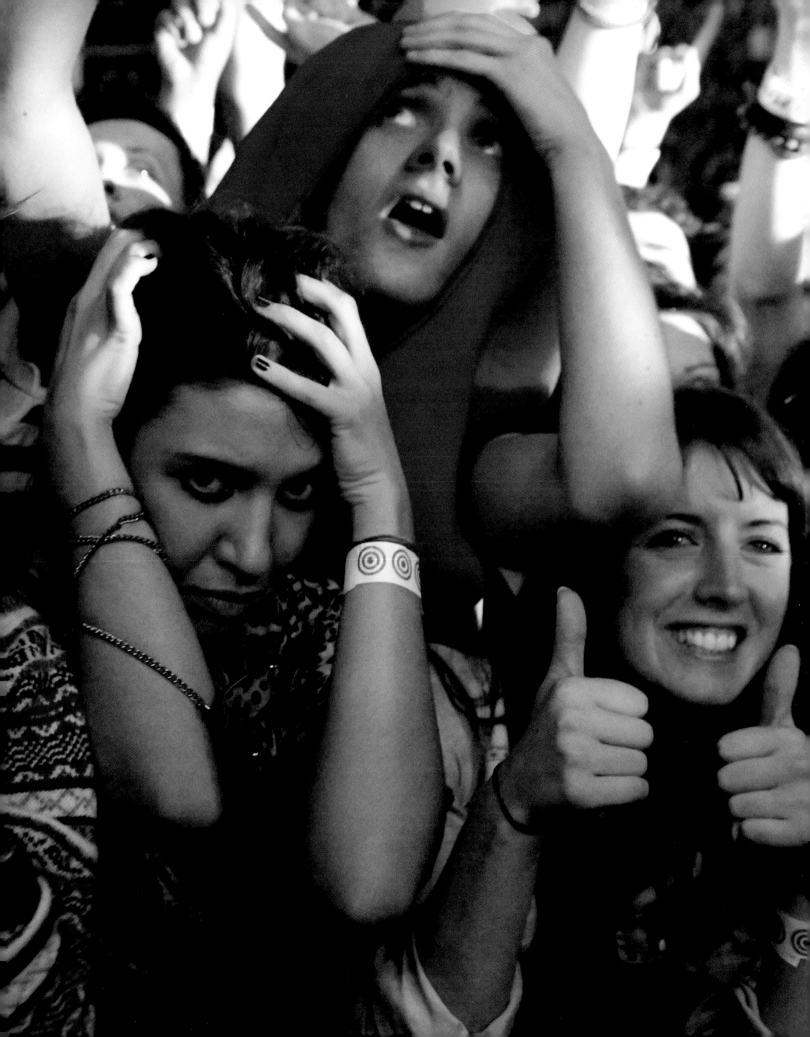

I love being a fan.

I am a fan of so many things. Writers, athletes, musicians, filmmakers, and artists of every variety, to name a few. The joy that I get from being a fan is something that sustains me, inspires me, and gives me a reason to break out of any flavor of doldrum that might befall me. I cheer on my favorite human beings and their works with the most sincere passion and love.

Being as self-critical as I am, and always wondering how we can be better as a band, it often befuddles me that people like our band as much as they do, and the lengths they go to, to be a part of our live concert experience. The only way I can deal with this concept, to honor it, is to do my best to never let them down. I want to give them every ounce of love I can channel every time we step onto a stage, no matter if I collapse in a pool of blood and puke afterwards.

I love being a fan so much, the artists I love have mythological status in my life. They advise me in times of joy and despair, and raised me up from when I was a wee little fan till growing up into the wee little man that I am. So to the RHCP fans I can sincerely say, I am one of you.

Flea

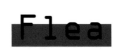

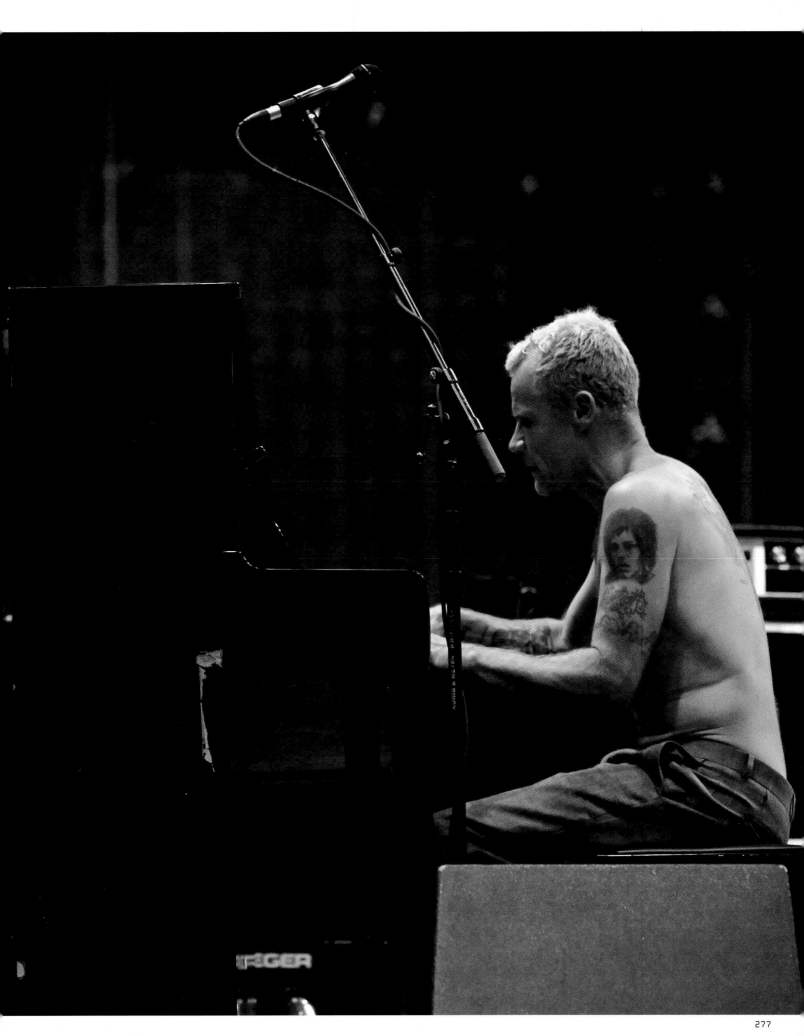

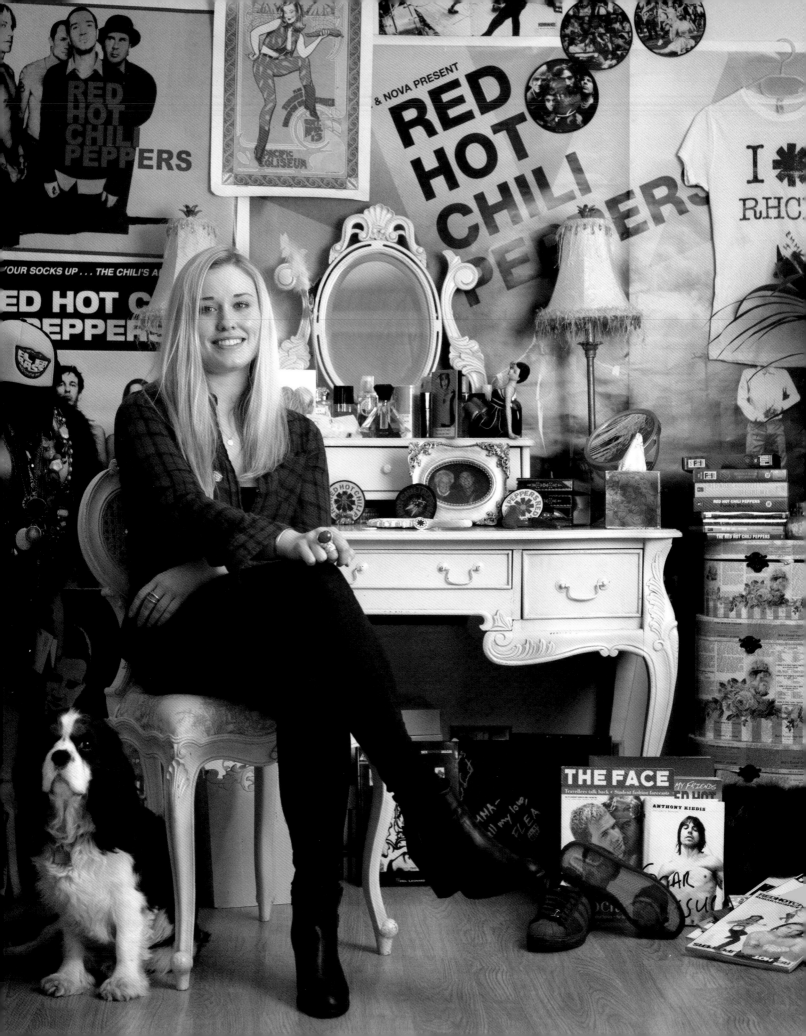

FAN CLUB CONVENTION
HOLLYWOOD CALIFORNIA

ALL ACCESS

Emma Griffiths, 26
London (102 RHCP Shows)

WHERE DO I BEGIN? THERE ARE SIMPLY TO MANY STORIES TO MENTION BUT THE HIGHLIGHTS INCLUDE: THE SECRET SHOW AT THE GARARGE LONDON 2002 AND MEETING THE BAND FOR THE FIRST TIME AFTERWARDS. THE AMAZING ROUND THE WORLD JOURNEY THAT *STADIUM ARCADIUM* TOUR TOOK ME ON AND ALL THE ADVENTURES INVOLVED. JOHN COMING OVER TO ME SIDESTAGE DURING AN ENCORE TO GIVE ME A HUG BECAUSE I WAS CRYING LIKE A NUTTER. CHAR SINGING AND PLAYING GUITAR TO ME ON MY 21ST BIRTHDAY AND MORE IMPORTANTLY MEETING AND DEDICATING A JAM TO MY 84 YEAR OLD GRANDMA. BEING IN VEGAS FOR THE NEW YEARS EVE 2012 SHOW. PLAYING FLEA'S BASS AND INTERVIEWING THE BAND FOR UNI AND MANY MORE AMAZING MEMORIES OF THE *I'M WITH YOU* TOUR. LAST BUT NOT LEAST, MEETING LOTS OF PEOPLE ALONG THE WAY, INCLUDING THOSE THAT I'LL BE LIFELONG FRIENDS WITH.

I'VE SEEN THE BAND 101 TIMES ALL OVER THE WORLD, IS THAT CRAZY ENOUGH? I'M A PRETTY FREE SPIRIT AND I'M A VERY PASSIONATE PERSON ESPECIALLY WHEN IT COMES TO MUSIC. I'M CLEARLY A LITTLE NUTS BUT I'D LIKE TO THINK THAT THE BEST PEOPLE ARE.

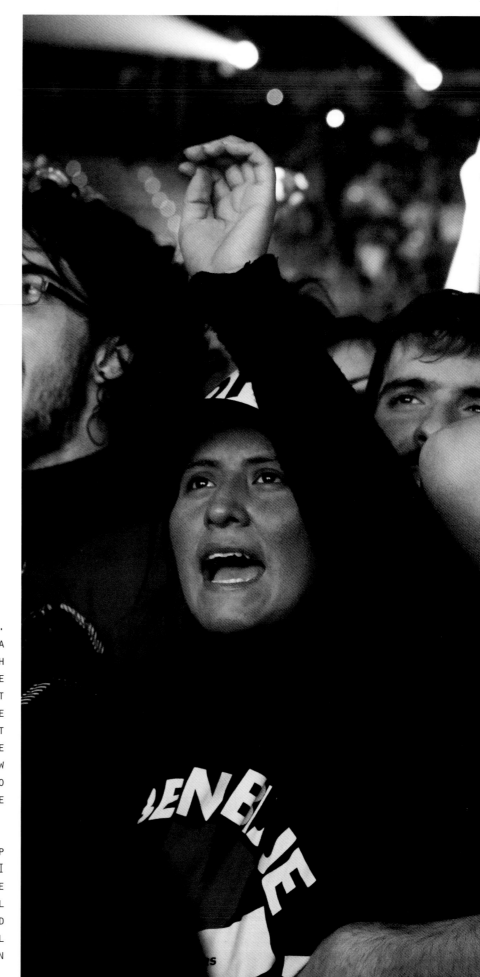

Giulia, 21
Italy

Music has always been essential to me. For everything I can remember, I have a song that I like to imagine goes with it. Of course, the Chili Peppers have themed many of my experiences. In that way, they have always been with me during my life. Surely one of the best experiences was when I had the chance to meet Anthony and tell him that I grew up with their music and that I had to thank them for the support they gave me through some hard moments in my life.

I am a makeup student. Surely makeup can be considered an art, so here I am, trying to be an artist, too. I hope this band will keep on doing wonderful music and make tons of people around the world happy. And yes, Josh will keep on being the most adorable human being on this planet.

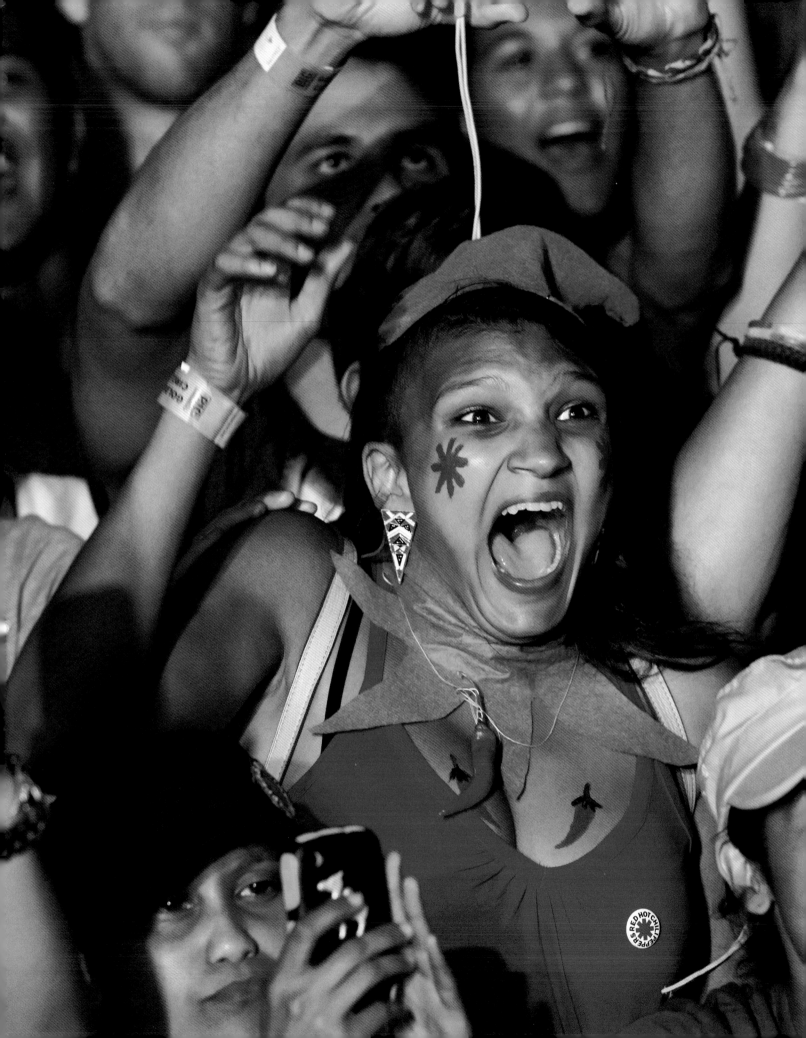

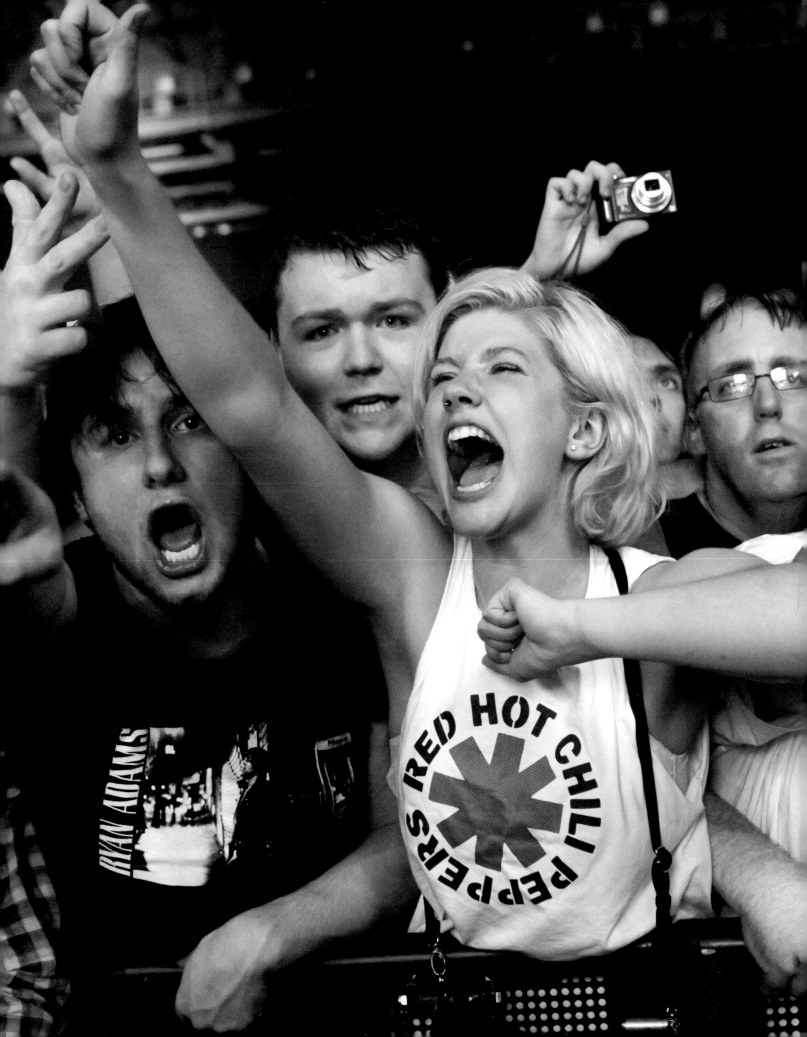

As a thirteen-year-old my bedroom was covered in posters and magazine pages of my favorite bands. Led Zeppelin, Kiss, Alice Cooper, and Black Sabbath adorned my walls. I would put the records on, staring at the album covers and pictures, trying to imagine what these musicians were like or what inspired them to make their music. To all of you in this book...I was you. I am you...I'm with you. On this last tour we were fortunate to play so many new cities all over the world (a lot of those fans are inside this book).

I'm still amazed at the response and turn out we received in all of these new countries. For this we are eternally grateful.When writing our songs in a little rehearsal room or garage, I never think about how these songs are going to affect some kid in Estonia or Turkey, or a mom in Arkansas, until they come up to me and say something like "you know that 'Under the Bridge' song really helped me through a really, really hard time in my life, thank you." Red Hot Chili Pepper fans are the most dedicated, passionate, crazy, and loving people I have ever had the pleasure to meet. Not just the millions that have come to more than thirty years of shows, or the hardest of hardcore that are in this book; but also all the smiling faces I have seen from the best spot on stage (the drums!) around the world. Sometimes its dads, moms, and kids, all rocking out together that inspires all of us to play our hearts out every single night. Thank you, thank you!

I live in NYC and nearly every day I'm stopped by a fan on the street who just wants to say "I'm a big fan, thanks for all the music." As a musician, I can't think of a better compliment to receive.
Hopes and Dreams,

Chad

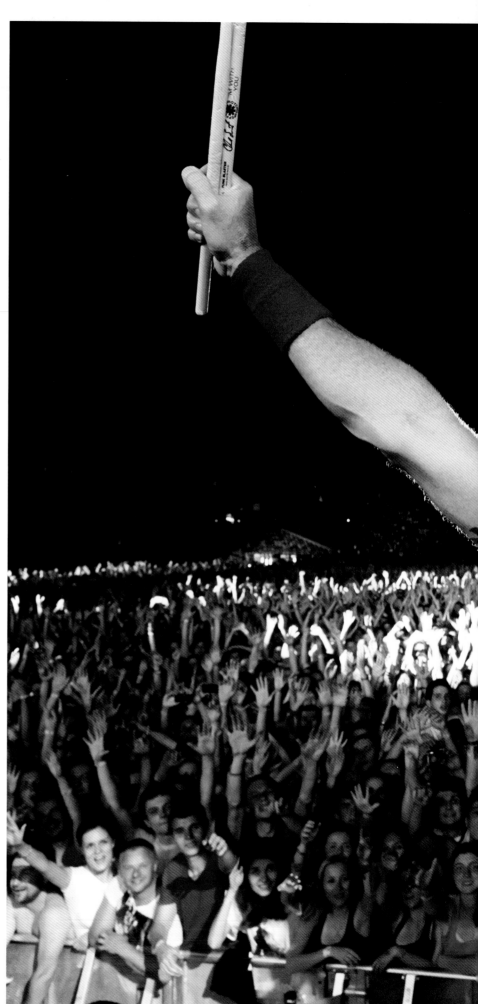

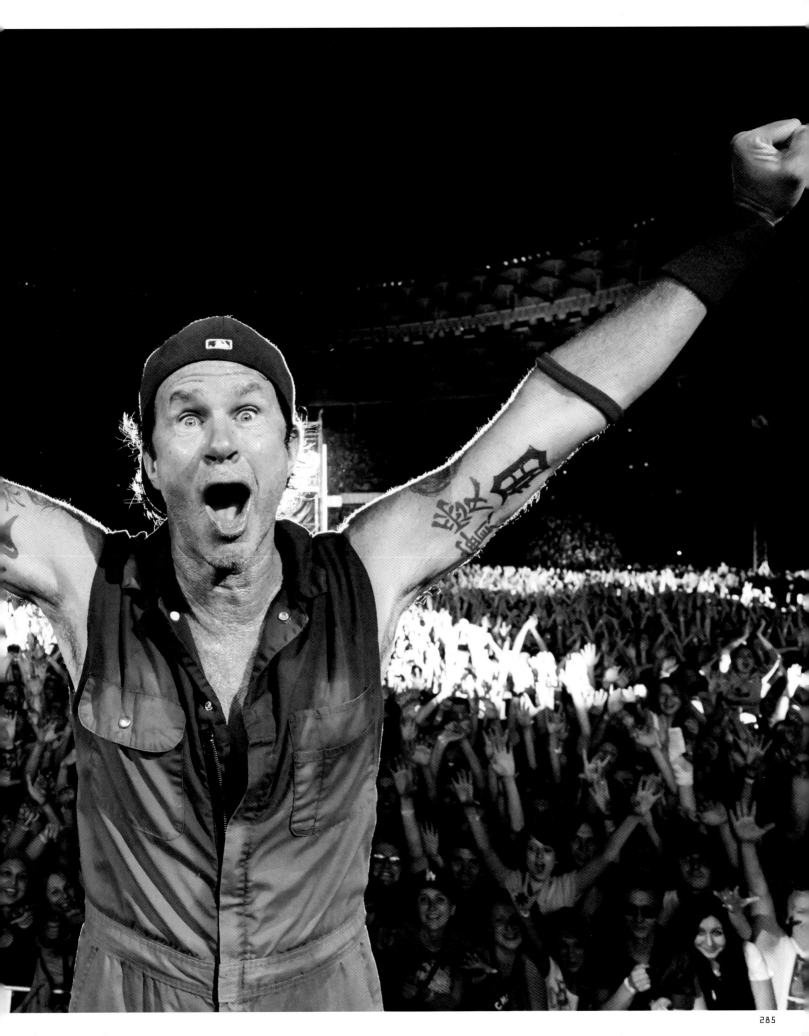